CW01191651

The Art of THE BLUES

The Art of THE BLUES

A VISUAL TREASURY OF BLACK MUSIC'S GOLDEN AGE

BILL DAHL

ART CONSULTANT
CHRIS JAMES

THE UNIVERSITY OF CHICAGO PRESS
Chicago and London

The University of Chicago Press, Chicago 60637
Copyright © 2016 Elephant Book Company Limited
The University of Chicago Press edition published 2016
All rights reserved. No part of this book may be used or reproduced
in any manner whatsoever without written permission, except in
the case of brief quotations in critical articles and reviews.
For more information, contact the University of Chicago Press, 1427 E. 60th St.,
Chicago, IL 60637.
25 24 23 22 21 20 19 18 17 16 1 2 3 4 5

ISBN-13: 978-0-226-39669-9 (cloth)
ISBN-13: 978-0-226-39672-9 (e-book)
DOI: 10.7208/chicago/9780226396729.001.0001

Library of Congress Cataloging-in-Publication Data

Names: Dahl, Bill, author.
Title: The art of the blues : a visual treasury of black music's golden age / Bill Dahl.
Description: Chicago : The University of Chicago Press, 2016. | Includes index.
Identifiers: LCCN 2016014268 | ISBN 9780226396699
(cloth : alk. paper) | ISBN 9780226396729 (e-book)
Subjects: LCSH: Blues (Music) in art. | Blues (Music)—United States—
Pictorial works. | Commercial art—United States—Pictorial works.
Classification: LCC ML85 .D3 2016 | DDC 704.9/49781643—dc23 LC record
available at https://lccn.loc.gov/2016014268

♾ This paper meets the requirements of ANSI/NISO Z39.48–1992
(Permanence of Paper).

CONTENTS

INTRODUCTION ... 6

1
THE JAZZ ME BLUES
SHEET MUSIC ... 10

2
THAT STUFF YOU SELL
PREWAR RACE RECORDS ADS ... 40

3
THE HOTTEST BANDS! THE BIGGEST HITS!
RECORD CATALOGS ... 60

4
RARE BEAUTY
PREWAR 78 LABELS ... 96

5
WHAT A NIGHT, WHAT A SHOW!
MUSIC AND MOVIE POSTERS ... 114

6
THAT SUNNY ROAD
POSTWAR BLUES 78 LABELS ... 130

7
THE BLUES ROLL ON
ALBUM COVERS, PART 1 ... 148

8
HANG IT ON THE WALL
PHOTOGRAPH GALLERY ... 166

9
I'M TALKIN 'BOUT YOU
PUBLICATIONS AND PROMOTIONS ... 184

10
THE BIG TIME
ALBUM COVERS, PART 2 ... 204

SOURCES ... 220

PICTURE CREDITS, CONTRIBUTOR BIOGRAPHIES,
AND ACKNOWLEDGMENTS ... 221

INDEX ... 222

INTRODUCTION

The African-American art form known as blues is at the heart of every roots music tributary—jazz, country, rhythm and blues, rock 'n' roll, through to the contemporary music of today. Its rich history can be charted through the array of artwork that has accompanied the music from album covers to record sleeves and from promotional photographs to show posters, proving that blues music culture is as much a feast for the eyes as it is for the ears.

BLUES DID NOT spring fully formed from the fertile imagination of a solitary African-American field hand looking for relaxation after toiling on a plantation from sunup to sundown. It was a blend of the field hollers, work songs, spirituals, and minstrel music prevalent across the South and other parts of the United States. In the latter part of the nineteenth century, the syncopated ragtime innovations of Scott Joplin and other composers swept the country, giving the music a more formal framework. New Orleans boasted a cultural diaspora like no other city in the United States, encompassing brass bands, orchestras, and a unique social climate that facilitated the development of jazz.

Orchestra leader W. C. Handy first encountered blues in 1903 when he heard a man singing and fretting his guitar with a knife at a train station in Tutwiler, Mississippi. His mammoth contributions to the genre as composer, arranger, and music publisher would eventually earn him the title "Father of the Blues."

Although scholars have stringently established boundaries between blues and jazz, there was a time when artificial separations between African-American musical genres did not exist. The climate of the day resulted in black music being universally stereotyped under the umbrella of "race music," from the classic blues chanteuses of the 1920s to territory bands and the many solo guitarists and pianists who proliferated in the South. Musicians of that era were not confined by barriers, so they performed together in a vast array of different combinations. That led to some memorably groundbreaking studio collaborations, including one seminal 1925 session that cast a young Louis Armstrong as sideman to Bessie Smith. Conversely, blues guitar virtuoso Lonnie Johnson appeared on an Armstrong recording session a couple of years later.

ORCHESTRA LEADER W. C. HANDY FIRST ENCOUNTERED BLUES IN 1903 WHEN HE HEARD A MAN SINGING AND FRETTING HIS GUITAR WITH A KNIFE AT A TRAIN STATION IN TUTWILER, MISSISSIPPI.

Regionally identifiable styles were commonplace during the 1920s and '30s, from the Mississippi Delta blues of Charley Patton and Robert Johnson to the intricate finger-picking guitar technique that defined the East Coast's Piedmont school and the rumbling barrelhouse piano tradition that thrived in St. Louis. The same was true in the jazz field, where bandleader Bennie Moten's blues-oriented Kansas City approach contrasted with the sophisticated sound that Duke Ellington perfected during the Harlem Renaissance.

Over the course of the twentieth century, the Great Migration brought hundreds of thousands of African-Americans up from the rural South to the urban North in search of a better life. Musicians were part of that trek northward, and once the transplants settled into their new surroundings, their blues took on a more citified

veneer. This quality defined the extremely popular recordings of prolific blues stars Tampa Red, Big Bill Broonzy, and Leroy Carr.

During the early 1940s, a new generation of innovative guitarists led by jazzman Charlie Christian and his blues counterpart T-Bone Walker plugged into amplifiers, and their flashy lead licks were instantly heard as distinctly as anyone in their respective bands. There would be no turning back as the electric guitar eventually became the instrument most closely associated with the idiom. The years following World War II were relatively prosperous ones, giving rise to a network of nightclubs, theaters, and taverns where the music flourished. On the West Coast, jump blues driven by roaring horn sections predominated. A tight ensemble approach was perfected in Chicago by Muddy Waters and Little Walter, one of the first harpists to use amplification (and easily the most important). Instead of the handful of major labels that once dominated the blues recording field, an invasion of hungry little independent record companies came to claim the lion's share of the postwar rhythm and blues (R&B) market as the fresh new sound spread like wildfire. There were still noticeable regional developments—south Louisiana spawned a lowdown sound during the mid-to-late 1950s that would later become known as swamp blues—but as more and more artists followed the example of B. B. King, it became difficult to pinpoint precisely where a blues musician hailed from just by listening.

ABOVE LEFT: A turn-of-the-century African-American minstrel band in fairly formal attire. One of the first forms of black music to be performed for white audiences; this group's lineup of two banjos, violin, and guitar was well-suited for dancing long into the night. Stringed instruments were portable and thus ideal for performances.

ABOVE RIGHT: The Empress of the Blues, Bessie Smith, in an early publicity photo that was the work of a New York photographer called Elcha. The linchpin of the classic blues movement, Smith recorded prolifically from 1923 to 1933. She died tragically in a car wreck on September 26, 1937, along US Route 61 between Memphis and Clarksdale, Mississippi.

INTRODUCTION

At the dawn of the 1960s, major music festivals began to present a wide array of African-American performers, finding room for gospel diva Mahalia Jackson as well as rock 'n' roll architect Chuck Berry. These events, attended by thousands of college students and other young people, revitalized the long-defunct careers of many blues greats that had not been heard from for decades, most notably Delta legend Son House, and introduced them to a demographic they could not have dreamed of reaching when they started out in the rural South. This new and relatively well-off audience purchased plenty of blues records but concentrated primarily on acquiring albums rather than the singles that had sustained blues for so long. Some Caucasian converts of a musically inclined nature were inspired to crank up the volume on their amps and let fly with their own high-energy brand of blues-rock, creating a hybrid that forever blurred the lines between the two genres.

The Art of the Blues is not intended to be an exhaustive history of the music and its masters. It is instead a tribute to the visual side of its golden age, when rare and beautiful images abounded that perfectly complemented the epochal music. These artifacts, including record advertisements, posters, and 78 rpm (78s) record labels, were diligently designed, especially during the prewar era. Lavish, color-soaked artwork adorning 1920s sheet music seemed to jump right off the page. During the 1930s, a sleeker, more streamlined look inspired by art deco came into fashion. That great attention to detail faded during the 1940s and '50s, but the period brought its own share of artistic delights, especially in the design of album covers. During the first half of the 1960s, stately portraits of the artists were in vogue for album cover art; near the decade's end, a blast of trippy psychedelia blew into the graphic design arena.

Just like the music itself, the art featured in this book is exceedingly rare and of the highest caliber imaginable. Its appeal is as timeless as it is captivating.

ABOVE LEFT: One of the most adventurous and accomplished blues guitarists to emerge during the 1920s, New Orleans native Lonnie Johnson recorded the mournful "Lonesome Ghost Blues" for OKeh in New York on August 11, 1927. It was later said to have been an influence on Robert Johnson. Lonnie was equally dazzling as a jazz guitarist.

OPPOSITE, ABOVE RIGHT: The front and back covers of Columbia's second Robert Johnson album reissue in 1970 contained an incredible illustration of his November 1936 debut recording session at San Antonio's Gunter Hotel credited to Tom Wilson and the *Daily Planet*. No photograph was then available of the shadowy guitarist, so he was pictured from behind, singing into a microphone.

ABOVE: Marion Post Wolcott's June 1940 photo of Frenchies Bar and Beer Garden allows us a stunning glimpse at a juke joint in Melrose, Louisiana. Spread across the rural South, juke joints were highly informal meeting places where African-Americans gathered to socialize, imbibe, and dance to a non-stop soundtrack of live blues.

RIGHT: An unbelievable lineup commanded the stage of Memphis's Ellis Auditorium on August 6, 1965, headlined by Chicago powerhouse Howlin' Wolf. Boogie man John Lee Hooker was second-billed above his Vee-Jay Records labelmate Jimmy Reed and soul-blues guitarist Little Milton. Big Joe Turner and T-Bone Walker had not had hits in a while, hence their low billing. Baltimore's Globe Poster Printing Corporation did the layout for this eye-catching poster.

INTRODUCTION

CHAPTER ONE

THE JAZZ ME BLUES
SHEET MUSIC

"Of course there are a lot of ways you can treat the blues, but it will still be the blues."
COUNT BASIE

Long before the masses enjoyed easy access to recorded music, people got together to make their own. They gathered around a piano and sang in parlors, using professionally printed sheet music that provided the musical notes and lyrics to the popular songs of the day—the same themes that were being performed in dance halls and on theater stages in the United States and abroad.

MUSIC PUBLISHING INTENSIFIED during the nineteenth century, when minstrel themes, spirituals, and "coon [sic] songs" were among the many forms of music to be published. From the 1880s onwards, a cottage industry blossomed in New York City—revolving around the publication of popular songs. The competition between those songs for local prominence was as fierce as it would prove to be with Top 40 fare more than half a century later.

Although notable music publishing houses were located in Chicago, New Orleans, St. Louis, and several other major American cities at the turn of the twentieth century, the epicenter of the business was in Manhattan. Most of the leading publishers were situated on 28th Street, between Broadway and Fifth Avenue, on a strip that came to be known as Tin Pan Alley. The term eventually became synonymous with the type of popular standards that those publishers specialized in.

The emergence of ragtime in the 1890s meant that African-American composers began to make real advances within the industry. Pianist Scott Joplin's sheet music to his "Maple Leaf Rag" reportedly sold a million copies around the turn of the century, and his subsequent compositions also did well. A dance called the Cakewalk made its way up from the South through black minstrelsy, inducing New York songsmiths to tailor some of their material to the new sensation.

During that same time frame, color ink and intricate illustrations became the norm for sheet music artwork, rendering it far more visually appealing. However, there was nothing attractive about the grotesque stereotypes sometimes employed in their front-page illustrations. Drawings of black characters with bright red lips and bulging eyeballs sullied the sheet music for "All Coons Look Alike to Me" published in 1896 and "Coon Coon Coon" in 1901. African-American vaudevillians Bert Williams and George Walker were prominent enough to merit their images being displayed on sheet music for tunes they performed, yet on "The Coon's Trademark" printed in 1898 they were overshadowed by drawings of a watermelon, a chicken, and a straight razor.

Blues and jazz followed hot on the heels of ragtime in the African-American musical timeline. Tin Pan Alley was quick to pick up on the trend. Its denizens churned out countless songs bearing the word "blues" in their titles during the first two decades of the new century, but

BLUES AND JAZZ FOLLOWED HOT ON THE HEELS OF RAGTIME IN THE AFRICAN-AMERICAN MUSICAL TIMELINE.

precious few of those largely forgettable songs had much to do with the actual genre. Of the handful of true blues compositions published in 1912, none was more important from a musical standpoint than pioneering bandleader W. C. Handy's "The Memphis Blues."

The Florence, Alabama-born trumpeter was living in the Bluff City and playing clubs on wide-open Beale Street when he wrote a campaign song in 1909 for local mayoral candidate Edward "Boss" H. Crump. Following Crump's election, Handy refashioned his tune into "The Memphis Blues." It was a milestone for the genre and the first of Handy's many musical triumphs. "Boss" Crump wielded immense political power for decades to come; his reign was immortalized in bluesman Frank Stokes's 1927 Paramount recording "Mr. Crump Don't Like It."

Handy's "The Saint Louis Blues," published in 1914 by Pace & Handy Music Company of Memphis (partner Harry Pace went on to found Black Swan Records), developed into a standard that crossed over into the popular lexicon. The cover of its sheet music claimed it was "the first successful blues published" and "the most widely known ragtime composition," showing how fluid the boundaries were between the two new styles. A spectacular color rendering of Memphis's favorite African-American thoroughfare graced the 1917 sheet

RIGHT: Carl Van Vechten was immersed in the Harlem Renaissance when he took this 1932 photo of composer/bandleader W. C. Handy, then living in New York. Florence, Alabama native Handy holds a copy of his 1926 book *Blues: An Anthology*. Sheet music for his 1913 composition "The Jogo Blues" adorns the wall behind him.

THE JAZZ ME BLUES: SHEET MUSIC

13

music for Handy's "Beale Street," with the bandleader's red-jacketed orchestra clearly visible in the intersection. The illustration also featured P. Wee's bar—one of the street's preferred destinations.

New York was the hub for ragtime and stride pianists starting out during the 1910s and '20s. James P. Johnson, Willie "The Lion" Smith, Luckey Roberts, and Fats Waller were masters of the propulsive stride style, their compositions finding their way onto piano rolls, 78s, and sheet music. Legend has it that several of these greats sold off some of their originals to Tin Pan Alley denizens, who attached their names to the future hits while eradicating those of their originators.

Pianist Eubie Blake and his compositional partner Noble Sissle were part of that teeming scene, parlaying their compositional prowess into co-writing and co-producing a series of groundbreaking African-American musical productions in New York during the early 1920s. A 1919 sheet music printing of the pair's "Baltimore Blues" featured a classy color drawing of a nattily dressed pianist. Its signature of Starmer signified it was the work of British-born brothers William and Frederick Starmer—prolific sheet music artists from the early 1900s into the '40s.

Though it remained fairly rare for African-American performers to have their photos displayed on 1920s sheet music, the "classic blues" movement brought some lovely exceptions. Composer Perry Bradford's publishing company printed up Mamie Smith's smash "Crazy Blues," its cover sporting an animated photo of the chanteuse and her quintet—the Jazz Hounds. Blues singer Alberta Hunter and pianist Lovie Austin wrote Bessie Smith's 1923 debut recording "Down Hearted Blues" (Hunter had cut it herself the year before), but at least two early versions of the sheet music for the hit substituted photos of white singers where Smith's face should have been. Interestingly, as powerful as Bessie's voice was, she amazingly flunked an audition for Thomas Edison and his record company (which had grown out of Edison's National Phonograph Company) prior to her signing with Columbia, Edison scribbling a dismissive "no good" beside her name.

Bessie's pianist and early manager Clarence Williams was the common thread between many of the top classic

ABOVE LEFT: Decorated with a colorful illustration of a field hand credited to Chicago's Hughes & Johnson Litho., *Minstrel Songs and Negro Melodies from the Sunny South* was published in 1884 by S. Brainard's Sons of Cleveland and Chicago. It was packed with songs of the era, including "Ring Dem Hebenly Bells" and "With My Banjo on My Knee."

ABOVE RIGHT: Ragtime innovator Scott Joplin was living in Sedalia, Missouri, when he published his seminal "Maple Leaf Rag" in 1899. Joplin later moved to St. Louis; John Stark & Son published his composition "The Cascades" there in 1904. The stately photo of Joplin on the cover dates from the previous year.

THE ART OF THE BLUES

blues chanteuses. He wrote "Gulf Coast Blues," the other side of Bessie's debut 78, his publishing house positioning her smiling countenance on its sheet music. Williams used virtually the exact same artistic layout for Smith's follow-up piece "Oh Daddy Blues" and Sara Martin's "'Tain't Nobody's Biz-Ness If I Do," written by Porter Grainger (a favored pianist of Bessie's) and Everett Robbins. The sheet music for the latter incorporated a stunning photo of Martin wearing a feather-festooned hat. Hunter's "Bleeding Hearted Blues," penned by Austin and cut for Paramount Records in February 1923, received deluxe treatment from publisher Jack Mills Inc.—Alberta's glamorous picture was accentuated by a red-tinted illustration of a bird.

The first generation of country blues guitarists enjoyed very little sheet music representation. Tampa Red and Georgia Tom's bawdy 1928 blockbuster "It's Tight Like That" made the cut, as did jazz-influenced guitarist Lonnie Johnson's "Love Story Blues" and "Falling Rain Blues." One sheet music version of banjo-playing bluesman Papa Charlie Jackson's 1925 smash recording "Shake That Thing" pictured a tuxedoed black dandy with top hat and cane shaking his thing next to a photo of—bizarrely—Guy Lombardo's orchestra!

African-American territory bands had their swinging orchestrations published as sheet music during the 1920s and '30s, as did the considerably better-known Duke Ellington and Cab Calloway. Hits by Louis Jordan and Nat King Cole were similarly honored during the next decade, though the design quality of such sheet music began to wane around this time. By the mid-1950s, rock 'n' roll's first generation—including Chuck Berry, Fats Domino, LaVern Baker, the Platters, and the Penguins—had to be content with the covers of their sheet music usually being printed in one color on a generic white background with minimal ornamentation and their promo photos being the lone focal point.

Even when soul recordings grew so slick during the 1960s and '70s that memories of sitting around that creaky parlor piano with lyrics securely in hand had been relegated to the ancient past, sheet music for those hits was a common commodity. Today, it is all online.

ABOVE LEFT: Robbins Music Corporation assembled a folio of Handy's best-known compositions. With "St. Louis Blues," "Beale Street Blues," and "Joe Turner Blues" featured, it touched on many of the orchestra leader's early career highlights. The Father of the Blues was eighty-four when he died on March 28, 1958, in New York.

ABOVE RIGHT: Lyricist Noble Sissle and pianist Eubie Blake met in Baltimore in 1915 and wrote the scores for the groundbreaking African-American Broadway musicals *Shuffle Along* (1921) and *The Chocolate Dandies* (1924). They wrote "Baltimore Blues" in 1919, its cover illustration was the creation of British-born brothers William and Frederick Starmer.

THE JAZZ ME BLUES: SHEET MUSIC 15

ABOVE LEFT: After growing up in a series of South Carolina orphanages, Tom Delaney wrote "The Jazz-Me Blues" in 1920. Lucille Hegamin recorded his composition late that year for the Arto label (only Mamie Smith preceded her onto record as a classic blues diva). Hegamin was on Paramount, Cameo, and other labels until 1932, then reemerged in the early 1960s.

TOP RIGHT: African-American composer Perry Bradford wrote Mamie Smith's 1920 smash "Crazy Blues." His self-published "Wicked Blues" became enmeshed in a lawsuit when it was alleged that after someone had bought the rights to it, Bradford simply changed its title to "Crazy Blues." The matter was ultimately settled out of court.

BOTTOM RIGHT: The lady who started it all, Mamie Smith, ignited the classic blues craze in August 1920 with her "Crazy Blues" under the aegis of its composer Perry Bradford. Mamie encored a month later on OKeh Records with Bradford's self-published "Fare Thee Honey Blues," recorded in New York with her Jazz Hounds again in support.

THE ART OF THE BLUES

ABOVE LEFT: Violinist Armand J. Piron and pianist Clarence Williams teamed up in New Orleans in 1915 to form a publishing company and to play the vaudeville circuit. They found success with Piron's "I Wish I Could Shimmy Like My Sister Kate," which Louis Armstrong later said he sold to them. Piron's New Orleans Orchestra recorded in New York from 1923 to 1925.

ABOVE RIGHT: Clarence Williams's New York-based firm also published Porter Grainger and Everett Robbins's "'Taint Nobody's Biz-ness If I Do," usually associated with Bessie Smith thanks to her classic April 1923 rendition. However, Sara Martin beat her to the punch, recording the anthem for OKeh on December 1, 1922, with a then-unknown Fats Waller on piano.

THE JAZZ ME BLUES: SHEET MUSIC

LEFT: Although Memphis-born diva Alberta Hunter recorded "Chirpin' the Blues" for Paramount in 1923 (she wrote it with pianist Lovie Austin, who gave way to Fletcher Henderson at the actual session), publisher Jack Mills Inc. placed a photo of Bessie Smith on the sheet music despite the fact that she had never recorded it.

THE ART OF THE BLUES

TOP & BOTTOM: Bandleader Leroy Smith took something of a symphonic approach to his arrangements. He recorded for labels large (Victor, Vocalion) and small (Nadsco, Up-to-Date) during the 1920s, his group included trombonist Wilbur DeParis. "No! No! Nora!" was the work of Tin Pan Alley songsmiths Gus Kahn, Ted Fiorito, and Ernie Erdman.

THE JAZZ ME BLUES: SHEET MUSIC

CLARENCE WILLIAMS

Clarence Williams wore every hat imaginable during the early days of blues and jazz recording in New York, from bandleader and piano accompanist to prolific composer. Williams was also one of the first and most successful African-American music publishers of the 1920s and '30s, blazing another essential trail. In short, he did it all.

BORN OF CHOCTAW Indian and Creole ancestry in Plaquemine, Louisiana (probably on October 8, 1893), Williams inherited some of his musical leanings from his father, a bassist and hotel proprietor whose humble inn hosted some of his earliest performances. Brimming with youthful confidence, Clarence left home aged twelve to sing with comedian Billy Kersands's minstrel show. Williams eventually returned to New Orleans, where the city's red-light Storyville district boasted some of the greatest piano talent to be found anywhere. Behind the facades of the saloons and sporting houses situated along wide open Rampart and Basin Streets, Jelly Roll Morton and Tony Jackson embodied the high life, stylishly pounding out ragtime, cakewalks, and pre-jazz selections as the good times rolled unabated all night long.

Clarence joined the select ranks on the Storyville circuit, his strong business sense already serving him well. He and violinist Armand J. Piron teamed up to form their own publishing house, Williams & Piron Music Company, as well as a vaudeville act. The duo continued to perform together until Williams decided to move north to Chicago in 1920. The enterprising pianist proceeded to establish three music stores on the city's South Side. But the real action was happening in New York, where the classic blues movement was in full bloom and capable piano accompanists were in heavy demand.

Pulling up stakes once more in 1923, Williams arrived in New York at precisely the right moment. His New Orleans-schooled piano skills were quickly put into service in the studio backing Lucille Hegamin, Virginia Liston, Sippie Wallace, and many more; only Fletcher Henderson rivaled him as an accompanist. OKeh Records recognized the multitalented newcomer's value, hiring him as an A&R (artists and repertoire) man. In the meantime, Williams founded another music publishing firm, this one named after himself. The company proudly proclaimed that it was the "Home of Jazz—Home of Blues" on its sheet music.

Williams played a crucial role in bringing Bessie Smith into the studio for her first Columbia recording session. Label honcho Frank Walker dispatched him to bring Smith in after Clarence had sung her praises to him, and the pianist stuck around to accompany Bessie. The savvy Williams signed Smith to a managerial contract rather than directly to Columbia, but a heated visit to Williams's office by Bessie and her husband, Jack Gee, put an end to that setup and Smith was quickly signed to Columbia. That did not stop Clarence and the Empress of the Blues from collaborating in the studio several times after that, stretching into late 1931. He also wrote "Gulf Coast Blues" and "Baby Won't You Please Come Home Blues," both recorded by Bessie Smith.

THE COMPANY PROUDLY PROCLAIMED THAT IT WAS THE "HOME OF JAZZ—HOME OF BLUES" ON ITS SHEET MUSIC.

Despite all that behind-the-scenes activity, Williams somehow found time to record and often featured as a bandleader. As boss of the studio-only aggregation the Blue Five, Williams made a series of seminal 1923–27 recordings for OKeh—the most important featuring the brilliant improvisations of Louis Armstrong and soprano saxophonist Sidney Bechet. Williams had previously teamed Satchmo and Bechet for some 1924–25 sides for Gennett that also featured singer Alberta Hunter, billing that lineup as the Red Onion Jazz Babies. Although he was on OKeh's payroll, Williams recorded for virtually every other label of the era simultaneously under a variety of guises. At Grey Gull, he commanded the Memphis Jazzers. Columbia billed Williams's combo of the moment as the Dixie Washboard Band, while on QRS Records he and his pals masqueraded as the Barrel House Five. Paramount placed Williams's own name on the label.

In 1927, Williams branched into theatrical production. He wrote the script and many of the songs for *Bottomland*, a musical that starred his wife, singer Eva Taylor. The show was not a major success, but Williams's publishing and compositional interests continued to prosper. He made recordings as a leader throughout the 1930s for Bluebird, Vocalion, and other labels. Williams sold his massive publishing catalog to Decca Records in 1943 for a reported $50,000. All of his activities were curtailed when he was hit by a taxi and blinded in 1956. Williams died in Queens, New York, on November 6, 1965. His vast legacy as a music business pioneer has been too often overlooked.

ABOVE LEFT: Music publishing was one of Clarence Williams's many specialties in the business, and he was very successful in the field. His self-named firm assembled a *Syncopated Piano Solos* folio in 1925. An artist named Stocker supplied the cover art, which was dominated by a nicely rendered portrait of Williams.

ABOVE RIGHT: An advertisement from another piece of Clarence Williams's published sheet music that plugged nine songs from his catalog—two-thirds of them performed on record during the mid-1920s by Williams's stellar studio-only band, the Blue Five. The design itself is similar to the advertisements that record labels placed in African-American newspapers.

THE JAZZ ME BLUES: SHEET MUSIC

LEFT: A longtime attraction at New York's classy Hunter Island Inn in 1924, William A. Tyler's orchestra no doubt did full justice to "Linger Awhile." The song was recorded in 1923 by bandleader Paul Whiteman, as well as by Fletcher Henderson's orchestra. Composer Vincent Rose and lyricist Harry Owens did their creating in New York's Tin Pan Alley.

THE ART OF THE BLUES

ABOVE LEFT: Bennie Moten led the most important orchestra to come out of Kansas City during the 1920s. He was on piano when his band made their first recordings in 1923 and their 1928 hit "South," before recruiting Count Basie to roll the ivories. Moten co-wrote "That's When You Need Somebody to Love," published in 1930.

ABOVE RIGHT: New Orleans was fertile ground for future songwriters. Spencer Williams was born there but rose to fame in New York, where he established his own publishing house. Williams's writing triumphs included "Royal Garden Blues," "I Ain't Got Nobody," "Squeeze Me," and the 1923 composition "Tired o' the Blues (Mournful Mamma's Wail)."

THE JAZZ ME BLUES: SHEET MUSIC

TOP & BOTTOM: Led by violinist Leon Abbey, the Savoy Bearcats were an eleven-strong ensemble and a regular mid-1920s attraction at New York's Savoy Ballroom (they also recorded for Victor). Tin Pan Alley songsmiths Gus Kahn and Walter Donaldson penned "Up and Down the Eight Mile Road," published by Irving Berlin's firm in 1926 with the Bearcats on the cover.

24 — THE ART OF THE BLUES

TOP & BOTTOM: Pianist Alphonso Trent and his orchestra only recorded eight sides over a five-year span. His trombonist, Leo "Snub" Mosley, wrote "Gilded Kisses" along with lyricist Ralph Soule, and Trent's band recorded it in Richmond, Indiana, for the Gennett label in 1928. Published by the Music Shop of Lexington, Kentucky, it was Trent's debut release.

THE JAZZ ME BLUES: SHEET MUSIC

25

THE MELROSE BROTHERS

The music business would be very good indeed to the Melrose brothers, thanks in large part to the lucrative world of song publishing—especially songs written by African-Americans.

BORN DECEMBER 14, 1891, in downstate Olney, Illinois, Lester Melrose made his way up to Chicago in 1912 to join his older sibling Walter, born October 26, 1889, in nearby Sumner, Illinois. Lester operated a grocery store prior to fighting overseas in World War II. After he returned stateside, he and Walter took the plunge into the music business. They opened Melrose Brothers Music Company in 1922 on Chicago's South Side—their store offering the latest 78s, sheet music, piano rolls, and various instruments under one roof. Not missing a trick, the Melroses also established a music publishing company, coining the slogan "the House that Blues Built" to describe its specialty. They were quite successful at publishing early Chicago jazz and blues.

Jazz pioneer Jelly Roll Morton swaggered into Melrose Brothers Music Company in 1923. Born to Creole parents in New Orleans, the well-traveled Morton had shaped his prodigious piano skills in the sporting houses of Storyville, developing a groundbreaking approach that provided a crucial bridge between ragtime and early jazz. His writing and arranging talents were every bit as immense as his piano technique. Morton signed a publishing pact with the Melrose brothers that formed the backbone of their growing catalog, his treasures including "King Porter Stomp" and "Milenberg Joys." The relationship would unravel in years to come as Jelly Roll and Walter battled in court over allegedly missing royalties.

Meanwhile, expanding their horizons, the ambitious brothers entered a recording studio to supervise the New Orleans Rhythm Kings' 1923 recording of "Tin Roof Blues" for Gennett. Although the band was credited with composing the song's melody, Walter shared in the royalties by writing a set of seldom-heard lyrics for the tune—not an altogether unfamiliar strategy for him at a time when writers' credits were often changed without the knowledge or permission of the original composers.

The allure of the studio seduced Lester. He sold Walter his share of the family business in 1926, venturing out on his own to concentrate on A&R work. He was spectacularly successful at it, producing a staggering number of sides during the 1930s and '40s. Basically, if it was Chicago blues and issued on Columbia, OKeh, Bluebird, or RCA Victor, it was a safe bet that Lester would have supervised its recording. His vast talent

NOT MISSING A TRICK, THE MELROSES ALSO ESTABLISHED A MUSIC PUBLISHING COMPANY, COINING THE SLOGAN "THE HOUSE THAT BLUES BUILT" TO DESCRIBE ITS SPECIALTY.

stable included Tampa Red, John Lee "Sonny Boy" Williamson, Big Bill Broonzy, Big Maceo, and Lil Green—and the hits flowed freely.

Lester knew the worth of a good copyright. His own company, Wabash Music, gobbled up the publishing for his myriad blues productions, a business model that proved extremely lucrative in decades to come.

Walter and Lester were not the only Melroses to make a living from the music business. Their younger brother was billed as Kansas City Frank and fashioned a career as a jazz pianist. He recorded for Brunswick as a leader and backed bluesmen Al Miller on Brunswick in 1929 and Tampa Red on Bluebird in 1934—a real rarity for a white musician. Frank Melrose died at the age of thirty-three in 1941 after a bar fight in Hammond, Indiana.

Lester retired to Arizona during the early 1950s, selling Wabash to Hill & Range Music midway through the decade. He lived in sunny Florida until he died on April 12, 1968.

Walter got out of the business, too, his publishing catalog ending up the property of Edwin H. Morris & Company. He passed away in May 1973. Despite the disagreements with some of their artists over royalties, the Melroses' reign as early publishing magnates had been long and fruitful.

ABOVE LEFT: Walter and Lester Melrose published Charlie Davis and Fred Rose's "Jimtown Blues," the 1925 sheet music paying tribute to the band that introduced it. Jimmie Wade's Moulin Rouge Syncopaters were resident in a Chicago nightspot, the Moulin Rouge, on South Wabash Avenue. They had recorded for Paramount two years earlier.

ABOVE RIGHT: The Melroses' sheet music made spectacular use of bright colors, ornate designs, and black-and-white band photos. New Orleans-based cornetist Joe "King" Oliver recorded "Sobbin' Blues" for OKeh in Chicago in 1923; he and his Creole Jazz Band (featuring a young Louis Armstrong) got this deluxe treatment from the Melroses.

THE JAZZ ME BLUES: SHEET MUSIC

27

RIGHT: Bennie Moten's primary Kansas City competition came from saxophonist George E. Lee's Novelty Singing Orchestra. Lee split the vocals in his band with his piano-playing sister, Julia Lee, who fronted their 1927 Meritt recording "Down Home Syncopated Blues," and later enjoyed a successful solo career. "Oh Baby! I'm Happy Now" was published in 1931.

28

THE ART OF THE BLUES

RIGHT: No single orchestra was more essential to the development of jazz than that of the magnificent Duke Ellington. The suave pianist insisted his music was beyond category, proving it by seducing black and white listeners alike. "Cabin in the Cotton" was not one of his countless works; Tin Pan Alley lyricist Mitchell Parish wrote it with Frank Perkins.

THE JAZZ ME BLUES: SHEET MUSIC

ABOVE LEFT: The Mills Brothers could simulate an entire band using only their mouths. Donald, Herbert, Harry, and John, Jr. (who doubled on guitar) comprised the expertly harmonized vocal quartet, originally hailing from Piqua, Ohio. After scoring big with "Tiger Rag," the Mills Brothers recorded "Good-bye Blues" in 1932 for Brunswick.

ABOVE RIGHT: African-American music publisher and label owner Joe Davis published Andy Razaf and saxophonist Leon "Chu" Berry's "Christopher Columbus (a Rhythm Cocktail)" in 1936. Pianist Fletcher Henderson's orchestra gave the number a torridly swinging ride and it became their theme as well as a hit for Andy Kirk and Benny Goodman.

RIGHT: Bandleader Les Hite primarily made his name in Los Angeles. He was one of four writers behind "It Must Have Been a Dream" and recorded the song for ARC in 1935, but it went unissued. Hite's band recut the theme in 1940 for Varsity and it was released, with "T-Bone Blues" (a young T-Bone Walker was its vocalist) on the other side.

THE JAZZ ME BLUES: SHEET MUSIC

LEFT: Pianist Claude Hopkins was a New York City bandleader who began recording for Columbia in 1932 (his residencies included the Savoy and Roseland Ballrooms). The natty photo of Hopkins adorning the western artwork on the 1936 "Saddle Your Blues to a Wild Mustang" was switched out for one of popular bandleader Phil Levant on an otherwise identical piece of western-themed sheet music.

32 THE ART OF THE BLUES

ABOVE LEFT: Andy Kirk and his Twelve Clouds of Joy were another of Kansas City's foremost bands. Kirk and his band began recording for Brunswick in 1929 and posted a string of hits on Decca during the 1930s and '40s. Carmen Lombardo, the co-writer of "A Sailboat in the Moonlight," was popular bandleader Guy Lombardo's younger brother.

ABOVE RIGHT: Diminutive drummer Chick Webb led the relentlessly swinging house band at the Savoy Ballroom from behind an unusually huge kit. He employed a teenaged Ella Fitzgerald as his band vocalist from 1935 on; the two wrote "Spinnin' the Web" and Webb recorded the theme for Decca in 1938. He died the following year from spinal tuberculosis.

THE JAZZ ME BLUES: SHEET MUSIC

LEFT: This hit-filled 1938 songbook drew from the repertoires of Louis Armstrong, Cab Calloway, Fats Waller, Duke Ellington, Ethel Waters, Bert Williams, and Bill "Bojangles" Robinson, placing accurate caricatures of them across its cover. Some of the book's songs harked back to the 1920s.

ABOVE LEFT: Although fluent on several instruments, Jimmie Lunceford's primary mode of expression was the baton. He commanded one of the tightest, hardest-swinging orchestras of the 1930s and '40s, recording for Decca and Vocalion. A sensational photo of Lunceford's orchestra from his film short graced the 1938 sheet music for "You Are Just That Kind."

ABOVE RIGHT: Caught by the photographer hard at work with the tools of his trade—pen, paper, and piano—before him, John Erby was doing business with Los Angeles music publisher Davis-Schwegler when he wrote "Hollywood Blues" in 1939. He had previously made a pair of solo 78s for Columbia as Jack Erby back in 1926.

THE JAZZ ME BLUES: SHEET MUSIC

35

ABOVE LEFT: Mills Music, Inc. assembled sheet music for seven of piano man Fats Waller's classics, including "Ain't Misbehavin'," for its 1943 publication *Boogie Woogie Conceptions of Popular Favorites*. The folio's cover caricature captured Waller's jolly aura and would make a fitting memorial to the rotund piano genius after he died that December.

ABOVE RIGHT: Long before he ascended to superstardom as a velvet-smooth pop crooner, Nat King Cole's jazz piano mastery put his King Cole Trio, featuring lightning-quick guitarist Oscar Moore, on the map. "Gee Baby, Ain't I Good to You," penned by bandleader Don Redman, was a Number 1 hit for the trio on the Capitol label in 1944.

RIGHT: Jazz violin virtuoso Stuff Smith was conversant enough with the piano to pose with one on the cover of his *Boogie Woogie* sheet music collection, marketed by M. M. Cole Publishing Co. of Chicago in 1944. Cited as the first jazz violinist to amplify his instrument, Smith debuted on Vocalion in 1936.

THE JAZZ ME BLUES: SHEET MUSIC

LEFT: A simpler two-color design template had become the norm for sheet music art by 1958, when R&B shouter LaVern Baker had a major hit with the soulful ballad "I Cried a Tear" on New York's Atlantic label. Baker was on an extended roll, having scored huge sellers with the perky "Tweedlee Dee" in 1955 and a rocking "Jim Dandy" the following year.

38

THE ART OF THE BLUES

CHUCK BERRY'S GREATEST HITS

MEMPHIS, TENNESSEE • MABELLENE • JOHNNY B. GOODE
YOU NEVER CAN TELL • SWEET LITTLE SIXTEEN • 30 DAYS
ROLL OVER BEETHOVEN • BYE, BYE, JOHNNY • SCHOOL DAY • and many others

RIGHT: It took a hefty book to hold all of rock 'n' roll architect Chuck Berry's hits for Chicago's Chess Records in sheet music form. This collection had "Maybellene," (interestingly, misspelled on the cover) the guitar great's first hit from 1955, as well as 1964's "You Never Can Tell" and many from in between. The duck-walking St. Louisian had certainly enjoyed a golden decade.

THE JAZZ ME BLUES: SHEET MUSIC

CHAPTER TWO

THAT STUFF YOU SELL

PREWAR RACE RECORDS ADS

*"All music is folk music.
I ain't never heard a horse sing a song."*
— LOUIS ARMSTRONG

The pioneering newspapers serving black urban communities during the 1920s and '30s were loaded with advertisements for the latest blues and jazz 78s. The *Chicago Defender* and *Baltimore Afro-American* were particularly bountiful in their array of ads showcasing the latest releases, and many of those same printed displays also turned up in other urban publications. Sometimes an adjoining notice gave details as to how to obtain the records by mail if no convenient nearby store stocked the platters. The labels encouraged direct ordering by parcel post, conveniently placing a checklist and mailing address at the bottom of their notices.

LARGER ADVERTISEMENTS WERE usually accompanied by an illustration tying in with the subject matter of the A-side of the 78 being promoted. Some were ornate, many were humorous, and quite a few of those artistic renderings were more than a little racist in their depictions of what record companies apparently believed daily African-American life was all about—whether in the big city or down on the farm. The wisdom of attempting to entice black audiences by sometimes portraying their demographic in a degrading manner seems highly questionable in hindsight.

Of all the blues labels that advertised in those newspapers over the course of the 1920s, none bettered the beauty and intricacy of Paramount Records' artwork. The firm's generously proportioned ads for Texas guitarist Blind Lemon Jefferson's popular releases were stunning in their graphic detail and vivid imagery.

Paramount called bucolic Grafton, Wisconsin home. A subsidiary of the Wisconsin Chair Company, Paramount jumped into the blues field in 1922–23 with releases by "Ma" Rainey, Lucille Hegamin (whose previous sides for Arto Records commenced in the fall of 1920, just after Mamie Smith's OKeh smash hit), and Alberta Hunter. From 1926 on, Paramount issued the work of the influential Jefferson and dazzling guitarist Blind Blake. Mississippi Delta pioneer Charley Patton joined the roster in 1929. Instead of sending someone to supervise Southern field recordings, Paramount often invited its blues artists up to Grafton, as was the case in May 1930 when Patton brought slide guitarist Son House and Willie Brown along for a mammoth session. Mississippi guitarist/pianist Skip James traveled to Grafton for his Paramount dates in 1931.

Paramount put together visually striking advertisements for Jefferson, Blake, and Patton as well as their label mates "Ma" Rainey, Ida Cox, and the rest of its extraordinary blues talent stable—making sure to plug the label's recent releases after extolling the virtues of the lead item. Photographs of Paramount's artists often accompanied their drawn depictions; in some cases they may have been their only studio portraits. Paramount's promotions remained consistent until the Great Depression put an end to the label's recording activities in 1932. Thanks to Paramount's recording history, Grafton has become a tourist destination—complete with an outdoor area called Paramount Plaza.

Labels marketing blues recordings in the genre's primordial days wasted little time in getting their advertisements into the black newspapers. Harry Pace's Harlem-based Black Swan Records (an African-American-owned logo) plugged two of its Ethel Waters

> **QUITE A FEW OF THOSE ARTISTIC RENDERINGS WERE MORE THAN A LITTLE RACIST IN THEIR DEPICTIONS OF WHAT RECORD COMPANIES APPARENTLY BELIEVED DAILY AFRICAN-AMERICAN LIFE WAS ALL ABOUT.**

releases in the October 29, 1921 national edition of the *Chicago Defender*. However, such promotions did not improve Pace's prospects in the long run—Black Swan was out of business by the end of 1923.

Fellow black entrepreneur J. Mayo Williams named his fledgling logo Black Patti and placed an extravagant ad to promote his catalog in May 1927. Black Patti was an even shorter-lived venture—Williams threw in the towel before the year was over. Nevertheless, during that tiny timespan, he did manage to crank out fifty-five releases under the Black Patti name. His lavish peacock logo was borrowed by another blues label, Nick Perls's Yazoo Records, during the late 1960s.

Another temporary entrant in the blues sweepstakes, H. S. Berliner's Ajax Records, maintained offices in Chicago's Loop, though its headquarters were located in faraway Quebec City, Canada. In January 1925, Ajax published a spread extolling the virtues of vocalist Susie Smith (real name Monette Moore). Confidently claiming the firm was producing "the Quality Race Record," Ajax spirited Mamie Smith away from OKeh, but again the operation folded before year's end.

Mamie's "Crazy Blues" officially ignited the "classic blues" movement in 1920. It was not Mamie's first OKeh release—"That Thing Called Love," cut six months earlier, beat it out the door. "Crazy Blues" sold 7,500 copies the first week it was released and went on to become a million-selling sensation.

RIGHT: Gertrude "Ma" Rainey spent time touring the South with the Rabbit Foot Minstrels prior to signing with Paramount in 1923. She was one of the most prolific of the classic blues singers, making nearly a hundred sides for the label through 1928. The majesty of this advertisement from October 4, 1924, for her "South Bound Blues" confirms her exalted status.

"South Bound Blues"

Sung by MA RAINEY

"GOOD-BYE State Street—good-bye all you gals and men and monkey-men. I'se goin' back home, sweeties, and I don't know when I'll get back north again!" Another great "Bound" Blues—even better than 'Bama Bound or Chicago Bound. "Ma" Rainey had this song written specially for her—and it's SOME Blues. It just makes you long and yearn and crave for old Alabam or Mississipp. Be sure to hear this feature Paramount Record No. 12227. On the reverse side is "Ma" Rainey's "Lawd, Send Me a Man".

"South Bound Blues" was written especially for Madame "Ma" Rainey — Paramount's Mother of the Blues — by the famous composer, Tom Delaney. He made a special trip to Chicago to get Madam Rainey to sing "South Bound Blues" as he believed "Ma" was the only Blues singer who could do justice to this great masterpiece. This is unquestionably Tom Delaney's biggest hit since his "Down Home Blues" — recorded and made famous more than two years ago by Ethel Waters who is now a Paramount star.

Be sure you hear "South Bound Blues"

If your dealer hasn't it, send us the coupon at the right.

Newest, Bluest BLUES—by Leading Race Artists

- 12227—South Bound Blues and Lawd, Send Me a Man. Sung by "Ma" Rainey.
- 12231—Hot Springs Water Blues and Who'll Drive My Blues Away, Sodarisa Miller, Piano acc. by James Blythe.
- 12220—Death Letter Blues and Kentucky Man Blues, Ida Cox. Acc. by Lovie Austin and Her Blues Serenaders.
- 12205—You Ain't Foolin' Me and True Blues, Priscilla Stewart, Piano acc. by James Blythe.
- 12226—I'm Leaving You and I'm Sorry For It Now, Duet, Eddie Green and Zora (Billie) Wilson. Piano acc. by Chas. Matson.
- 12211—Freight Train Blues and Don't Shake It No More, Trixie Smith and Her Down Home Syncopators.
- 20341—Mobile Blues (Clarinet Solo) and St. Louis Blues (Blues Fox Trot) Chicago DeLux Orchestra—featuring Boyd Senter.
- 12202—Chicago Monkey Man Blues and Worried Any How Blues, Ida Cox Acc. by Lovie Austin and Her Blues Serenaders.
- [12098—Dream Blues and Lost Wandering Blues, Madame "Ma" Rainey. Acc. by Pruett Twins on Two Guitars. Souvenir Record, with "Ma" Rainey's picture on the record.]

Inspiring Spirituals that Uplift You

- 12221—Jerusalem Morn and Do You Call That Religion, Sunset Four.
- 12035—Father, Prepare Me and My Lord's Gonna Move This Wicked Race, Norfolk Jubilee Quartette.
- 12073—When All The Saints Come Marching In and That Old Time Religion, Paramount Jubilee Singers.
- 12217—Ezekiel Saw De Wheel and Crying Holy Unto The Lord, Norfolk Jubilee Quartette.
- 12225—Swing Low Sweet Chariot and I'm a Pilgrim, Norfolk Jubilee Quartette.

Send No Money! If your dealer hasn't Paramount Records, order direct from us, using the coupon at the right. Note the numbers of the records listed above. These same numbers appear on the coupon. Just check the ones you want and mail the coupon to us. SEND NO MONEY! Records shipped promptly. We pay postage and insurance. You pay nothing until you get your records. Then, give the postman 75 cents per record, plus 10 cents C.O.D. fee. We will send you FREE, new Paramount-Black Swan "Book of the Blues."

The New York Recording Laboratories
12 Paramount Building Port Washington, Wis.

Paramount
[Including Black Swan] REG. U.S. PAT. OFF.
The Popular Race Record

The New York Recording Laboratories
12 Paramount Bldg.
Port Washington, Wis.

Send me the following records, 75 cents each. C O D. Postage and insurance paid.

12226 ()	12221 ()	
12227 ()	12211 ()	12035 ()
12231 ()	20341 ()	12073 ()
12220 ()	12202 ()	12217 ()
12205 ()	12098 ()	12225 ()

Name _____
Address _____
City _____

THAT STUFF YOU SELL: PREWAR RACE RECORDS ADS

Formed as a subsidiary of Otto K. E. Heineman's New York-based phonograph company, OKeh's early blues roster encompassed Sippie Wallace, Victoria Spivey, and Sara Martin as well as Sylvester Weaver, whose "Guitar Blues" has been hailed as the first country blues recording in 1923. OKeh became affiliated with Columbia in 1926, subsequently recording brilliant jazz-influenced guitarist Lonnie Johnson, singer Texas Alexander, and the Mississippi Sheiks. Seminal to the future of jazz, Louis Armstrong's Hot Five and Hot Seven recordings, featuring Satchmo's unparalleled improvisatory soloing on cornet, were also released on OKeh. The label's taste in newspaper advertisements ran from humorous drawings to splendid artist photo-dominated layouts.

OKeh faded during the latter half of the 1930s but was revived in 1940 by Columbia; much of its blues output being the province of Lester Melrose. After another moribund period, Columbia resuscitated OKeh in 1951 as a successful R&B imprint. OKeh scored many Chicago-cut 1960s soul hits—its purple label and script logo enduring to the end.

Formed as a subsidiary of a phonograph retailer, New York's Vocalion Records opened for business in 1916 and was acquired by Brunswick in 1925. Guitarist Jim Jackson waxed his immortal "Jim Jackson's Kansas City

THE LABEL'S TASTE IN NEWSPAPER ADVERTISEMENTS RAN FROM HUMOROUS DRAWINGS TO SPLENDID ARTIST PHOTO-DOMINATED LAYOUTS.

Blues" for the firm in 1927—the same year Furry Lewis and Henry Thomas debuted there. Pianist Leroy Carr recorded his signature "How Long—How Long Blues" at a 1928 Vocalion date, his first of many for the label. Piano boogie pioneer Pine Top Smith laid down his highly influential "Pine Top's Boogie Woogie" there at the end of that year. Vocalion released blues guitar legend Robert Johnson's 1936–37 output, as did ARC (American Record Corporation) and other dime store labels. Bukka White waxed his classic "Shake 'em on Down" for the label in 1937. Its jazz artists included New Orleans clarinetist Jimmie Noone and drummer/xylophonist Jimmy Bertrand—a musical mentor to Lionel Hampton. Vocalion's graphic artists took a more positive stance in their ad layouts: smiling singers, a chic flapper here and there, wild shindigs. The logo became a Columbia subsidiary in 1938 and folded in 1940, some of its current releases shuttled to OKeh. Decca eventually acquired the Vocalion name, using it for its budget LP line.

ABOVE: On the front porch of their Mississippi farmhouse, sharecropper Lonnie Fair and his daughter posed for photographer Alfred Eisenstaedt as they listened to their wind-up Victrola. The German-born Eisenstaedt is best-known for his iconic 1945 photo of a sailor kissing a young woman as they celebrated V-J Day in Times Square.

Established by the Brunswick-Balke-Collender Company of Dubuque, Iowa—successful manufacturers of sporting goods, pianos, and phonographs—Brunswick Records based itself primarily in Chicago and became a success during the 1920s. Bluesmen Lovin' Sam Theard, Speckled Red, Robert Wilkins, Charlie McCoy, Henry Spaulding, and Joe Calicott made appearances on Brunswick during the late 1920s and early 1930s, as did trumpet ace Jabbo Smith and Kansas City territory bandleaders George E. Lee and Andy Kirk. Brunswick envisioned more sedate scenes when brainstorming its 1929 advertisements—a couple dancing to the strains of a mellow orchestra, an inviting nightlife strip aglow with lights, a young boy dozing against a tree in the meadow. Warner Brothers bought Brunswick in 1930, but the logo spent much of that decade as ARC's full-price imprint. After briefly reverting to Warner's control, Brunswick was sold to Decca and mainly trafficked in pop as a subsidiary of Coral Records into the mid-1960s, when it came under the aegis of Nat Tarnopol and specialized in soul music. Tarnopol ended up owning Brunswick in 1969, scoring major hits with Jackie Wilson and the Chi-Lites.

ABOVE LEFT: Lucky folks who sent away to Chicago's Kapp Music Company for Bessie Smith's 1926 Columbia recording of "Money Blues" received an autographed photo of the Empress as a bonus. Kapp's ad listed plenty of other possibilities for purchase, including a generous array of spirituals. All they had to do was fill out Kapp's "Coupon to Happiness!"

ABOVE RIGHT: A determined woman has all of her worldly possessions piled into a small rowboat as she takes a last look at her sinking shack in the illustration accompanying Columbia's April 2, 1927 advertisement for Bessie Smith's "Back-Water Blues." The song memorialized the Great Mississippi Flood of 1927, the most destructive river flood in US history.

LEFT: Black Patti Records existed for less than a year, but J. Mayo Williams spared no expense promoting his Chicago label. This May 27, 1927 *Defender* advertisement paid tribute to "the original 'Black Patti'," opera star Madame Sissieretta Jones. Beneath her were Moaning Mozelle and Blind James Beck and the Down Home Boys (Papa Harvey Hull and Long "Cleve" Reed).

46 — THE ART OF THE BLUES

ABOVE LEFT: Guitarist Blind Joe Taggart made his first spiritual recordings for Vocalion in November 1926, including "I Wish My Mother Was on That Train," a haunting a cappella duet with his wife Emma. Josh White made his recording debut as the South Carolina-born Taggart's second guitarist in 1928 for Paramount Records.

ABOVE RIGHT: One of the few things we know for sure about Arthur "Blind" Blake is that he was one of the most dazzling guitarists of his time. Blake hailed from the Southeast and recorded more than eighty titles for Paramount from 1926 to 1932. "Dry Bone Shuffle," from April 1927, is a romping example of Blake's finger-picking mastery. He died young in 1934.

THAT STUFF YOU SELL: PREWAR RACE RECORDS ADS 47

RIGHT: Blue Belle's debut recording "High Water Blues," with Lonnie Johnson on guitar, got the full buildup from OKeh Records in an August 1927 advertisement. She needed the pseudonym; her real name was apparently Bessie Mae Smith! Other aliases employed by Smith on record reportedly include St. Louis Bessie and Streamline Mae.

"UNDER THE CHICKEN TREE"

by Earl McDonald's Original Louisville Jug Band

Nobody will want to miss this record. No sir, not by a jugful! This, new and exclusive, Columbia outfit, sure does get lots of pep out of its jug. If you want something different in a record way, this is it.

Under the Chicken Tree
(Incidental singing by Earl McDonald and Quartet)
Melody March Call
Earl McDonald's Original Louisville Jug Band

Record No. 14206-D, 10-inch, 75c

Columbia Phonograph Company
1819 Broadway, New York City

Columbia
NEW PROCESS RECORDS
Made the New Way – Electrically
Viva-tonal Recording – The Records without Scratch

"If I Had My Way I'd Tear the Building Down"

A Singing Sermon by Rev. T. E. Weems

Here is a powerful straight-from-the-shoulder sermon by the Rev. T. E. Weems. "If I Have a Ticket Lord Can I Ride?" is also a masterpiece of earnest eloquence.

Record No. 14254-D, 10-inch, 75c

If I Had My Way I'd Tear the Building Down
If I Have a Ticket Lord Can I Ride?

Singing Sermons—Rev. T. E. Weems

Ask Your Dealer for Latest Race Record Catalog
Columbia Phonograph Company, 1819 Broadway, New York City

Columbia
NEW PROCESS RECORDS
Made the New Way – Electrically
Viva-tonal Recording – The Records without Scratch

ABOVE LEFT: Described as a "jug virtuoso," Earl McDonald fronted the Original Louisville Jug Band, whose raucous "Under the Chicken Tree" was issued by Columbia in 1927. McDonald blew his jug at the Kentucky Derby as a young man and later shared recording studios with Sara Martin and jazz clarinetist Johnny Dodds.

ABOVE RIGHT: The impassioned preacher that Columbia conjured up in its November 1927 ad for Rev. T. E. Weems's "singing sermon" "If I Had My Way I'd Tear the Building Down" looks like he is in danger of destroying his pulpit. The good reverend did three sessions that year and had three releases on the label before ending his brief recording career.

COLUMBIA RECORDS

Despite a series of ownership changes during the 1920s and '30s that almost ended the label, the stately Columbia Records brand has endured from 1887 right up to the present day. It rebounded from its various front office upheavals to take its exalted place as one of America's leading major labels. Primarily associated with popular, country, and classical music, Columbia nevertheless issued its share of seminal blues, jazz, and spirituals over the course of its early existence.

TODAY A MAMMOTH CORPORATE entity controlled by Sony Music, Columbia's early existence was quite a different story.

Originally an offshoot of the Columbia Phonograph Company, the fledgling label began its existence selling wax cylinder records and the machinery to play them on, in direct competition with Edison and Victor during the early years of the twentieth century (the label did not switch to exclusively issuing discs until 1912). Columbia's distinctive logo—two sixteenth notes that were christened "Magic Notes" by the firm's braintrust—was introduced during this era.

Columbia produced some of the earliest jazz recordings, most notably a ten-song session by W. C. Handy's Orchestra of Memphis in September 1917 and a series of 1918–20 dates by clarinetist Wilbur Sweatman. The label got in on the ground floor of the classic blues movement with Louisville, Kentucky native Edith Wilson in 1921, then signed the Empress of the Blues—Bessie Smith—in 1923. Born April 15, 1894, in Chattanooga, Tennessee, Bessie would endure as one of Columbia's brightest stars until the Great Depression hit, but even her first acclaimed releases could not stop the label from going into receivership in late 1923. It was acquired by its British subsidiary, the Columbia Gramophone Company, and weathered the storm gracefully.

In 1926, a handful of country blues guitarists joined the Columbia ranks. None was more impressive than Blind Willie Johnson, and he did not sing blues at all. While living in Marlin, Texas, the seven-year-old Johnson lost his sight when his stepmother threw lye in his face after suffering a beating at the hands of his father. Blind Willie's exquisite, bone-chilling slide technique screamed lowdown blues, yet his sanctified vocal message operated on an exclusively heavenly level. Johnson first recorded for Columbia in Dallas in December 1927. The bounty included his supremely eerie "Dark Was the Night—Cold Was the Ground," easily his best-known composition. Johnson receded from view after a 1930 Columbia session in Atlanta. He died on September 18, 1945, a

BUT EVEN THE CLEVEREST ADVERTISING CAMPAIGNS COULD NOT STAVE OFF THE DEVASTATING IMPACT OF THE GREAT DEPRESSION, WHEN INDUSTRY-WIDE SALES FIGURES PLUMMETED PRECIPITOUSLY.

victim of malarial fever brought on by having to sleep in the wet, burned-out ruins of his Beaumont home because he and his wife had nowhere else to go.

As one of the more active purveyors of African-American recordings during the prewar era, Columbia's policy in newspaper advertisements was not a particularly consistent one. It encompassed beautifully detailed drawings, a handful of artist photographs (including the only known one of the elusive Johnson), and funny illustrations. But even the cleverest advertising campaigns could not stave off the devastating impact of the Great Depression, when industry-wide sales figures plummeted precipitously.

In 1934, Columbia was purchased by ARC and fell on hard times until William S. Paley rescued the label in 1938. He bought ARC for the Columbia Broadcasting System and revitalized the Columbia label as well as its subsidiary—OKeh Records. A wide range of musical styles would dominate Columbia's catalog, but OKeh was reactivated in 1940 and inherited the company's blues roster.

50 THE ART OF THE BLUES

Columbia offers These New Race Records

BESSIE SMITH
Back-Water Blues
Preachin' the Blues —Vocals
No. 14195-D 10-inch, 75c

REV. J. C. BURNETT
Assisted by Sisters Grainger and Jackson
Daniel in the Lions' Den
Hebrew Children in the Fiery Furnace
Sermons with Singing
No. 14211-D 10-inch, 75c

CLARA SMITH
Ease It
Percolatin' Blues —Vocals
No. 14202-D 10-inch, 75c

"PEG LEG" HOWELL AND HIS GANG
New Jelly Roll Blues
Beaver Slide Rag —Vocals
No. 14210-D 10-inch, 75c

MARTHA COPELAND
Sorrow Valley Blues
Soul and Body (He Belongs to Me)
—Vocals
No. 14208-D 10-inch, 75c

EARL McDONALD'S ORIGINAL LOUISVILLE JUG BAND
Under the Chicken Tree (Singing by Earl McDonald and Quartet)
Melody March Call
No. 14206-D 10-inch, 75c

And many others
Ask your dealer for list

"Them's Graveyard Words"

Yes sir, they sure are graveyard words. Anything that's coupled with "Send Me to the 'Lectric Chair" ought to be just that sort.

And how Bessie Smith does sing words like these. Anything that's blue is made to order for Bessie, famous "Empress of Blues," and exclusive Columbia recording artist.

If you have other Bessie Smith records, you'll certainly want this one. If you haven't, here's the record to start with.

[Them's Graveyard Words
Send Me to the 'Lectric Chair]
Vocals, Bessie Smith and Her Blue Boys
No. 14205-D 10-inch, 75c

Columbia Phonograph Company
1819 Broadway New York City

Columbia
NEW PROCESS RECORDS
Made the New Way — Electrically
Viva-tonal Recording - The Records without Scratch

"Barbecue Blues"
by Barbecue Bob

These blues are sure cooked to a turn. Anybody who likes the real thing in blues is in for a feast this time. Accompanied by the guitar, Bob adds plenty of vocal seasoning to this record.

["Barbecue Blues"
"Cloudy Sky Blues"
Vocals—Barbecue Bob]

Record No. 14205-D, 10-inch, 75c.

Columbia Phonograph Company
1819 Broadway, New York City

Columbia
NEW PROCESS RECORDS
Made the New Way — Electrically
Viva-tonal Recording - The Records without Scratch

ABOVE LEFT: A lonely gravedigger trudging away from his completed task amid the tombstones provided a macabre image for Columbia's June 1927 ad plugging Bessie Smith's "Them's Graveyard Words." The label paired the funereal number with another violence-laden theme, "Send Me to the 'lectric Chair."

ABOVE RIGHT: Barbecue Bob came by his nickname honestly—he worked at Tidwell's BBQ Place in Atlanta. Robert Hicks was his real name; he played twelve-string guitar with a slide on his 1927 Columbia debut "Barbecue Blues" and the rest of the sides he made for the label through 1930. Tragically, he died from pneumonia the following year.

THAT STUFF YOU SELL: PREWAR RACE RECORDS ADS

ABOVE LEFT: It is unlikely that any label ran a more outrageous illustration than that of Paramount for Blind Lemon Jefferson's July 1928 release "Cannon Ball Moan." Poor Lemon rides a flying cannonball through the air, guitar in hand, as it sails into the stratosphere. The Texan was incredibly prolific from 1926 until his death in Chicago in December 1929.

ABOVE RIGHT: An exquisite illustration of an auto highlighted the storyline of guitarist Willard "Ramblin'" Thomas's 1928 Paramount release "Hard to Rule Woman Blues." The Louisiana native, an expert slide guitarist, cut fifteen songs for Paramount in 1928 and four more for Victor in 1932. His younger brother Jesse made his debut recordings in 1929.

52 THE ART OF THE BLUES

ABOVE LEFT: Walter Barnes and His Royal Creolians were a Chicago fixture, recording a series of 1928–29 sides there for Brunswick that included "Buffalo Rhythm." Barnes and the Creolians performed regularly for a time at Al Capone's nightclub in Cicero, Illinois. They toured the South frequently during the 1930s.

RIGHT: Double-entendre themes were Lil Johnson's specialty. She first turned up on Vocalion in 1929; "House Rent Scuffle" was half of her encore release on the label. Lil hit her suggestive stride during the mid-1930s, her Chicago-cut Vocalion output was typified by "Sam—the Hot Dog Man" and "Let's Get Drunk and Truck."

ABOVE LEFT: Surrounded in an October 1928 issue of the *Afro-American* by ads for various Baltimore music shops, Leroy Carr's debut Vocalion blockbuster "How Long—How Long Blues" received royal treatment. Nearly always accompanied by guitarist Scrapper Blackwell, the Indianapolis-based pianist recorded extensively until his death in 1935, aged thirty.

LEFT: Vocalion was on a roll in late 1928. The bawdy hokum piece "It's Tight Like That" by guitar wizard Tampa Red and pianist Georgia Tom gave the label another mammoth hit, one that transcended idiomatic boundaries. Tampa soon went solo and was hailed for decades as a leading Chicago bluesman, while Tom revolutionized gospel music as Thomas A. Dorsey.

ABOVE RIGHT: A sunny caricature of classic blues singer Luella Miller industriously pushing a full wheelbarrow cleverly tied in with her 1928 Vocalion recording of "Brick House Blues." Miller had been on the label for a couple of years, doing most of her recording in Chicago. She would have one more release on Vocalion.

ABOVE LEFT: Wynn's Creole Jazz Band was led by trombonist Albert Wynn, but he shared the spotlight with Punch Miller, whose cornet work was deeply influenced by Louis Armstrong. Punch doubled on vocals for "Down by the Levee," recorded in Chicago in October 1928 and advertised by Vocalion early the following year.

ABOVE RIGHT: Following the dissolution of his pioneering Creole Jazz Band (the springboard for Louis Armstrong's emergence), New Orleans-bred cornetist Joe "King" Oliver came right back with a new outfit, the Dixie Syncopators, and kept on blowing up a storm on Chicago's South Side. Oliver's band cut the strutting "Lazy Mama" for Vocalion in July 1928.

THE CHICAGO DEFENDER

As one of the top African-American newspapers in the country, the *Chicago Defender* disseminated an uplifting message to Southern residents that a better and safer life could be experienced in the North. That sentiment convinced countless blacks to abandon the racial inequities of their rural homeland for an urban existence that was like the difference between night and day compared to what they were accustomed to.

DEBUTING IN MAY 1905, the weekly paper, published by Robert Sengstacke Abbott (initially using his landlady's kitchen as his headquarters), tirelessly promoted the noble cause of racial equality and devoted extensive print coverage to the unspeakable horror of Southern lynchings. Migration represented an enticing way to free those downtrodden souls from their misery, and the *Chicago Defender* promoted the concept endlessly, declaring May 15, 1917, the date of the "Great Northern Drive."

Black porters working on passenger trains that originated in Chicago and wound through the segregated South helped to distribute the *Defender* to a constituency weary of backbreaking toil, crushing poverty, and terrifying violence inflicted upon them by racist whites. So inflammatory did Southern powers-that-be deem the *Defender*'s message that the paper had to be smuggled into hostile destinations below the Mason-Dixon Line. The enlightening publication would surreptitiously pass from one eager reader to the next or would be read out loud at small gatherings, translating to an estimated circulation of over half a million when the paper was at its zenith. More than two-thirds of its readership lived outside of Chicago.

Abbott steadfastly refused to use the terms "Negro" and "black" in his publication, referring to his people as "the Race" and individuals as "Race men" and "Race women." He was also a strong supporter of black youth, launching the Bud Billiken Parade and Picnic in 1929 as a gala event that African-American children could enjoy on the South Side. The parade is still held every August to herald the imminent end of summer vacation and the reopening of Chicago's schools.

The *Defender* was reportedly the first African-American newspaper to publish a detailed entertainment section, harking back to well before the classic blues era. The record companies recognized the value of reaching its readership, placing advertisements aplenty in its pages for blues and jazz 78s during the 1920s and early '30s before the Great Depression curtailed their budgets. Covering the performers who distinguished Chicago's constantly changing network of theaters, swanky nightclubs, and corner taverns was another *Defender*

IT STANDS AS A HISTORICALLY SEMINAL VOICE THAT RAILED COURAGEOUSLY AGAINST THE WORST ASPECTS OF SOUTHERN LIFE FOR AFRICAN-AMERICANS AND GAVE HOPE, KNOWLEDGE, AND COMFORT TO GENERATIONS OF MIGRANTS IN SEARCH OF A MORE FULFILLING LIFE.

strength. Those establishments were also paying customers, their ads promoting their swinging joints and the stars who headlined there.

Abbott passed the publishing reins to his nephew, John Sengstacke, in 1940, and the paper kept on printing news that white mainstream publications ignored altogether. A host of legendary writers contributed their prose to the *Defender* over the decades, including author Langston Hughes and poet Gwendolyn Brooks. Sengstacke transformed the *Defender* into a daily on February 6, 1956.

Sengstacke's publishing empire eventually grew to encompass the *Pittsburgh Courier*, Detroit's *Michigan Chronicle*, and Memphis's *Tri-State Defender*.

Although it reverted to a weekly in 2003, the *Chicago Defender* remains in business today; its offices are back on the South Side where they moved to after a brief stay downtown. It stands as a historically seminal voice that railed courageously against the worst aspects of Southern life for African-Americans and gave hope, knowledge, and comfort to generations of migrants in search of a more fulfilling life.

RIGHT: Having honed her stage presentation with the Rabbit Foot Minstrels and Silas Green from New Orleans, Georgia-born Ida Cox was signed by Paramount a few months before "Ma" Rainey, giving the label two of the best classic blues singers in the field. With Lovie Austin on piano, Cox belted "Chicago Bound Blues" during the summer of 1923.

Wonderful IDA COX sings "CHICAGO BOUND BLUES"

[The Famous Migration Blues]

THOSE achin' "Migration Blues"! How Ida Cox does moan 'em! "I'd follow my daddy, but my feet refuse to walk", so this left-behind Birmingham girl low-downs Chicago Bound Blues—the latest itching, twitching success by the Race's greatest Blues artist. Ask for No. 12056.

On Paramount, the popular Race Record. The other side? "I Love My Man Better Than I Do Myself" by Ida Cox. Both accompanied by Lovie Austin, and she sure do romp on those ivories!

Get These Ida Cox Hits and Other Popular Paramount Race Records

12056—Chicago Bound (Famous Migration Blues) and I Love My Man Better Than Myself—Sung by Ida Cox.—Piano acc. by Lovie Austin.

12053—Any Woman's Blues and Blue Monday Blues—Piano acc. by Lovie Austin—Ida Cox.

12044—Graveyard Dream Blues and Weary Way Blues—Ida Cox.

12045—'Bama Bound Blues and Lovin' Is The Thing I'm Wild About—Sung by Ida Cox, piano acc. by Lovie Austin.

12054—Stop Dat Band and Sad Blues—Vocal Quartette—Norfolk Jazz Quartette.

12058—I'm Broke Fooling With You and I Ain't No Man's Slave—Vocal Blues with Piano acc.—Rosa Henderson.

12059—Play That Thing—Slow Drag—Ollie Power's Harmony Syncopators and Jazzbo Jenkins—Tenor with Orch.—Ollie Powers

12061—What a Time Talking With The Angels and Hard Trials — Horace George's Jubilee Harmonizers.

12043—Mistreated Blues and I'm Going Away—Alberta Hunter—Piano acc. by Fletcher Henderson.

12035—Father Prepare Me and My Lord's Gonna Move This Wicked Race — Norfolk Jubilee Quartette.

12050—Big Foot Ham and Muddy Water Blues—Jelly Roll Morton and His Orchestra.

SEND NO MONEY!

Clip this ad — take it to your dealer — If he can't supply genuine Paramount Records, order direct from factory. Records are mailed C.O.D. 75¢ each, postage prepaid. Write for free catalog of all Paramount Records.

IDA COX's NEW

Graveyard Dream Blues. Piano accompaniment by Lovie Austin with one new verse and a piano chorus. Ask for No. 12022—New Graveyard Dream Blues and Come Right In—by Ida Cox.

THE NEW YORK RECORDING LABORATORIES
12 PARAMOUNT BLDG. PORT WASHINGTON, WIS.

Paramount Records

ABOVE LEFT: Victor made sure to get plenty of bang for their promotional buck, plugging no fewer than five releases in one jam-packed May 1930 ad. Framed in the center was "Washboards Get Together" by the Washboard Serenaders. The rowdy group included guitarist Teddy Bunn from 1929 to 1931. The Serenaders later appeared in a handful of film musicals.

ABOVE MIDDLE: Cladys "Jabbo" Smith recorded twenty rousing jazz themes in 1929 for Chicago producer J. Mayo Williams at Brunswick, including the joyous "Decatur Street Tutti." The Georgia native could double on trombone when the situation called for it, but cornet and trumpet were his primary instruments.

ABOVE RIGHT: Huge-voiced Alger "Texas" Alexander used nothing but the finest accompanists on his 1929 OKeh singles. On "The Risin' Sun," he had the incomparable guitar duo of Lonnie Johnson and white jazzman Eddie Lang behind him, while "Tell Me Woman Blues" boasted the regal presence of King Oliver's cornet and Clarence Williams on piano.

58 THE ART OF THE BLUES

Advertisement 1 (Left)

The country's greatest trumpet player,....

Louis Armstrong,

plays his sensation in Blues..

~ Fox Trots ~

"Tight Like This"
— AND —

"HEAH ME TALKIN' TO YA?"

Fox Trots By LOUIS ARMSTRONG And His Savoy Ballroom Five

No. 8649 — 10 in. 75c.

and that razzle, dazzling totsy Blues...

No. 8651 — 10 in. 75c.

(HONEY)
"IT'S TIGHT LIKE THAT"
Sung By PAPA TOO SWEET *and* HARRY JONES

"BIG FAT MAMA"
Sung By PAPA TOO SWEET

RACE OKeh ELECTRIC RECORDS

OKEH PHONOGRAPH CORP., 25 WEST 45th ST., NEW YORK, N. Y.

Advertisement 2 (Right)

I'M GOIN' UP COUNTRY
(Chicago Bound)

Sung by **"PAPA EGGSHELL"** (Lawrence Casey) in 2 parts

Brunswick RACE RECORD No. 7082

ST. LOUIS don't mean no good to Papa Eggshell so he's takin' himself up the country, Chicago Bound. He says that town is O. K. if you've got a lot of money and want to go broke, as well as a lot of other things, but that ain't his idea of a good place to stay in. Be sure to hear this new Brunswick Star. He'll hold your mind all through both sides of this great record.

Hear it Today!

ELECTRICALLY RECORDED

I'm Goin' Up the Country — Pt. I **7082**
(Chicago Bound) 75c

Im' Goin' Up the Country — Pt. II
(Chicago Bound) Voice with Guitar
(Lawrence Casey) "Papa Egg Shell"

Ask your dealer to play this record for you today. If he can't supply you, write to us direct.

Brunswick
RACE RECORDS
"Get 'em - cause they're HOT!"

Manufactured by THE BRUNSWICK-BALKE-COLLENDER CO., Chicago

ABOVE LEFT: Louis Armstrong's "Tight Like This" was granted an unusually formal advertisement by OKeh in early 1929, complete with a photo of a tuxedoed Satchmo. The Savoy Ballroom Five comprised the same crew as his Hot Seven of the previous year. OKeh squeezed a mention of "It's Tight Like That" by Papa Too Sweet and Harry Jones into the same ad.

ABOVE RIGHT: Brunswick issued two 78s by solo guitarist Lawrence Casey, who went by the odd professional sobriquet of Papa Egg Shell. The first one, a driving two-part "I'm Goin' Up the Country," elicited a July 1929 ad featuring a young man reclining against a tree in a bucolic meadow.

STARDOM...

DECEMBER
BRU

tor Records

CHAPTER THREE

THE HOTTEST BANDS! THE BIGGEST HITS!
RECORD CATALOGS

"Life is like a trumpet—if you don't put anything into it, you don't get anything out of it."
—W. C. HANDY

Record catalogs were a veritable shop window for artists' latest and greatest recordings and shed light on the ever-changing trends of the record industry.

WHEN IT CAME to promoting their most recent releases in the catalogs that they sent out to dealers across the country, record labels of the 1920s and '30s treated their "race artists" like royalty. Segregated royalty, of course, but royalty nonetheless. As you might expect, commerce trumped the mores of the period.

There was plenty of competition between prewar companies specializing in blues music, so getting the word out about new releases in a timely fashion was imperative. Prewar labels tended to release supplementary catalogs monthly in addition to their quarterly or annual editions. Black artists were usually unceremoniously lumped in with the other "specialty" genres—hillbilly, Cajun, Hawaiian, etc. Every label published catalogs, even the small dime store outfits, such as Cameo and Perfect. The major operations listed their 78s for 75 cents each, but the dime store brands usually sold theirs for 35 cents apiece or three for a buck.

Every catalog was filled to bursting with titles, artists, and release numbers—invaluable information for the little stores out in the hinterlands that faithfully stocked their wares and wanted to keep the latest 78s on hand. What is more, artists' faces began to be placed beside their names, adding to a sense of familiarity for those dealers who ordered their records. During the late 1930s and into the '40s, serious record collectors in the US and abroad tracked down as many of those precious catalogs as they possibly could so they could knowledgeably fill in the gaps within their 1920s jazz and blues archives. Those informative booklets became primary sources for the first wave of blues and jazz discographers as they attempted to document the history of the music.

Most prewar labels marketing blues 78s were conveniently located either on the East Coast or in Chicago, but Gennett Records was headquartered in Richmond, Indiana, situated in the middle of the state and on its eastern edge. It was owned by the Starr Piano Company, which opened for business there in 1872 and immediately transformed tiny Richmond into a bustling factory town. Starr inaugurated its Gennett label in 1917, christening it after the surname of the three Italian brothers—Harry, Fred, and Clarence Gennett—who had been placed in charge of the operation.

In 1916, the company installed its own recording studio behind the piano factory. It was reportedly situated close to a nearby railroad track, necessitating an occasional pause in the musical action while trains rumbled by outside. Gennett brought an incredible array of talent into town for recording sessions, most notably several New Orleans immortals. Piano great Jelly Roll Morton traveled to Richmond in 1923 and 1924 for bountiful sessions. Cornetist King Oliver made a series of legendary New Orleans-style recordings for Gennett in 1923 with his Creole Jazz Band, featuring his protégé Louis Armstrong improvising in tandem on the other cornet.

Slide guitar specialist Sam Collins visited Richmond three times in 1927 to lay down a wealth of blues masters (he was prominently featured in Gennett's 1928 catalog). Pianist Georgia Tom Dorsey came into town to lead Gennett sessions in 1929 and 1930. Sides by Alberta Jones, Bertha Ross, Frankie "Half Pint" Jaxon, and

EVERY CATALOG WAS FILLED TO BURSTING WITH TITLES, ARTISTS, AND RELEASE NUMBERS—INVALUABLE INFORMATION FOR THE LITTLE STORES OUT IN THE HINTERLANDS THAT FAITHFULLY STOCKED THEIR WARES AND WANTED TO KEEP THE LATEST 78S ON HAND.

harpist Jaybird Coleman were recorded elsewhere and then issued on Gennett. Some of those same recordings also came out on the label's Champion budget subsidiary. There was a strong connection between Gennett and J. Mayo Williams's Black Patti imprint during the latter's brief 1927 existence, resulting in quite a few releases appearing on both labels (Fred Gennett was said to have been Williams's partner at Black Patti; the label's discs were pressed at Gennett and shipped from there).

Gennett was another casualty of the Great Depression, though Starr continued to make pianos and Harry Gennett offered record pressing services at the Richmond plant. Decca acquired the Gennett and Champion logos as well as some of its masters in 1935. Gennett's last studio ventures involved sound effect recordings. By the late 1940s, Starr's once-thriving record division was fading into oblivion. Before long, Starr itself followed it. But much like Paramount in Grafton, Richmond has capitalized on the town's recording legacy as a tourist draw in recent times. In 2007, the Starr-Gennett Foundation established a Gennett Walk of Fame near the company's original site on South 1st Street, and the town hosts an annual festival.

RCA Victor introduced its inexpensive Bluebird subsidiary to counter the many budget labels that were biting into its Depression-era sales ledgers. Bluebird fully took wing in 1933, the label amassing an incredible blues talent lineup. Its chirpy mascot "Buff" flew majestically

ABOVE LEFT: Prewar labels followed a policy of segregation when compiling their printed catalogs. Columbia Records spotlighted their vaudeville star Bert Williams on the cover of their 1922 "race music" catalog. Williams formed a very successful duo with George Walker before going solo in 1909. He died the same year that this catalog was printed.

ABOVE RIGHT: This 1929 catalog found Victor boasting the strongest African-American talent lineup in the recording field, from blues and jazz to uplifting spirituals and sermons.

THE HOTTEST BANDS! THE BIGGEST HITS!: RECORD CATALOGS

on a pair of lovely label layouts and was content to perch happily on the front of many Bluebird catalogs. Unlike most of its competitors, the label did not segregate its releases in separate numeric series—from the outset, country and pop artists rubbed elbows with blues and jazz players.

The ambitious imprint brought together Walter Davis, Roosevelt Sykes, the Mississippi Sheiks, Big Bill Broonzy, Tampa Red, Bo Carter, Joe Pullum, Amos "Bumble Bee Slim" Easton, Big Joe Williams, Robert Lee McCoy, Jazz Gillum, Washboard Sam, Merline Johnson ("the Yas Yas Girl"), Tommy McClennan, Big Maceo, Doctor Clayton, and John Lee "Sonny Boy" Williamson—who revolutionized the role of blues harmonica from the moment he waxed "Good Morning, School Girl" for Bluebird in 1937.

Arthur "Big Boy" Crudup, a primary influence on Elvis Presley, joined the Bluebird family in 1941 (the Mississippi-born guitarist would later move over to RCA Victor proper). Pianist Memphis Slim was just getting started with his prolific career when he waxed three dates for Bluebird in 1940–41. Lester Melrose supervised nearly all of Bluebird's myriad Chicago blues sessions. His bouncy, band-backed approach, often incorporating horns, was so identifiable that it retroactively became known as "the Bluebird Beat." Bluebird's wings as a label were permanently clipped in 1945, its remaining luminaries reverting to the parent firm.

Initially formed in Britain in 1929 by Edward Lewis, Decca Records entered the American music business in 1934. Under the American leadership of Jack Kapp, Decca

> **BLUEBIRD FULLY TOOK WING IN 1933, THE LABEL AMASSING AN INCREDIBLE BLUES TALENT LINEUP. ITS CHIRPY MASCOT "BUFF" FLEW MAJESTICALLY ON A PAIR OF LOVELY LABEL LAYOUTS AND WAS CONTENT TO PERCH HAPPILY ON THE FRONT OF MANY BLUEBIRD CATALOGS.**

immediately jumped into the race records fray, recruiting its own exceptional talent lineup. Its blues stars during its fledgling years included Memphis Minnie and Kansas Joe, Charley Jordan, Bumble Bee Slim, Kokomo Arnold, Peetie Wheatstraw, Georgia White, Sleepy John Estes, Johnnie Temple, and, beginning in 1938, alto sax-blowing Louis Jordan, who would provide a vivid outline for the ascendancy of rhythm and blues in years to come with his inexorably swinging little combo, the Tympany Five. Decca endured for many decades as a pop and country-driven major label, vying with Columbia and RCA Victor for full-service supremacy.

Catalogs for the countless independent R&B labels entering the market during the tumultuous postwar era ranged from first-class publications distinguished with plenty of artist photos to the simplest of layouts with no illustrations at all (the only photos anywhere in a 1951 King Records catalog were shots of the company's line of record players). The emphasis steadily changed in the record business during the 1950s from selling 78s to LPs and 45s. The heyday of lavish record company catalogs and their artistic charm was over.

ABOVE LEFT: Joshua Barnes Howell lost his right leg as the result of a gunshot wound, earning him the enduring nickname of Peg Leg. The Georgia native was the first country blues guitarist on Columbia in 1926. Exclusively recording in his hometown of Atlanta, the fez-wearing Howell stayed with the label into 1929.

ABOVE RIGHT: One of the most popular of the classic blues singers, Ethel Waters was also one of the first, making her first recording for the Cardinal label in 1921. She landed at Columbia in 1925 and cut "Heebie Jeebies" for the company the next year. Waters was part of the Harlem Renaissance and later excelled as a film actress.

64 THE ART OF THE BLUES

RIGHT: Columbia Records was proud enough of its classic blues contingent to splash three of them across the cover of its 1928 race catalog. Bessie Smith, Clara Smith, and Ethel Waters were joined by Peg Leg Howell and Rev. J. C. Burnett, who came aboard the label in 1926 and briefly had Porter Grainger and later Fats Waller as his studio keyboardists.

GENNETT RECORDS

1924 CATALOG

"The Difference is in the Tone"

GENNETT COLORED ARTIST RECORDS

Here are the latest popular songs and snappy dance hits on Gennett Records by exclusive Gennett Colored Artists. You'll find here the "blues" the "joys" the "stomps" in fact every kind of music by those most famous in musical comedy and vaudeville and who know just how to interpret this popular style of melody and syncopation. You'll like the music, you'll like the artists and you'll agree the recordings are the highest type. Gennett Colored Artists records are supreme in musical value.

If You Want To Keep Your Daddy Home (Grainger-Ricketts-Paisley) and *Laughin' Cryin' Blues*—Viola McCoy	10	5108	.75
Laughin' Cryin' Blues (Grainger-Ricketts) and *If You Want To Keep Your Daddy Home*—Viola McCoy	10	5108	.75
Midnight Blues (A Wee Hour Chant) (Thompson-Williams) and *Triflin' Blues*—Viola McCoy	10	5128	.75
Triflin' Blues (Daddy Don't You Trifle On Me) (Grainger-Rick-etts) and *Midnight Blues*—Viola McCoy	10	5128	.75
Gulf Coast Blues (Williams) and *Tired O' Waitin' Blues*—Viola McCoy and Bob Ricketts' Band	10	5151	.75
Tired O' Waitin' Blues (Grainger-Ricketts) and *Gulf Coast Blues*—Viola McCoy and Bob Ricketts' Band	10	5151	.75
Crazy Over Daddy (Dowell) and *Cootie Crawl*—Sammie Lewis	10	5147	.75
Cootie Crawl (Booker) and *Crazy Over Daddy*—Sammie Lewis	10	5147	.75
Chirpin' The Blues (Hunter) and *Just Thinkin'*—Viola McCoy	10	5162	.75
Just Thinkin' (A Blues) (Grainger-Ricketts) and *Chirpin' The Blues*—Viola McCoy	10	5162	.75
Maybe Some Day (Spikes Bros.) and *All Night Blues*—Callie Vassar	10	5172	.75
All Night Blues (Jones) and *Maybe Someday*—Callie V.	10	5172	.75
Long Lost Mama (Woods) and *Wish I Had You*—V.			.75

Richard Jones

GENNETT RECORDS—COLORED ARTIST SECTION

Weather Bird Rag (Armstrong) and *Dipper Mouth Blues*—King Oliver's Creole Jazz Band	10	5132	.75
Just Gone (Oliver-Johnson) and *Canal Street Blues*—King Oliver's Creole Jazz Band	10	5133	.75
Canal Street Blues (Oliver-Armstrong) and *Just Gone*—King Oliver's Creole Jazz Band	10	5133	.75
Mandy Lee Blues (Bloom-Melrose) and *I'm Going Away To Wear You Off My Mind*—King Oliver's Creole Jazz Band	10	5134	.75
I'm Going Away To Wear You Off My Mind (Smith) and *Mandy Lee Blues*—King Oliver's Creole Jazz Band	10	5134	.75
Waitin' For The Evenin' Mail (Fox Trot) (Baskette) and *I Ain't Never Had Nobody Crazy Over Me* (Fox-Trot)—Ladd's Black Aces	10	5164	.75
I Ain't Never Had Nobody Crazy Over Me (Fox-Trot) (Durante-Stein-Roth) and *Waitin' For The Evenin' Mail* (Fox-Trot)—Ladd's Black Aces	10	5164	.75
Jazzin' Babies Blues (Jones) and *12th Street Rag*—Richard M. Jones	10	5174	.75
12th Street Rag (Bowman) and *Jazzin' Babies Blues*—Richard M. Jones	10	5174	.75
Choo Choo Blues (Barr-Creager)—Art Landry's Syncopatin' Six and *Snake Rag*—King Oliver's Creole Jazz Band	10	5184	.75

Callie Vassar

King Oliver's Creole Jazz Band

Gennett 5174-A 11492
Jazzin' Babies Blues
(Jones)
Richard M. Jones
Piano Solo
DIVISION OF
THE STARR PIANO CO.
RICHMOND
IND.

ALL: "The Difference is in the Tone," announced Gennett Records on the front of their 1924 catalog—and they meant it. The Richmond, Indiana label boasted an impressive array of African-American artists in its catalog. Known for writing the blues standard "Trouble in Mind," Richard M. Jones was a Gennett artist, recording the piano instrumental "Jazzin' Babies Blues" in June 1923. He accompanied Callie Vassar at her only recording session for Gennett the month before. Gennett issued fourteen historic sides by King Oliver and His Creole Jazz Band that featured a young Louis Armstrong and Johnny Dodds. The information card for their now incredibly rare Gennett release "Zulus Ball" notes that the song was published by the Melrose brothers.

66 — THE ART OF THE BLUES

Ted Claire Snappy Bits Band

Ladd's Black Aces

ABOVE LEFT: We know Whistler and his Jug Band were led by vocalist Buford Thelkeld (he doubled on guitar and nose whistle), while B. J. Tite was his jug blower at the band's 1924 Gennett session in Richmond, which included "I'm a Jazz Baby." The band was later immortalized on film performing their 1931 Victor recording "Foldin' Bed."

TOP & BOTTOM RIGHT: The Ted Claire Snappy Bits Band recorded for Gennett in January 1923, their session including "Four O'Clock Blues" and "Laughin' Cryin' Blues." Ladd's Black Aces were considerably more prolific, but the photo Gennett claimed was of them actually was not—the Aces were in reality a white outfit better known as the Original Memphis Five (the identity of the gents in this catalog photo is unknown).

THE HOTTEST BANDS! THE BIGGEST HITS!: RECORD CATALOGS

67

VICTOR RECORDS

Victor Records could point with pride to the most famous of all record company logos: the lovable image of Nipper, an inquisitive little fox terrier, staring intently at the horn of a 78 rpm record player with the motto "His Master's Voice" situated directly underneath.

ONLY COLUMBIA RECORDS would rival Victor's success and endurance over the entirety of the twentieth century and beyond. Based in Camden, New Jersey, Victor Records was initially the domain of Eldridge R. Johnson, whose Victor Talking Machine Company was incorporated in 1901. Johnson had previously invented a spring-driven mechanism that allowed Emile Berliner's hand-cranked gramophones to operate at a steadier speed (Berliner pioneered the use of discs to record on and then to release music to the public on, ultimately rendering obsolete the cylinders that preceded them).

Victor was in business as a label from the first years of the century. As the company gained financial traction, it constructed a sprawling factory complex on the banks of the Delaware River that was dominated by a huge structure known as the Nipper Building. The plant's majestic tower was topped off in 1915 by four massive stained glass depictions of the iconic dog and his trusty gramophone that were illuminated after dark, providing a highly distinctive beacon on the shoreline.

The label's early catalog was filled with classical, opera, and popular fare. Like its competitors, Victor stepped into the classic blues arena when it became an economically viable style, then built an uncommonly strong country blues roster. The Memphis Jug Band settled in with Victor in 1927 and remained with the company through 1930, their rollicking sides the work of a revolving cast that always included founder Will Shade.

Georgia-born Blind Willie McTell made his first two sessions for the company, his remarkable facility on guitar (he was a wizard on the twelve-string) and relaxed, conversational vocal approach setting him well apart from most of his peers. Just as impressive was the company's jazz lineup; Eddie South, who also joined Victor in 1927, was one of the first important violinists within the genre. Known as "the Dark Angel of the Violin," the Louisiana-born South recorded for Victor through 1933, though he spent considerable time during those years in Europe.

Victor's formidable African-American talent lineup contributed mightily to its long reign as the country's biggest record label, though most of its blues contingent shifted over to the Bluebird budget logo from 1933 until it was permanently grounded in the mid-1940s. That was around the same time the parent company expanded its name to RCA Victor, belatedly reflecting its 1929 acquisition by the Radio Corporation of America.

With R&B growing in popularity in 1953, RCA launched a fresh subsidiary, Groove Records, to battle the indie labels and establish a new identity in the growing market. Much of Groove's output consisted of New York-cut urban blues and R&B, and while hits were inexplicably few, the company did score an R&B chart-topper just before it folded in 1957 with Mickey & Sylvia's duet "Love Is Strange."

Perhaps more than any other major label, RCA Victor spent a great deal of time and effort on combing through its massive archives for vintage masters, assembling a wealth of visually and aurally stunning blues and jazz reissue albums. Victor recognized the value of its back catalog as far back as the 1940s, when it compiled 78 rpm albums of 1920s and '30s jazz and blues. RCA also kept important recordings in print for decades when other less enlightened labels might have deleted those still viable releases, exhibiting a commendable commitment to its storied past right into the CD era.

ABOVE: In the early days of recording, retail stores were often associated with one company that carried a full line of that firm's products, specifically records and the equipment to play them on. Photographed in March 1916, this store on Broadway in New York City was exclusively tied to Victor, stocking its talking machines and records.

TOP & BOTTOM LEFT: Victor Records displayed its wide variety of African-American artists in this May 17, 1930 advertisement, including "Bloodhound Blues" by Victoria Spivey, Kentucky blues guitarist Clifford Gibson's "Don't Put That Thing on Me," jazz dance fare by Wilton Crawley's orchestra, and Rev. F. W. McGee's fiery preaching.

An April 12, 1930 ad from the *Baltimore Afro-American* promoted the Memphis Jug Band's "I Whipped My Woman with a Single Tree." Harpist Will Shade, kazooist Ben Ramey, and guitarist Charlie Burse were the mainstays of the Memphis Jug Band at Victor.

ABOVE RIGHT: The cover of Victor's 1930 race catalog consisted of an atmospheric painting of a guitar-playing bluesman that vividly recreated a scene from director King Vidor's pioneering soundie film *Hallelujah*.

THE HOTTEST BANDS! THE BIGGEST HITS!: RECORD CATALOGS

69

NEW ORTHOPHONIC VICTOR RECORDS			Number	Size	List prc.
Jesus, the Light of the World *Sermons with*		Rev. F. W. McGee	V-		
He's Got the Whole World in His Hand Singing		Rev. F. W. McGee	38513	10	.75
Jesus the Lord is a Saviour *Sermons with*		Rev. F. W. McGee	V-		
I Looked Down the Line and Wondered Singing		Rev. F. W. McGee	38561	10	.75
Jive Me Blues	*with Guitar*	Clifford Gibson	V-		
Don't Put That Thing On Me		Clifford Gibson	38572	10	.75
Jogo Rhythm—*Stomp*		"Tiny" Parham and His Musicians	V-		
Stuttering Blues—Stomp		"Tiny" Parham and His Musicians	38009	10	.75
JOHNSON, CHARLIE, AND HIS ORCHESTRA					
Harlem Drag			V-38059		
Hot Bones and Rice			V-38059		
Hot-Tempered Blues			21247		
You Ain't the One			21247		
JOHNSON, JIMMIE, AND HIS ORCHESTRA					
You Don't Understand	V-38099	You've Got to Be Modernistic	V-38099		
JOHNSON, TOMMY—*with Guitar*					
Big Fat Mamma Blues			V-38535		
Big Road Blues			21279		
Bye Bye Blues			21409		
Canned Heat Blues			V-38535		
Cool Drink of Water			21279		
Maggie Campbell Blues			21409		
Join That Band		Taskiana Four			
I Shall Not Be Moved		Taskiana Four	20183	10	.75
Jonah in the Belly of the Whale		Rev. F. W. McGee			
With His Stripes		Rev. F. W. McGee	20773	10	.75
JONES AND COLLINS ASTORIA HOT EIGHT					
Astoria Strut			V-38576		
Duet Stomp			V-38576		
JONES AND JONES—*Comedians*					
Cicero and Caesar—1, 2			21208		
Cicero and Caesar—3, 4			21237		
JONES', RICHARD M., JAZZ WIZARDS					
African Hunch	21345	Novelty Blues	V-38040		
Boar Hog Blues	21203	Tickle Britches Blues	V-38040		
Jazzin' Baby Blues	21203				
JORDAN, LUKE—*with Guitar*					
Church Bells Blues	21076	My Gal's Done Quit Me	V-38564		
Cocaine Blues	21076	Won't You Be Kind?	V-38564		
Jubilee Stomp		Duke Ellington and His Orchestra			
Black Beauty—Fox Trot		Duke Ellington and His Orchestra	21580	10	.75
Judge Harsh Blues	*with Guitar*	Furry Lewis	V-		
I Will Turn Your Money Green		Furry Lewis	38506	10	.75
Jug Band Waltz		Memphis Jug Band	V-		
Mississippi River Waltz		Memphis Jug Band	38537	10	.75
Jungle Blues		Morton's Red Hot Peppers			
African Hunch—Fox Trot		Jones' Jazz Wizards	21345	10	.75

Ch. Johnson

Tommy Johnson

ABOVE LEFT: When it came to the full spectrum of African-American music, Victor had it covered. Selected pages from its 1930 catalog offer convincing testimony: Mississippi blues guitarist Tommy Johnson shares space with often overlooked Harlem orchestra leader Charlie Johnson (both pictured) and Luke Jordan, a blues songster guitarist from Virginia best known for his "Cocaine Blues."

ABOVE RIGHT: Tommy Johnson's falsetto-laden vocals and forceful guitar work made him one of the Mississippi Delta's most influential bluesmen, an inspiration to Howlin' Wolf and Houston Stackhouse. Johnson made three 78s for Victor in 1928 (including "Canned Heat Blues") and another handful for Paramount in 1929–30. "Cool Drink of Water Blues," Johnson's first Victor release, was recorded February 3, 1928, in Memphis. He died in 1956.

70 THE ART OF THE BLUES

NEW ORTHOPHONIC VICTOR RECORDS			Number	Size	List prc
Leaning on the Lord *Balm in Gilead*	Spiritual	Utica Jubilee Singers Utica Jubilee Singers	21842	10	.75
Leave It There *Stand by Me*		Pace Jubilee Singers with Hattie Parker Pace Jubilee Singers with Hattie Parker	21551	10	.75
Leavin' Town Blues *The Four Day Blues*	with Guitar and Mandolin	Ishman Bracey Ishman Bracey	V-38560	10	.75
LEECAN, B.—COOKSEY, R.—Guitar, Harmonica *Black Cat Bone Blues* 20251 *Dirty Guitar Blues*			20251		
Left Alone Blues *Saturday Blues*	with Guitar and Mandolin	Ishman Bracey Ishman Bracey	21349	10	.75
Lenox Avenue Blues *St. Louis Blues*	Pipe Organ	Thomas Waller Thomas Waller	20357	10	.75
Let's Get It—Fox Trot *Moten's Blues*		Bennie Moten's Kansas City Orchestra Bennie Moten's Kansas City Orchestra	V-38072	10	.75
Let Us Cheer the Weary Traveler *Somebody's Knocking at Your Door*		Utica Singers Utica Singers	22052	10	.75
Levee Camp Moan *Hard-Headed Blues*	with Guitar	Clifford Gibson Clifford Gibson	V-38577	10	.75
LEWIS, FURRY—with Guitar *Furry's Blues* *I Will Turn Your Money* *Judge Harsh Blues* *Kassie Jones—Parts 1, 2* *Mistreatin' Mamma*			V-38519 V-38506 V-38506 21664 V-38519		
LEWIS, NOAH—Harmonica Solos *Chickasaw Special* *Devil in the Wood Pile*			V-38581 V-38581		
Lie Was Told, But God Know'd It *Wild Man in Town Sermon*		Elder Richard Bryant Elder Richard Bryant	21694	10	.75
Little Orphan Annie—Fox Trot with *Bless You! Sister—Fox Trot Vocal Refrain*		Coon-Sanders Orchestra Coon-Sanders Orchestra	21895	10	.75
Live a-Humble *Good News Negro Spiritual*		Tuskegee Quartet Tuskegee Quartet	20520	10	.75
Long Gone *Traveling Man*	with Guitar	Jim Jackson Jim Jackson	V-38517	10	.75
Longin' for Home *Heartbreakin' Blues*	with Orchestra	Sweet Peas Sweet Peas	V-38565	10	.75
Lookin' for Another Sweetie—Fox Trot *When I'm Alone—Fox Trot*		Waller and His Buddies "Fats" Waller and His Buddies	V-38110	10	.75
Lookin' Good But Feelin' Bad—Fox Trot *I Need Someone Like You—Fox Trot*		Waller and His Buddies "Fats" Waller and His Buddies	38086	10	.75
Loose Like a Goose *It Won't Be Long*	Piano, Clarinet and Traps	B. and B. Moten Bennie Moten's Orchestra	V-38123	10	.75
Louder and Funnier—Fox Trot *Smiling Skies—Fox Trot with Vocal Refrain*		Coon-Sanders Orchestra Coon-Sanders Orchestra	V-38083	10	.75
Love Changing Blues *Drive Away Blues*	with Guitar	Blind Willie McTell Blind Willie McTell	V-38580	10	.75

NEW ORTHOPHONIC VICTOR RECORDS			Number	Size	List prc
Love of God *City of Pure Gold*	Sermons with Singing	Rev. F. W. McGee Rev. F. W. McGee	V-38005	10	.75
Loving Talking Blues *Dark Night Blues*	with Guitar	Blind Willie McTell Blind Willie McTell	V-38032	10	.75
Lucky "3-6-9" *Jungle Crawl*		"Tiny" Parham and His Musicians "Tiny" Parham and His Musicians	V-38082	10	.75

M

MACK, IDA MAY—with Piano
 Elm Street Blues — V-38030
 Good-Bye, Rider — V-38030
 Mr. Forty-Nine Blues — V-38532
 Wrong Doin' Daddy — V-38532

Madison Street Rag *Minglewood Blues*		Cannon's Jug Stompers Cannon's Jug Stompers	21267	10	.75
Maggie Campbell Blues *Bye Bye Blues*	with Guitar	Tommy Johnson Tommy Johnson	21409	10	.75
Make a Country Bird Fly Wild—Fox Trot *Pleasing Paul—Fox Trot*		Allen's N. Y. Orch. Henry Allen and His New York Orchestra	V-38107	10	.75
Mamma, Tain't Long Fo' Day *Writing Paper Blues*	with Guitar	Blind Willie McTell Blind Willie McTell	21474	10	.75
March of the Hoodlums—Fox Trot *Breakfast Dance—Fox Trot*		Ellington's Cotton Club Orch. Ellington's Cotton Club Orchestra	V-38115	10	.75
Market Street Stomp—Stomp *Missouri Moan—Fox Trot*		The Missourians The Missourians	V-38067	10	.75
Mary Bowed So Low *Hallelujah Side*		Taskiana Four Taskiana Four	38520	10	.75
Mary Lee—Fox Trot *Sweetheart of Yesterday—Fox Trot*		Bennie Moten's Kansas City Orchestra Bennie Moten's Kansas City Orch.	V-38114	10	.75

McGEE, REV. F. W.—Sermons
 Babylon Is Falling Down — 21090
 City of Pure Gold — V-38005
 Crooked Made Straight — 21090
 Crucifixion of Jesus — V-38028
 Dead Cat on the Line — V-38579
 Death May Be Your — 21656
 From the Jailhouse — V-38528
 Half Ain't Never Been Told — 21492
 He Is a Saviour for Me — 20858
 He's Got the World — V-38513
 Holes in Your Pockets — V-38583
 Holy City — 21205
 I Looked Down the Line — V-38561
 I've Seen the Devil — V-38583
 Jesus Cried — V-38536
 Jesus in the Fire — V-38574
 Jesus, the Light — V-38513
 Jesus, the Lord — V-38561
 Jonah in the Whale — 20773
 Love of God — V-38005

ABOVE LEFT & RIGHT: Memphis blues guitarist Furry Lewis made a spectacular session for Victor in August 1928 that included a two-part "Kassie Jones" and "I Will Turn Your Money Green." It was followed in the catalog by a release from another Bluff City standout, jug band harpist Noah Lewis. The secular and sanctified mingled when two 78s by blues singer Ida May Mack were followed by sermons and singing by Rev. F. W. McGee and his flock.

THE HOTTEST BANDS! THE BIGGEST HITS!: RECORD CATALOGS

ALL: Bennie Moten's Kansas City Orchestra came to Victor in 1926 and posted a major hit in 1928 with "South," which the pianist co-wrote. Trumpeter Hot Lips Page, reedman Harlan Leonard, and vocalist Jimmy Rushing all came through the band. Ira "Bus" Moten was also part of the crew; the Motens wrote and recorded "Loose Like a Goose" in 1929.

THE ART OF THE BLUES

NEW ORTHOPHONIC VICTOR RECORDS		Number	Size	List prc.
Original Jelly-Roll Blues *Someday Sweetheart Blues*	Morton's Red Hot Peppers Morton's Red Hot Peppers	20405	10	.75
Overnight Blues *Charlie's Idea*	Paul Howard's Quality Serenaders Paul Howard's Quality Serenaders	V- 38070	10	.75
Ozark Mountain Blues *You'll Cry For Me, But I'll Be Gone—Fox Trot*	The Missourians The Missourians	V- 38071	10	.75

P

Pace Jubilee Singers

PACE JUBILEE SINGERS—Mixed Voices

All the Way	20947	I've Done My Work	V-38501
Cryin' Holy Unto the Lord	V-38573	Leave It There	21551
Everybody Got to Walk	20310	My Lord Is Writin'	20226
Everytime I Feel the Spirit	V-38019	My Lord's Going to Move	21705
Ezekiel Saw de Wheel	21582	My Lord What	20225
Haven of Rest	V-38511	My Task	V-38501
Holy Ghost	V-38573	No Night There	V-38543
I Do, Don't You	20226	Nothing Between	21655
I'll Be Satisfied	V-38522	Seek and You Shall Find	21705
I'll Journey On	20947	Stand By Me	21551
I'm Going Through Jesus	20225	Steal Away and Pray	V-38511
I'm Going to Do All I Can	V-38019	What a Friend	21655
In That City	V-38543	When the Saints Go	21582
It Pays to Serve Jesus	V-38522	You Gonna Reap Just What	20310

PAINE, BENNIE—See "Waller"

| **Pane in the Glass** *Too Low* | Piano | Clarence Williams
Clarence Williams | V-
38524 | 10 | .75 |

PARHAM, "TINY", AND HIS MUSICIANS

Black Cat Moan	V-38126
Blue Island Blues	V-38041
Blue Melody Blues	V-38047
Cathedral Blues	V-38111
Clarice—Fox Trot	21659
Cuckoo Blues	21553
Dixieland Doin's	V-38111
Echo Blues	V-38076
Fat Man Blues	V-38126
Head Hunter's Dream	21553
Jogo Rhythm	V-38009
Jungle Crawl	V-38082
Lucky "3-6-9"	V-38082
Skag-A-Lag	V-38054
Snake Eyes—Stomp	21659
Stompin' On Down	V-38060

Parham, "Tiny", and His Musicians

Stuttering Blues	V-38009	Tiny's Stomp	V-38060
Subway Sobs	V-38041	Voodoo	V-38054
That Kind of Love	V-38047	Washboard Wiggles	V-38076

PARIS, BLIND BENNY, AND WIFE—with Guitar

| Hide Me in the Blood | V-38503 | I'm Gonna Live | V-38503 |

ALL: Charles Henry Pace assembled his Pace Jubilee Singers from the senior choir at Beth Eden Baptist Church on Chicago's far South Side. Eight members strong (half men, half women), they emerged on Victor in 1926—the year they cut "I'm Going through Jesus"—and built a sizable legacy, though they also appeared on Brunswick, Paramount, and other labels. "Tiny" Parham and His Musicians were also Windy City-based. Their jazz was popular on Victor from 1928 to 1930.

NEW ORTHOPHONIC VICTOR RECORDS

			Number	Size	List prc.
Swanee Shuffles—Fox Trot		Duke Ellington's Orchestra	V-38089	10	.75
Mississippi—Fox Trot		Duke Ellington's Orchestra			
Sweet Aneta Mine—Fox Trot		Jelly-Roll Morton and His Orch.	V-38093	10	.75
Courthouse Bump—Fox Trot		Jelly-Roll Morton and His Orchestra			
Sweet Bunch of Daisies—Waltz	Harmonica	El Watson	21585	10	.75
Bay Rum Blues		El Watson			
Sweetheart of Yesterday—Fox Trot	Moten's Kansas City Orch.		38114	10	.75
Mary Lee—Fox Trot		Bennie Moten's Kansas City Orchestra			
Sweet Like This—Slow Fox Trot		King Oliver and His Orchestra	V-38101	10	.75
I Want You Just Myself—Fox Trot		King Oliver and His Orchestra			
Sweet Lorraine—Fox Trot		Johnny Dodds' Orchestra	V-38038	10	.75
Pencil Papa—Fox Trot		Johnny Dodds' Orchestra			
SWEET PEAS—with Orchestra					
Heartbreakin' Blues			V-38565		
Longin' for Home			V-38565		
Sweet Savannah Sue—Fox Trot (from "Connie's Hot Chocolates") with Vocal Refrain	Fess Williams' Royal Flush Orch.		V-38085		
Ain't Misbehavin'—Fox Trot		Fess Williams' Royal Flush Orchestra			
Swing Out—Fox Trot		Henry Allen, Jr., and His Orchestra	V-38080	10	.75
Feeling Drowsy—Blues		Henry Allen, Jr., and His Orchestra			

T

Tailspin Blues		Mound City Blue Blowers	V-38087	10	.75
Never Had a Reason to Believe in You—F. T.	Mound City Blue Blowers				
'Taint Nobody's Business—Part 1	with Guitars	Frank Stokes	V-38500	10	.75
'Taint Nobody's Business—Part 2		Frank Stokes			
Take Me Back	with Guitars	Frank Stokes	V-38531	10	.75
What's the Matter Blues		Frank Stokes			
Take Me to the Water		Rev. E. D. Campbell	20546	10	.75
Daniel Prayed Three Times		Rev. E. D. Campbell			
Tank Town Bump—Fox Trot	Jelly-Roll Morton's Red Hot Peppers		V-38075	10	.75
Burnin' the Iceberg—Fox Trot		Jelly-Roll Morton's Red Hot Peppers			
TARTER AND GAY					
Brownie Blues	V-38017	*Unknown Blues*	V-38017		

TASKIANA FOUR

Brightly Beams	V-38553
Creep Along Moses	20184
Crying Holy Unto Lord	20959
Dixie Bo-Bo	20852
Hallelujah Side	V-38520
Hide You in the Blood	V-38553
I'm a Pilgrim	V-38029
I'm in His Care	V-38029
I Shall Not Be Moved	20183
Join That Band	20183
Lead Kindly Light	20185
Mary Bowed So Low	V-38520
Oh My Mother	20959
Stop Dat Band	20184
Then He Brought Joy	20185
Toot, Toot, Dixie	20852

NEW ORTHOPHONIC VICTOR RECORDS

			Number	Size	List prc.
Stevedore Stomp—Fox Trot	Ellington's Cotton Club Orchestra		V-38053	10	.75
The Dicty Glide—Fox Trot	Ellington's Cotton Club Orchestra				
Stingy Woman—Blues		Memphis Jug Band	20552	10	.75
Sun Brimmers—Blues		Memphis Jug Band			
St. James Infirmary with Vocal Refrain	King Oliver and His Orch.		22298	10	.75
When You're Smiling—Fox Trot		King Oliver and His Orchestra			
St. Louis Blues *Piano Duet*		"Fats" Waller-Bennie Paine	22371	10	.75
After You've Gone		"Fats" Waller-Bennie Paine			
St. Louis Blues		Leroy Smith and His Orchestra	21472	10	.75
I'm a Broken-Hearted Blackbird		Leroy Smith and His Orchestra			
St. Louis Blues *Pipe Organ*		Thomas Waller	20357	10	.75
Lenox Avenue Blues		Thomas Waller			

STOKES, FRANK—with Guitar

Bedtime Blues	21272
Bunker Hill Blues	V-38548
Downtown Blues	21272
How Long?	V-38512
I Got Mine	V-38512
It Won't Be Long Now	21672
Mistreatin' Blues	21672
Nehi Mamma Blues	21738
South Memphis Blues	V-38548
Stomp That Thing	21738
'Taint Nobody's Business	V-38500
Take Me Back	V-38531
What's the Matter Blues	V-38531

Stompin' On Down—Fox Trot	"Tiny" Parham and His Musicians		V-38060	10	.75
Tiny's Stomp—Fox Trot	"Tiny" Parham and His Musicians				
Stomp That Thing with Guitar		Frank Stokes	21738	10	.75
Nehi Mamma Blues		Frank Stokes			
Stop Dat Band		Taskiana Four	20184	10	.75
Creep Along Moses		Taskiana Four			
Stop Kidding—Fox Trot		McKinney's Cotton Pickers	V-38025	10	.75
Put It There—Fox Trot		McKinney's Cotton Pickers			
Stoppin' the Traffic—Fox Trot		The Missourians	V-38120	10	.75
Prohibition Blues—Fox Trot		The Missourians			
Street Urchin *Male Quartet—Unacc.*	Four Wanderers		V-38540	10	.75
Farmer's Life For Me		Four Wanderers			
Stuff—Slow Fox Trot		Carson Robison's Kansas Jack-Rabbits	V-38074	10	.75
Nonsense—Fox Trot		Carson Robison's Kansas Jack-Rabbits			
Stuff—Stomp		Paul Howard's Serenaders	V-38122	10	.75
Quality Shout—Fox Trot		Paul Howard's Serenaders			
Stuttering Blues—Stomp		"Tiny" Parham and His Musicians	V-38009	10	.75
Jogo Rhythm—Stomp		"Tiny" Parham and His Musicians			
Subway Sobs—Fox Trot		"Tiny" Parham and His Musicians	V-38041	10	.75
Blue Island Blues		"Tiny" Parham and His Musicians			
Sun Brimmers—Blues		Memphis Jug Band	20552	10	.75
Stingy Women—Blues		Memphis Jug Band			
Sure-Enough Soldier		Rev. Gates and Congregation	21523	10	.75
Do It Yourself		Congregation			

ABOVE LEFT: Perhaps to differentiate her from her older sister, blues diva Victoria Spivey, Addie Spivey adopted the sobriquet of Sweet Peas for her 1929 debut Victor date. Subsequent sessions saw her name spelled as Sweet Pease; she also recorded for Vocalion as Hannah May and the State Street Four. Daniel Johnson, Norman Allen, Edward Foster, and James Ricks sang a cappella spirituals for Victor as the Taskiana Four from 1926 to 1928.

TOP & BOTTOM RIGHT: A product of the songster era, Frank Stokes was one of Memphis's most influential prewar blues guitarists. The minstrel show veteran teamed with guitarist Dan Sane to record for Paramount as the Beale Street Sheiks in 1927 before Stokes signed as a solo artist at Victor. He cut "How Long" there in August 1928 with Sane back on second guitar.

THE ART OF THE BLUES

NEW ORTHOPHONIC VICTOR RECORDS

Title	Artist	Number	Size	List prc.
Three Women Blues *with Guitar* / *Statesboro Blues*	Blind Willie McTell / Blind Willie McTell	V-38001	10	.75
Tickle Britches Blues—Fox Trot / *Novelty Blues*—Fox Trot	Richard Jones' Jazz Wizards / Richard Jones and His Jazz Wizards	V-38040	10	.75
Tiny's Stomp—Fox Trot / *Stompin' On Down*—Fox Trot	"Tiny" Parham and His Musicians / "Tiny" Parham and His Musicians	V-38060	10	.75
Too Late—Fox Trot / *What You Want Me to Do*—Slow Fox Trot	King Oliver and His Orchestra / King Oliver and His Orch.	V-38090	10	.75
Too Low *Piano* / *Pane in the Glass*	Clarence Williams / Clarence Williams	V-38524	10	.75
Toot, Toot, Dixie / *Dixie Bo-Bo*	Taskiana Four / Taskiana Four	20852	10	.75
Top and Bottom—Fox Trot / *Coal-Yard Shuffle*—Fox Trot	Joe Steele and His Orchestra / Joe Steele and His Orchestra	V-38066	10	.75
Tough Breaks—Stomp / *It's Hard to Laugh or Smile*—Fox Trot	Bennie Moten's Kansas City Orchestra / Moten's Kansas City Orchestra	V-38037	10	.75
Transatlantic Stomp / *Barrell House Stomp*	E. C. Cobb and His Corn Eaters / E. C. Cobb and His Corn Eaters	V-38023	10	.75
Traveling Man *with Guitar* / *Long Gone*	Jim Jackson / Jim Jackson	V-38517	10	.75
Trav'lin' All Alone—Fox Trot / *Words Can't Express*—Fox Trot	McKinney's Cotton Pickers / McKinney's Cotton Pickers	V-38112	10	.75
Trouble-Hearted Blues *with Mandolin and Guitar* / *Brown Mamma Blues*	Ishman Bracey / Ishman Bracey	21691	10	.75
Trouble in Mind / *Justrite*	Moten's Kansas City Orchestra / Moten's Kansas City Orchestra	21739	10	.75
Trumpet's Prayer—Fox Trot / *Call of the Freaks*—Fox Trot	King Oliver and His Orchestra / King Oliver and His Orchestra	V-38039	10	.75
Try Me Out—Fox Trot / *Down My Way*—Fox Trot	Jelly-Roll Morton and His Orchestra / Jelly-Roll Morton and His Orchestra	V-38113	10	.75

TUCKER, BESSIE—with Piano

Title	Number
Bessie's Moan	V-38526
Better Boot That Thing	V-38542
Fryin' Pan Skillet Blues	V-38018
Got Cut All to Pieces	V-38018
Katy Blues	V-38542
Mean Old Jack Stropper Blues	V-38538
Old Black Mary	V-38538
Penitentiary	V-38526

Title	Artist	Number	Size	List prc.
Turn On the Heat *Piano* / *My Fate Is In Your Hands*	Thomas ("Fats") Waller / Thomas ("Fats") Waller	V-38568	10	.75
Turtle Twist—Fox Trot / *Smilin' the Blues Away*—Fox Trot	Jelly-Roll Morton Trio / Jelly-Roll Morton Trio	V-38108	10	.75

TUSKEGEE QUARTET

Title	Number	Title	Number
Go Down Moses	20518	I Want to Be Like Jesus	20518
Golden Slippers	20843	Live a-Humble	20520
Good News	20520	Old-Time Religion	20519
Heaven Song	20843	Steal Away to Jesus	20519

Title	Artist	Number	Size	List prc.
12th Street Rag / *Baby Dear*—Fox Trot	Bennie Moten's Orchestra / Bennie Moten's Orchestra	20946	10	.75

U

Title	Artist	Number	Size	List prc.
Undertaker Blues *with Vocal Refrain* / *P-Wee Strut*	Douglas Williams' Orchestra / Douglas Williams and His Orchestra	V-38550	10	.75
Unknown Blues *Guitars with Vocal Refrain* / *Brownie Blues*	Tarter and Gay / Tarter and Gay	V-38017	10	.75

UTICA INSTITUTE JUBILEE SINGERS

Title	Number	Title	Number
Ain't It a Shame	21600	Leaning On the Lord	21842
Angels Watching	20665	Let Us Cheer the Weary Traveler	22052
Balm in Gilead	21842	O Mary Don't You Weep	21373
Chicken	21925	Peter On the Sea	21925
Climbin' Up the Mountain	20665	Somebody's Knocking at Your Door	22052
Couldn't Hear Nobody Pray	21373	Standing in Need of Prayer	22159
Don't You Want to Be	22159	Watermelon	21600
Do You Call That Religion	20506		
Honey	20506		

V

Title	Artist	Number	Size	List prc.
Valentine Stomp *Piano Solo* / *Gladyse*	Thomas ("Fats") Waller / Thomas ("Fats") Waller	V-38554	10	.75
Vine Street Drag—Fox Trot / *I've Got Someone*—Fox Trot	The Missourians / The Missourians	V-38103	10	.75
Viola Lee Blues *with Vocal Refrain* / *Heart Breakin' Blues*	Cannon's Jug Stompers / Cannon's Jug Stompers	V-38523	10	.75

VIRGINIA FOUR—Male Voices—Unaccompanied

Title	Number
Comin' Down the Shiny Way	V-38569
Since I Been Born	V-38569

Title	Artist	Number	Size	List prc.
Voodoo—Fox Trot / *Skag-A-Lag*—Fox Trot	"Tiny" Parham and His Musicians / "Tiny" Parham and His Musicians	V-38054	10	.75

W

Title	Artist	Number	Size	List prc.
Wait Until Your Chance Comes / *Saul of Tarsus*	Rev. E. D. Campbell / Rev. E. D. Campbell	21642	10	.75
Walk Thru the Valley in Peace / *On My Knees*	Bethel Quartet / Bethel Quartet	V-38510	10	.75

WALLACE, MINNIE—with Orchestra

Title	Number
Dirty Butter	V-38547
Old Folks Started It	V-38547

WALLER, THOMAS ("FATS")—Piano

Title	Number
After You've Gone	22371
Gladyse	V-38554
Handful of Keys	V-38508
My Fate Is In Your Hands	V-38568
Numb Fumblin'	V-38508
St. Louis Blues	22371
Turn On the Heat	V-38568
Valentine Stomp	V-38554

WALLER, THOMAS—Pipe Organ

Title	Number
He's Gone Away	21202
Lenox Avenue Blues	20357

ABOVE LEFT: The brief recording career of Texas native Bessie Tucker spanned eighteen titles cut in 1928–29 for Victor. Visiting studios in Memphis and then in Dallas, her accompanists were pianist K. D. Johnson and on her later sides, guitarist Jesse "Babyface" Thomas.

ABOVE RIGHT: The Virginia Four were far less prolific than Bessie Tucker—with one largely a cappella New York session on December 2, 1929, that produced both of their Victor 78s. Minnie Wallace debuted on the label with "Dirty Butter," cut with the Memphis Jug Band backing her (she popped back up on Vocalion in 1935). Fats Waller was a budding Victor superstar. His Harlem stride piano mastery, ebullient vocals, and larger-than-life aura made him a global luminary of the first order during the 1930s and beyond.

F. W. BOERNER CO.

Mail-order firms scattered across the country stood ready and willing to sell music fans the latest blues and jazz records via parcel post. They capitalized on those buyers who were located so far out in the wilderness that purchasing records in person was an impossibility. Few of those record merchants stayed in business as long or moved as much product as F. W. Boerner Co.

THE FIRM WAS launched in January 1925 by Fred Boerner, his sister Viola, and her husband Maurice Supper in Port Washington, Wisconsin, which also served as the headquarters for Paramount Records' parent Wisconsin Chair Company. Boerner and Supper both worked for Paramount and were involved behind the scenes with the label's blues output, so it is not a great surprise that Boerner's independently operated sideline business carried a nice stock of the label's 78s. They remained on offer from Boerner long after Paramount itself locked its doors.

Boerner boldly advertised itself as the "world's largest record mail order house." The catalogs the company sent out to their sizable mailing list tried hard to live up to the lofty claim. A 1934 Boerner mailer sported a stunning photograph of a seated Charley Patton on its cover to plug his Vocalion releases. Before that, the intense Mississippi Delta guitarist had been a longtime Paramount artist. Boerner's foldout catalogs listed generous selections of 78s by blues stars such as Tampa Red alongside releases by more obscure artists. The company carried inventory from all the leading labels and kept everything in stock for as long as they could. The small ads in its mailers mirrored the considerably larger ones that ran in black newspapers such as the *Chicago Defender* and the *Baltimore Afro-American*.

During the late 1930s, Boerner and his cohorts formed the Ideal Irrigation Company, so shipping 78s to the hinterlands became somewhat less of a priority as time went on. Supper, the vice-president of the company, died in June 1943, but his partner kept the mail-order business going

BOERNER BOLDLY ADVERTISED ITSELF AS THE "WORLD'S LARGEST RECORD MAIL ORDER HOUSE."

without him. Boerner was still selling records in the years following World War II, although now a new crop of rhythm and blues stars were featured front and center in its catalogs (the back page was generally devoted to spirituals by the Golden Gate Quartet and their heavenly ilk).

With the new R&B sound came fresh ways for record sellers to publicize their wares, even after Boerner's demise. Some record stores and mail-order suppliers advertised their latest releases over the radio, while others bought ads in music and entertainment magazines well into the rock 'n' roll era. All it took was a minor adjustment or two to modernize the business model that F. W. Boerner Co. had helped to pioneer, which worked just fine and continues to do so right up to the present day.

ABOVE LEFT: The first song Jim Jackson ever recorded for Vocalion in October 1927 became his eternal theme. The two-part "Jim Jackson's Kansas City Blues" was an instant standard, selling so well that the guitarist encored with Parts 3 and 4 on January 22, 1928. The Hernando, Mississippi product appeared in King Vidor's 1929 film *Hallelujah*.

ABOVE RIGHT: F. W. Boerner Co. no doubt shipped out plenty of copies of Tampa Red and Georgia Tom's 1928 sensation "It's Tight Like That." It was so hot that the duo revisited it for Vocalion, designated as "No. 2." Its Vocalion sleeve bears photos of King Oliver, Luella Miller, Joe Taggart, Revs. A. W. Nix and E. W. Clayborn, and Jimmy Bertrand.

LEFT: Brunswick's December 1931 catalog made its way as far as the Sherman Music Company in Helena, Montana. Baton-wielding cover subject Cab Calloway's meteoric rise to the top was progressing full speed ahead thanks to the livewire bandleader's prior Brunswick releases "Minnie the Moocher" and "St. James Infirmary."

THE SMARTLY-MODERN RECORD
Vocalion

35¢ each — 3 for $1

AARONSON, IRVING AND HIS COMMANDERS
- 25005 Ah! But Is It Love—FT
- 2536 Day You Came Along, The—FT
- 2571 Good Night, Little Girl of My Dreams—Waltz
- 25005 I've Gotta Get Up and Go to Work—FT
- 25004 Lazybones—FT
- 2570 Marching Along Together—FT
- 2571 Marching Along Together—FT
- 25004 Shadows On the Swanee—FT
- 2535 Snowball—FT
- 2536 Thanks—FT
- 2535 That's How Rhythm Was Born—FT
- 2570 You Gotta Be a Football Hero—FT

- 5474 After The Ball—Vocal and Inst. Bradley Kincaid (Bury)
- 1124 After the Ball Is Over—Sermon Rev. Nix & Cong. (Prayer)
- 2610 After Me the Sun Goes Down—Novelty Dance Joseph Robechaux and his Orchestra (Why)
- 2588 After Sundown—FT (From "Going Hollywood") Dick Himber Orchestra (Our)
- 2736 After To-Night—Nov. Dance Clarence Williams Orch. (Old)
- 1658 After While Blues—Voc. with Guitars Memphis Minnie (Soo)
- 15864 After You've Gone—FT Eddie Lang, Joe Venuti Orch. (Beale)
- 25005 Ah! But Is It Love—FT (From "Moonlight and Pretzels") Irving Aaronson and his Orchestra (I've Gotta)
- 2805 Ain't Gonna Give You None of My Jelly Roll—Nov. Dance Clarence Williams and his Orchestra (Sugar)
- 1649 Ain't It a Pity and Shame—Voc. with Guitar Peetie Wheatstraw (Don't)
- 2826 Ain't It Nice?—FT Alex Hill Orchestra (Functionizin')
- 02789 Ain't No Use to High Hat Me—Voc. & Inst. Ashley & Foster (Go)

AKERS, GARFIELD—Vocal (Race)
- 1442 Cottonfield Blues-Parts 1 and 2

ALABAMA WASHBOARD STOMPERS
Washboard Band (Race)
- 1684 Can't We Talk It Over?—FT
- 1630 Corrine Corrina—FT
- 1689 If all the World Was Made of Glass—FT
- 1546 If I Could Be with You—FT
- 1689 If You Don't Love Me, Make Believe You Do—FT
- 1635 I Need Lovin'—FT
- 1626 I Surrender Dear—FT
- 1586 I Want a Little Girl—FT
- 1697 Pepper Steak—FT
- 1546 Pig Meat Stomp—FT
- 1630 Porter's Love Song, The—FT
- 1587 Rockin' Chair—FT
- 2688 St. Louis Blues
- 2688 Some of These Days
- 1626 Treat Me Like a Baby—FT
- 1684 Was That the Human Thing to Do?—FT
- 1587 Who Stole the Lock—FT
- 1697 You Can Depend on Me—FT
- 1635 You Can't Stop Me From Loving You
- 1586 You're Lucky to Me—FT

- 1549 Alabama Women Blues—Vocal and Inst. Le...
- 02769 Alamo Waltz—Waltz O'Daniel Doug...

ALEXANDER, TEXAS—Vocal Blues (Race)
- 02912 Deceitful Blues
- 02856 Easy Rider Blues
- 02876 Good Feelin' Blues
- 02856 Justice Blues
- 02894 Katy Crossing Blues
- 02894 Lonesome Blues
- 02876 Lonesome Valley Blues
- 02912 One Morning Blues

Vocalion RECORDS Electrically Recorded
35¢ Each — 3 for $1

JULY RELEASE

VOCAL
- 2730 Jig Time—Novelty Vocal and Instrumental
 Someone Stole Gabriel's Horn The Three Keys (Bon Bon, Slim & Bob)

DANCE
- 2722 All I Do Is Dream of You—Fox Trots with Vocal Chorus (From "Sadie McKee")
 With My Eyes Open I'm Dreaming Gene Kardos and his Orchestra (From "Shoot the Works")
- 2717 Don't Let Your Love Go Wrong—Fox Trots with Vocal Chorus
 Moon Country (Is Home to Me) Gene Kardos and his Orchestra
- 2721 So Help Me—Fox Trots with Vocal Chorus
 Easy Come, Easy Go Paul Hamilton and his Orchestra
- 2715 Ridin' Around in the Rain—Fox Trots with Vocal Chorus
 The Beat o' My Heart Eddie Jackson and his Orchestra
- 2716 True—Fox Trot with Vocal Chorus
 Dream of Me Darling Tonight—Waltz with Vocal Chorus
 Joe Green and his Orchestra

HOT DANCE
- 2718 Won't You Come over and Say "Hello"—Novelty Dance with Vocal Chorus
 Pretty Baby, Is It Yes or No? Clarence Williams and his Orchestra
- 2723 Zuddan—Novelty Dance
 Mazie Ruben 'River' Reeves and his River Boys

INSTRUMENTAL
- 2724 The Skaters' Waltz—(Recorded in Europe)
 Espana—Waltz Alfredo Campoli and his Salon Orchestra
- 2725 Somewhere a Voice Is Calling—Pipe Organ (Recorded in England)
 A Perfect Day—(Played on the World's Mightiest Wurlitzer at the Granada, London) Alex Taylor

ALL: A mere 35 cents could buy you a lot of music from the Vocalion catalog in July 1934—the latest release by the Three Keys or a new one by veteran New York piano man Clarence Williams. An impressive list of titles by the Alabama Washboard Stompers and Texas Alexander was on display in the May 1935 catalog. Amos Easton, who went by the handle of Bumble Bee Slim, was on a variety of labels from 1926 on, including Vocalion. He cut "You Can't Take It Baby" in Chicago on November 26, 1934, reportedly backed on guitar by Carl Martin and Ted Bogan.

THE HOTTEST BANDS! THE BIGGEST HITS!: RECORD CATALOGS

LEFT: Introduced in 1932 but not fully launched until the following year, Victor's budget-priced Bluebird label released a steady stream of resplendent blues records before folding in 1945, the great majority produced in Chicago by Lester Melrose. The cover of Bluebird's 1937 catalog was embellished by the label's mascot, known as "Buff."

WASHBOARD SAM AND HIS WASHBOARD BAND

B-6765	Nashville, Tennessee—Blues / Razor Cuttin' Man—Blues
B-6870	Big Woman—F.T. / Come On In—F.T.
B-6970	The Big Boat—F.T. / Easy Ridin' Mama—F.T.
B-7001	Back Door—F.T. / We Gonna Move—F.T. Blues
B-7048	Low Down Woman—F.T. Blues / I Drink Good Whiskey—F.T.
B-7096	Lowland Blues / I'm on My Way Blues
B-7148	Out with the Wrong Woman—F.T. / Shim Shaming—F.T.
B-7179	I Love All My Women—F.T. / Hey Hey Blues (Griffin)
B-7194	You Done Tore Your Playhouse Down / Young Heifer Blues (Griffin)
B-7291	Washboard's Barrel House Song—F.T. / Where Were You Last Night?—F.T.
B-7328	Ladies' Man—F.T. / Beer Garden Blues—F.T.
B-7365	You Got to Take It—F.T. / Gonna Be Some Walkin' Done—F.T.
B-7403	Somebody's Got to Go—F.T. / Second Story Man—F.T.
B-7440	Want to Woogie Some More—F.T. / C N A (Robert L. McCoy)
B-7501	Don't Leave Me Here—F.T. / Towboat Blues—Slow F.T.
B-7526	Down at the Old Village Store / Stuff Stomp (Elijah Jones)
B-7552	My Woman's a Sender—F.T. / Barbecue—Slow F.T.
B-7601	Mountain Blues—Slow F.T. / Phantom Black Snake—Slow F.T.
B-7655	The Gal I Love—Blues / Lonesome Man (Elijah Jones)
B-7664	Yellow, Black and Brown—Blues / It's Too Late Now—Blues

Washboard Sam (Kelly's Band)

WALTER DAVIS

B-5031	M. and O. Blues—Parts 1 and 2
B-5129	M. and O. Blues—No. 3 / Worried Man Blues
B-5982	Travelin' This Lonesome Road / Sad and Lonesome Blues
B-6074	Pearly May / What Have I Done Wrong?
B-6410	Just Wondering / Fallin' Rain
B-6498	Think You Need a Shot / She Don't Know My Mind (Tampa Red)
B-6971	What Else Can I Do? / Nightmare Blues
B-7064	Angel Child / West Coast Blues
B-7329	Streamline Woman / Holiday Blues
B-7375	Big Jack Engine Blues / My Babe
B-7512	I Hear My Baby Crying / Walking the Avenue
B-7551	Easy Goin' Mama / If You Only Understand
B-7589	Million Dollar Baby / When Nights Are Lonesome
B-7643	I Did Everything I Could / Candy Man
B-7663	If You Ever Get Lonesome / Friendless
B-7693	Angel Child—Part 2 / 13 Highway

Walter Davis

TOP & BOTTOM LEFT: Robert Brown, known as Washboard Sam, signed with Bluebird in 1935 and, with Big Bill Broonzy on guitar, cut "Back Door" in 1937. He remained on RCA Victor into 1949 before joining the Chicago police force. Sam recorded one more time with his longtime musical partner Broonzy for Chess in 1953 and made his final recordings in 1964.

TOP & BOTTOM RIGHT: A carryover from Victor (where he began in 1930), Walter Davis joined Bluebird in 1933. A mainstay of the St. Louis scene, his early Bluebird sides had him backed by pianist Roosevelt Sykes, but by 1935 he accompanied himself. 1937's "What Else Can I Do?" was cut in the Sky Club on the top floor of the Leland Hotel in Aurora, Illinois.

THE HOTTEST BANDS! THE BIGGEST HITS!: RECORD CATALOGS

Rev. J. M. GATES

- B-5033 Adam and Eve in the Garden / Samson and the Woman
- B-5111 I Know I Got Religion / Funeral Train
- B-5627 Wolf Cat and His Catcher / New Dead Cat on the Line
- B-5660 There's Something About the Lord Mighty Sweet / On the Battlefield
- B-5703 Highway Robbers in the Night / Don't Hide from Your Furniture Man
- B-5725 Will You Have Christmas Dinner in Jail? / No Bad Streets in Town
- B-5755 Rev. Gates' Song Service / Valley of Death
- B-5792 Highway to Hell / Hell Ain't Half Full
- B-5824 Lord, I'm in Your Care / Goin' Through the Pearly Gates
- B-5901 Born to Die / Prepare to Meet Thy God

BO CARTER

- B-5453 Sweet Maggie / Sales Tax (with Mississippi Sheiks)
- B-5489 Bo Carter Special / Queen Bee
- B-5594 Banana in the Fruit Basket / Pin in Your Cushion
- B-5704 Please Don't Drive Me from Your Door / Nobody's Business
- B-5861 Old Shoe Blues / Let Me Roll Your Lemon
- B-5912 Mashing That Thing / Who Broke the Latch?
- B-5997 Don't Do It No More / Skin Ball Blues
- B-6058 Please Warm My Wiener / She Gonna Crawl Back Home to You
- B-6295 All Around Man / Cigarette Blues
- B-6315 Ride My Mule / Spotted Sow Blues
- B-6373 Ain't Nobody Got It / Rolling Blues
- B-6407 It's Too Wet / Dinner Blues
- B-6444 Fat Mouth Blues / You Better Know Your Business
- B-6529 T Baby Blues / Erie Train Blues (Milton Sparks)

ABOVE LEFT: The pulpit at Mount Calvary Baptist Church in Atlanta was where Rev. J. M. Gates did most of his soul-saving from 1914 until passing away in 1945. Rev. Gates was by far the most recorded African-American preacher of his day, beginning in 1926. He arrived at Bluebird in 1934 and stayed loyal to the label through to 1941.

ABOVE RIGHT: His repertoire loaded with amusing songs that included "Banana in Your Fruit Basket" (1931) and "Please Warm My Wiener" (1935), guitarist Bo Carter (real name: Armenter Chatmon) was the brother of the Mississippi Sheiks' Lonnie Chatmon. Unlike most of his labelmates, Bo recorded down south for Bluebird from 1934 onwards, rather than in Chicago.

THE ART OF THE BLUES

TAMPA RED

B-5450	I'll Find My Way / You've Got to Do Better
B-5515	I'll Kill Your Soul / If I Let You Get Away With It
B-5546	Mean Mistreater Blues / Grievin' and Worryin' Blues
B-5572	Somebody's Been Using That Thing / Give It Up, Buddy, and Get Goin'
B-5617	Kingfish Blues / You Don't Want Me Blues
B-5673	I'm Just Crazy 'Bout You / I Still Got California on My Mind
B-5723	Christmas and New Year's Blues / Witchin' Hour Blues
B-5744	Worried Devil Blues / I'll Get A Break Some Day
B-5878	Mean Old Tom Cat Blues / Shake It Up a Little
B-5929	Don't Dog Your Woman / Singing and Crying Blues
B-5981	Worthy of You / If It Ain't That Gal of Mine
B-6037	My Baby Said Yes / (I Could Learn to Love You) So Good
B-6059	Keep On Dealin' (Play Your Hand) / I Can Tell by the Way You Smell
B-6126	Rowdy Woman Blues / I Wake Up in the Morning (Milton Sparks)
B-6166	When I Take My Vacation in Harlem / You Missed a Good Man
B-6211	Drinkin' My Blues Away / Dark and Stormy Night
B-6241	Good Woman Blues / Waiting Blues
B-6199	Selling My Pork Chops / Doctor Doctor Blues
B-6202	Hustlin' Woman Blues / Got the Blues About My Baby (Pine Top)
B-6188	Keep Your Hands Off Her Big Bill / Sun Gonna Shine in My Door Some Day
B-6230	Good Liquor Gonna Carry Me Down / Down the Line Blues
B-6241	Good Woman Blues / Waiting Blues
B-6353	Let's Get Drunk and Truck—F.T. / Maybe It's Someone Else You Love—F.T. (with Chicago Five)
B-6388	I Wonder What's the Matter—Blues / She Don't Know My Mind
B-6425	Stormy Sea Blues / Nutty and Buggy Blues
B-6443	When You Were a Gal of Seven—Rhumba F.T. (with Chicago Five) / River Blues (Jesse's String Five)
B-6498	She Don't Know My Mind—Part 2 / Think You Need a Shot (W. Davis)
B-6532	All Night Long—F.T. (with Chicago Five) / You Got Me Worryin'—F.T. (with Chicago Five)

ABOVE LEFT: Pictured in Bluebird's 1937 catalog with his famous National Tricone resonator guitar, Hudson "Tampa Red" Whittaker was a Bluebird mainstay from 1934 to its demise, then shifted to parent RCA Victor into 1953. He forged close musical partnerships with pianists Black Bob, Blind John Davis, Big Maceo, and Johnny Jones.

TOP & BOTTOM RIGHT: Bluebird's first two label designs featured a bird in flight as their logo. The first blue-and-yellow layout, used from 1933 to 1937, is known as "Buff"—exemplified here by Milton Sparks's 1935 recording of "Ina Blues." A musical staff lies beneath the bird on the gold-on-dark-blue layout on Sonny Boy Williamson's 1938 recording of "Honey Bee Blues," so it is called a "staff Bluebird."

THE HOTTEST BANDS! THE BIGGEST HITS!: RECORD CATALOGS

ALL: Brunswick thought so much of Duke Ellington that the label featured photos of his entire ten-piece horn section in its 1938 catalog— and his rhythm section, too. The publication promised "a Complete List of His Recordings on Brunswick" and delivered. The perpetually elegant bandleader had recorded "Blue Ramble" for Brunswick in 1932.

84 THE ART OF THE BLUES

Vocalion

Blues Singing (SA 2754)

with Piano Guitar and Washboard

BLACK HEART BLUES
—Leon Calhoun—
SON BECKY
04081

COMPLETE ALPHABETICAL AND CLASSIFIED CATALOG

Vocalion
RECORDS

COUNTRY FOLK and SACRED SONGS, NOVELTY DANCE, STRING BANDS, RACE BLUES, HOT DANCE and SPIRITUAL

by

AMERICA'S GREATEST ARTISTS

ALL: Vocalion's catalog was integrated by 1938, listing blues and hot dance alongside country and folk. Releases by Blind Boy Fuller and Robert Johnson would have been featured, as was pianist Son Becky (real name Leon Calhoun). He cut "Black Heart Blues" and five other titles at his only date on October 25, 1937, in San Antonio, Texas.

THE HOTTEST BANDS! THE BIGGEST HITS!: RECORD CATALOGS

TOP TO BOTTOM LEFT: Roosevelt Sykes billed himself as the Honey Dripper for the five years he was on Decca; he cut "Monte Carlo Blues" for the label in 1937. Shreveport slide guitar ace Oscar Woods was known as the Lone Wolf, hence titling his 1936 solo debut "Lone Wolf Blues." Longtime Mississippi Sheiks guitarist Walter Vinson spelled his surname as Vincent on his 1936 solo Decca effort "Losin' Blues."

ABOVE RIGHT: Decca Records entered the "race music" arena as soon as the label opened stateside in 1934. The label's 1938 catalog featured singers Rosetta Howard and Ollie Shepard; pianists Roosevelt Sykes and Georgia White, pianist/guitarist Peetie Wheatstraw, guitarist Sleepy John Estes (whose Decca output included the classic "Brownsville Blues"), and the only non-blues act to make the cover, the spiritually inclined Norfolk Jubilee Quartet.

86 THE ART OF THE BLUES

TOP TO BOTTOM LEFT: Singer Charlie "Specks" McFadden was backed at the 1937 Decca session that produced "Groceries on My Shelf" by Roosevelt Sykes, as he had been on previous sides for Paramount and Bluebird. Carolina guitarist Rich Trice debuted on Decca in 1937 with "Come on Baby," his brother on the other guitar. Decca ended Lonnie Johnson's five-year hiatus that year, his output including "Got the Blues for the West End."

ABOVE RIGHT: Four of the stars showcased on the cover of Decca's 1938 catalog encored in 1940, but this time they were joined by Blue Lou Barker, Leroy's Buddy (Bill Gaither), Johnnie Temple, Lee Brown, Skeets Tolbert, two sanctified aggregations (the Dixie Hummingbirds and the Selah Jubilee Singers), and bandleader Louis Jordan, who would be the label's top African-American star in years to come.

THE HOTTEST BANDS! THE BIGGEST HITS!: RECORD CATALOGS

87

LONNIE JOHNSON, Blues Singer

B-8322	Nothing But a Rat / She's My Mary
B-8338	Four O Three Blues / The Loveless Blues
B-8363	Why Women Go Wrong / She's Only a Woman
B-8387	Trust Your Husband / Jersey Belle Blues
B-8530	Get Yourself Together / Don't Be No Fool
B-8564	Be Careful / I'm Just Dumb
B-8684	Somebody's Got to Go—Blues / She Ain't Right—Blues

TOMMY McCLENNAN (Singing with guitar)

B-8347	You Can Mistreat Me Here / New "Shake 'Em on Down"
B-8373	Whiskey Head Woman / Bottle It Up and Go
B-8408	Baby, Don't You Want to Go? / Cotton Patch Blues
B-8444	Brown Skin Girl / Baby, Please Don't Tell on Me
B-8499	New Highway No. 51 / I'm Goin', Don't You Know
B-8545	My Baby's Doggin' Me / She's a Good Looking Mama
B-8605	She's Just Good Huggin' Size / My Little Girl
B-8669	My Baby's Gone / It's Hard to Be Lonesome

ALL: Thanks to Lester Melrose's stable, Bluebird was still a blues force to be reckoned with when it published its 1941 catalog, which also featured "Old Familiar Tunes" (i.e., hillbilly), Cajun, Irish, and even children's music. Bluebird's blues roster had gained Lonnie Johnson as well as Mississippi guitarist Tommy McClennan, whose 1939 solo recordings included "New Shake 'em on Down" and "Bottle It Up and Go."

88 THE ART OF THE BLUES

ALL: Pianist John Len Chatman first recorded for OKeh in August 1940 under the name of his father, Peter Chatman, before switching to the moniker of Memphis Slim at Bluebird less than three months later. John Lee "Sonny Boy" Williamson was the most important prewar blues harpist and remained on top after the war ended. The Tennesseean premiered on Bluebird in 1937 with "Good Morning, School Girl" and immortalized African-American boxing hero Joe Louis on his 1939 Bluebird recording "Joe Louis & John Henry Blues," one of many musical tributes to the champ. This 1940 photo of Louis at his training camp was taken by LIFE magazine's William C. Shrout.

MEMPHIS SLIM

B-8584	Beer Drinking Woman / Grinder Man Blues
B-8615	Empty Room Blues / You Didn't Mean Me No Good
B-8645	I See My Great Mistake / Shelby County Blues

SONNY BOY WILLIAMSON

B-7059	Good Morning, School Girl / Sugar Mama Blues
B-7302	Early in the Morning / Project Highway
B-7352	Suzanna Blues / Black Gal Blues
B-7404	Worried Me Blues / Frigidaire Blues
B-7428	Up the Country Blues / Collector Man Blues
B-7536	I'm Tired Truckin' My Blues Away / You Can Lead Me
B-7576	Miss Louisa Blues / Until My Love Come Down
B-7603	Moonshine / Beauty Parlor
B-7665	Decoration Blues / Down South
B-7707	Honey Bee Blues / Whiskey Headed Blues
B-7756	You Give an Account / You've Been Foolin' 'Round Downtown
B-7805	My Baby, I've Been Your Slave / Deep Down in the Ground
B-7847	Lord, Oh Lord Blues / Shannon Street Blues
B-8010	Little Girl Blues / Number Five Blues
B-8034	The Right Kind of Life / Insurance Man Blues
B-8094	Rainy Day Blues / Christmas Morning Blues
B-8237	Sugar Mama Blues No. 2 / Good for Nothing Blues
B-8265	Bad Luck Blues / My Little Baby
B-8307	Doggin' My Love Around / Little Low Woman Blues
B-8333	Good Gravy / T. B. Blues
B-8357	Something Going On Wrong / Good Gal Blues
B-8383	I'm Not Pleasing You / New "Jailhouse Blues"

THE HOTTEST BANDS! THE BIGGEST HITS!: RECORD CATALOGS

CURTIS JONES
(Vocal Blues with Inst. Acc.)

05744	Blue And Lonesome
05834	Blue Memories
05744	Bosom Friend Blues
05996	Cradle Rockin' Blues
05907	Day And Night Blues
04996	Down Town Blues
06069	Dream Land Blues
05834	Heart Breaking Blues
03990	Highway 51 Blues
06105	Itty Bitty Jitter Bug
03990	Let Me Be Your Playmate
03756	Lonesome Bedroom Blues
05947	Love Land Blues
06069	Love Valley Blues
06140	Low Down Worried Blues
06140	Mean Old Blues
05907	Moonlight Lover Blues
05947	Treat Me Like I Treat You
06105	Worryin' Away My Heart For You
03756	You Got Good Business

BROWNIE MC GHEE
(Blind Boy Fuller No. 2)
(Vocal Blues with Inst. Acc.)

ALL: Columbia Records revived the OKeh label in 1940 (pictured is its 1941–42 catalog). Pianist Curtis Jones began recording for Vocalion in 1937 in Chicago. He made "Too Many Blues" for OKeh in 1941. Guitarist Brownie McGhee was a promising find for the label in 1940. Barrelhouse pianist Charlie Spand had not been in a studio in nearly a decade when he recorded "Soon This Morning No. 2" in 1940.

90 THE ART OF THE BLUES

ABOVE: Tennessee-born guitarist Brownie McGhee's "The Death of Blind Boy Fuller" paid tribute to the departed great in 1941. McGhee briefly did business as Blind Boy Fuller No. 2 on OKeh and Conqueror. He teamed with harpist Sonny Terry in 1942, the two moving to New York and becoming linchpins of the folk-blues movement.

THE HOTTEST BANDS! THE BIGGEST HITS!: RECORD CATALOGS

91

TOP LEFT: Northern California's Bay Area was home to Rene T. LaMarre's Trilon Records, which opened for business in 1946 with an artist roster that spanned blues, group harmony, gospel, and pop.

BOTTOM LEFT: Trilon's sanctified roster included the Paramount Singers, among whose ranks were lead tenor Vance "Tiny" Powell. Trilon released their "Standing in a Safety Zone" in 1948. Powell later went secular, recording the sleek blues "My Time after While" for the tiny Wax label in 1964.

TOP RIGHT: Singing pianist Viviane Greene, a hot West Coast attraction, enjoyed some success on Trilon with her mellow 1947 debut "Honey, Honey, Honey," which inspired several covers.

BOTTOM RIGHT: "Jelly, Jelly" was the first Trilon release in 1947 for guitarist Lowell Fulson, who came to the label through Bay Area producer Bob Geddins.

92 THE ART OF THE BLUES

LOWELL FULSON
and the FUL-TONES

#185 **JELLY, JELLY**
Vocal: Lowell Fulson

MEAN WOMAN BLUES
Vocal: Lowell Fulson

#186 **9:30 SHUFFLE**
Vocal: Lowell Fulson

THINKIN' BLUES
Vocal: Lowell Fulson

#192 **TRYIN' TO FIND MY BABY**
Vocal: Lowell Fulson

LET'S THROW A BOOGIE-WOOGIE
Vocal: Lowell Fulson

#193 **HIGHWAY 99**
Vocal: Lowell Fulson

WHISKEY BLUES
Vocal: Lowell Fulson

The 4 ACES

#178 **I'LL NEVER LET YOU GO AGAIN**
Vocal: Ensemble

CHERIE
Vocal: Geo. Smith

#179 **I'M CRYING ALL THE TIME**
Vocal: James Franks

THIS LITTLE CHICK WENT TO MARKET
Vocal: Geo. Smith

#180 **AIN'T IT A CRYIN' SHAME**
Vocal: Ensemble

GUMBO
Vocal: Algia Pickett

#143 **I WONDER, I WONDER, I WONDER**
Instrumental

I WONDER, I WONDER, I WONDER
Vocal: Ensemble

#145 **THERE'S A RUMOR GOING AROUND**
Vocal: Algia Pickett

ST. LOUIS BOOGIE
Instrumental

ABOVE LEFT: Oklahoma-born Lowell Fulson made four 78s for Trilon, all listed in the label's catalog under an early promotional photograph of the guitarist. Fulson would record his biggest hits for other companies, including "Blue Shadows" in 1950 for Swing Time.

ABOVE RIGHT: The 4 Aces did well on Trilon with "I Wonder, I Wonder, I Wonder." Trilon folded by the end of 1948.

THE HOTTEST BANDS! THE BIGGEST HITS!: RECORD CATALOGS

RIGHT: Alfred Lion and Francis Wolff were the masterminds at Blue Note Records, a New York jazz label that was launched in 1939 and became one of the leaders in the field for decades. Their 1941 catalog spotlighted clarinetist Edmond Hall's all-star quartet, featuring pioneering electric guitarist Charlie Christian and pianist Meade Lux Lewis.

ABOVE LEFT: An old factory building in Cincinnati served as expansive headquarters for Syd Nathan's King Records. The label was launched as a hillbilly company in 1943, but Nathan soon branched into black music, scoring hits by Wynonie Harris, Bull Moose Jackson, Lonnie Johnson, and Tiny Bradshaw during the late 1940s and early '50s.

ABOVE RIGHT: Ex-bandleader Dootsie Williams established Dootone Records in 1951, specializing in jump blues and R&B vocal groups (the Penguins' "Earth Angel" was a 1955 R&B chart-topper). No one sold for him the way comedian Redd Foxx did. Williams had shortened his label's name to Dooto by 1960, when Foxx's mug graced the cover of its catalog.

CHAPTER FOUR

RARE BEAUTY

PREWAR 78 LABELS

"White folks hear the blues come out, but they don't know how it got there."
— "MA" RAINEY

The exquisitely designed labels adorning prewar blues 78s still possess an incredible beauty, even nearly a century after they were first applied to shellac. They have become almost as iconic as the music itself.

THE OVERWHELMING SUCCESS of Mamie Smith's "Crazy Blues" convinced other labels to jump onto the blues bandwagon when it became apparent that there was money to be made. To most of those companies, blues and jazz were just styles of music to be marketed alongside dance bands, country, and ethnic 78s. Some firms segregated their black artists on separately numbered series of releases; others mixed them into their general output.

In 1923, Sylvester Weaver's instrumental "Guitar Blues" brought country blues to the fore as another attractive and less expensive option for recording companies. Many country blues sessions were held in Southern ballrooms, hotel rooms, and other makeshift facilities rather than at the New York and Chicago headquarters of the labels concerned.

Early recording studios were equipped with an "acoustical" recording setup involving a large metal horn that a performer sang or played directly into. The resulting sound waves were transmitted to a glass disc attached to a stylus, which cut the sound into a thick wax disc. Aural quality was limited with such a primitive method of capturing performances for posterity. More powerful performers had to be positioned further away from the recording equipment so they would not overwhelm it.

During the mid-1920s, Columbia and Victor Records began experimenting with a new electrically powered recording process developed by Western Electric utilizing microphones—revolutionizing the sound of 78s. Although Columbia was recording electrically as early as April 1925, neither that label nor Victor announced the switch until the following year. Columbia designated its electrically cut releases as "Viva-tonal Recordings," while Victor dubbed the new development "Orthophonic Recording." Other companies dreamed up their own terminology to let buyers know that they, too, were up to date with the latest technology. OKeh used the "TrueTone Process," Gennett called theirs "New Electrobeam," and Paramount simply labeled their product as "Electrically Recorded."

Among the many blues legends that made their entrance during the 1920s, none were more prolific in years to come than Tampa Red. Born Hudson Woodbridge in Georgia but better known as Hudson Whittaker, Tampa's mastery of slide guitar was influential to a host of bottleneck specialists. He and pianist Georgia Tom Dorsey backed "Ma" Rainey in the studio for Paramount in 1928, the same year dapper Tampa made his Chicago recording debut. Teamed as a duo, Tampa Red and Georgia Tom's bawdy hokum duet "It's Tight Like That" was a national blockbuster that year on Vocalion.

Tampa recorded on a regular basis with Dorsey until the pianist quit blues altogether in 1932 to shape the future of gospel music. Armed with an up-to-the-minute National Tricone resonator guitar that allowed his slide work to shimmer and sparkle (he often doubled on kazoo), Tampa joined Bluebird's roster as a solo artist in 1934. His classics included "Black Angel Blues," "Love with a Feeling," and "It Hurts Me Too." Tampa's South Side home served as an unofficial clubhouse and rehearsal studio for the entirety of Lester Melrose's talent stable.

MORE POWERFUL PERFORMERS HAD TO BE POSITIONED FURTHER AWAY FROM THE RECORDING EQUIPMENT SO THEY WOULD NOT OVERWHELM IT.

Tampa switched to electric guitar at the dawn of the 1940s and adapted beautifully to the developing Chicago ensemble sound in years to come, accompanied by pianists Big Maceo and later Johnny Jones. The guitarist stayed with RCA Victor into 1953 (apart from a moonlighting session for the independent Sabre label earlier that year where he masqueraded as Jimmy Eager), resurfacing on Prestige's Bluesville subsidiary in 1960 after a long recording hiatus. Sadly, the "Guitar Wizard" died broke and largely forgotten in 1981.

There were few classic blues singers who did not benefit from Fletcher Henderson's piano accompaniment during the 1920s if they were based in New York. Some of Bessie Smith's best sides were done with Henderson massaging the ivories. Ditto "Ma" Rainey, Ethel Waters, Rosa Henderson, Clara Smith, and Trixie Smith. But that was only one facet of the incredibly important contributions that the Georgia native made to the jazz and blues lexicons.

Henderson led the top African-American band in New York during the 1920s, recording for nearly every label around. Louis Armstrong left King Oliver's Creole Jazz Band to join Henderson in New York in 1924; other future luminaries to play in his band included Coleman Hawkins, Chu Berry, and Clarence Holiday (Billie's guitar-playing father). Henderson was not the only arranger for his pioneering outfit—Don Redman and Benny Carter shared the load at various times—but his extraordinary vision as an arranger drew up the

OPPOSITE, ABOVE LEFT & TOP MIDDLE: The guitar innovations of New Orleans-born Lonnie Johnson were astonishing. He was as comfortable playing jazz as he was blues and did both at OKeh. Johnson cut a solo vocal, "Low Land Moan," in December 1927. His breathtaking 1928 instrumental "Stompin' 'em along Slow," one of a great many he made throughout his career, was indicative of his highly advanced technique.

LONNIE JOHNSON

Here is the low-down moaner doing big-time blues!

Sings ---

'LOW LAND MOAN'

'I'm So Tired Of Living All Alone'

No. 8677

75¢ OKeh ELECTRIC 75¢
Race Records

OKEH PHONOGRAPH CORP., 25 West 45th St., New York, N.Y.

BOTTOM MIDDLE: Richmond, Indiana-based Gennett Records proudly boasted of its "New Electrobeam" recording process on the label of Blind Richard Yates's April 1927 recording "I'm Gonna Moan My Blues Away." Yates also played kazoo; Louis Hooper was his piano accompanist. After cutting two 78s for Pathé Actuelle the next month under the pseudonym of Uncle Charlie Richards, Yates disappeared for good.

TOP TO BOTTOM RIGHT: "Society Blues" by Ory's Sunshine Orchestra marked the first time an African-American jazz band from New Orleans recorded. Led by trombonist Edward "Kid" Ory, the band recorded three historic 78s for Los Angeles-based Sunshine Records in 1922, owned by John and Reb Spikes. Pianist/bandleader Fletcher Henderson's 1924 Columbia release "The Meanest Kind of Blues" showcased the earthshaking cornet improvisations of Louis Armstrong, just arrived in New York from Chicago. Henderson led New York's top 1920s African-American jazz orchestra. "Someday Sweetheart" was originally on Vocalion in 1926 under the actual name of the band that cut it, King Oliver's Dixie Syncopators. It was simultaneously out under the alias of the Savannah Syncopators on Brunswick, a pseudonym the label also used for Fletcher Henderson and Jimmie Noone.

RARE BEAUTY: PREWAR 78 LABELS

ABOVE LEFT & RIGHT: Pictured in this 1924 photo is ex-vaudevillian Viola McCoy, who recorded under several aliases. She was Gladys Johnson on her 1927 version of Victoria Spivey's "Black Snake Blues" for the obscure Variety label, where she was backed by famous pianist Cliff Jackson and cornetist Horace Holmes.

THE ART OF THE BLUES

blueprint for swing music during the 1930s. Benny Goodman bought many of Henderson's arrangements and in 1939 Fletcher joined Goodman's orchestra as pianist, also serving as staff arranger for a time. Henderson died in 1952 after suffering a debilitating stroke a couple of years earlier.

Blues and jazz artists were selling briskly across the country, but they did not get rich off their hits—no matter how many copies of their records flew off the shelves. In those days, royalties based on sales were rather rare; blues performers usually recorded for a flat fee, and the publishing rights on their compositions ended up the property of their producers and the record companies. Often the writing credits were purloined by the talent scouts who had brought them to the labels. Although not so overt, that practice was still going strong during the 1950s and '60s—another injustice that died hard in the record business.

In those days, 78s could be purchased in a wealth of establishments. Furniture stores, five-and-dimes, and department stores often offered an impressive array of the latest records. Phonograph and musical instrument emporiums were sure to have a sizable selection on hand, although in the early days quite a few places had exclusive agreements with one or two labels rather than carrying them all.

BLUES AND JAZZ ARTISTS WERE SELLING BRISKLY ACROSS THE COUNTRY, BUT THEY DID NOT GET RICH OFF THEIR HITS—NO MATTER HOW MANY COPIES OF THEIR RECORDS FLEW OFF THE SHELVES.

By the late 1930s, some record stores had repositories of old jazz and blues 78s that a new generation of serious collectors would dig through, often in the hope of locating hard-to-find 1920s discs. David Stuart's Jazz Man Record Shop in Hollywood was one of Los Angeles's finest. Not content with retail alone, Jazz Man established its own record label in 1941—dedicated to traditional jazz.

No one could have envisioned the incredible prices that prewar blues 78s change hands for today. In 2013, a Tommy Johnson 78 on Paramount set a new auction record for the highest price paid for a prewar blues platter, fetching a staggering $37,100. Prices in the thousands of dollars have become routine for coveted prewar rarities, testifying to the eternal appeal that these records hold for hardcore collectors. The musicians who created these masterpieces so long ago and received so little remuneration for their brilliance (a great many suffered extremely impoverished lives when their moment in the spotlight dimmed) would no doubt be astonished.

ABOVE LEFT & RIGHT: Built to last, Victoria Spivey debuted on OKeh in 1926 and was still going strong in the 1960s. The Texas native recorded "T-B Blues" in 1927 in her then-home of St. Louis with Lonnie Johnson on guitar and pianist John Erby. "Furniture Man Blues," Spivey's suggestive two-part duet with Johnson, was done the following year in New York.

RARE BEAUTY: PREWAR 78 LABELS

ALL: Hightowers Night Hawks were led by pianist Lottie Hightower, a rare position for a woman back then (her husband, Willie, was the Chicago-based band's cornetist). They had one release in 1927 on J. Mayo Williams's Black Patti Records coupling versions of Richard M. Jones's "Boar Hog Blues" and Fats Waller and Clarence Williams's "Squeeze Me," the latter listed as by Duke Randall and His Boys. Black Patti had an ambitious release schedule, yet they folded before completing a full year of business.

102 THE ART OF THE BLUES

TOP & BOTTOM LEFT: After starting out as a piano roll manufacturer, New York's QRS label began recording jazz and blues (its roster included Earl Hines). George "Chicken" Wilson and Jimmy "Skeeter" Hinton cut "House Snake Blues" for QRS near the end of 1928. Pianist Romeo Nelson tore through "Head Rag Hop" for Vocalion in September 1929. Originally from Tennessee, he moved to Chicago as a child. Nelson only made four sides for Vocalion, every one epitomizing barrelhouse piano mastery.

TOP RIGHT: Self-taught on banjo, Gus Cannon migrated from Mississippi to Memphis. At his first Paramount session in 1927 with Blind Blake on guitar (which was recorded under the alias of Banjo Joe), "Poor Boy, Long Ways from Home" featured Cannon's unique slide banjo. As leader of Cannon's Jug Stompers in 1929, he sang the original "Walk Right In" for Victor. Cannon made a comeback album for Stax in 1963 and was ninety-six years old when he passed away in 1979.

BOTTOM RIGHT: Vocalion kept Tampa Red and Georgia Tom busy in the wake of their 1928 smash "It's Tight Like That." Their 1929 duet "Jelly Whippin' Blues" was typical of their collaborations, full of goodtime vocal harmonies and Tampa's shimmering guitar.

RARE BEAUTY: PREWAR 78 LABELS

THE DIME STORE LABELS

As the Great Depression ravaged the United States, its citizens turned to various forms of entertainment to take their minds off their troubles even though money was scarce. In these difficult times, record sales were down, but American Recording Corporation, known as ARC, rode to the rescue of hard-hit consumers.

A JULY 1929 MERGER of a handful of smaller record companies—Cameo (including Lincoln and Romeo), the US branch of Pathé (including Perfect), Plaza's label group (including Banner and Oriole but not Plaza), and Emerson—was the catalyst for ARC's formation. The company established an extended family of budget imprints that became known as dime store labels because they were sold at various five-and-dime outlets rather than traditional record shops. Like their full-price competitors, the dime store labels covered a wide range of musical styles in their huge catalogs, including blues and jazz.

While some of the company's labels—Banner, Perfect, Melotone—were sold at more than one national chain store, others were tied specifically to a solitary retailer. Conqueror and Challenge, for example, were exclusive to Sears, Roebuck & Co. department stores. Oriole releases could only be purchased at McCrory's dime stores, Romeo 78s were on offer at a similar chain known as S. H. Kress, and Banner was primarily found at S. S. Kresge Company.

Pianist Walter Roland's 1932–35 output could be found on a dizzying array of logos. Roland 78s came out simultaneously on Banner, Melotone, Oriole, Perfect, and Romeo. Big Bill Broonzy, Blind Boy Fuller, Robert Johnson, and many more blues and jazz artists received the same multi-label treatment.

ARC was an ambitious endeavor that hungrily gobbled up other labels. Brunswick and Vocalion were leased to the company in 1931, and once-prestigious Columbia and OKeh were added to ARC's holdings in 1934. Artist pseudonyms were often used by ARC in an attempt to generate more sales by selling the same songs more than once.

ARC WAS AN AMBITIOUS ENDEAVOR THAT HUNGRILY GOBBLED UP OTHER LABELS.

At the end of 1938, the Columbia Broadcasting System purchased ARC, and most of its labels ceased operations except for Conqueror, which remained in business through 1941. Columbia would initially issue the releases of Big Bill, Memphis Minnie, and others on its OKeh subsidiary and then release them on Conqueror. Since they were produced in small quantities and not treated well because of their inexpensive price, a number of blues releases on the dime store logos are coveted by contemporary collectors, who attempt to seek out rare, good-quality versions of these records.

The Depression created a unique situation in the record business that allowed these dime store labels to thrive before prosperity returned. Budget-priced singles would not resurface until the 1950s, well into the rock 'n' roll era.

TOP LEFT: Atlanta guitarist Eugene "Buddy" Moss, a stylistic bridge between Blind Blake and Blind Boy Fuller, was well represented on the dime store labels, including Melotone. Cut in 1933, "Somebody Keeps Calling Me" featured Curley Weaver on second guitar.

BOTTOM LEFT: A member of Lester Melrose's stable, Merline Johnson was suggestively sub-billed as the Yas Yas Girl. After a May 1937 session for Bluebird, Merline moved over to the ARC labels (including Perfect), recording "Jackass for Sale" that October in Chicago.

TOP RIGHT: Although it came out on Vocalion, "Mama Don't Allow No Easy Riders Here," cut in 1929 by Tampa Red's Hokum Jug Band, was also issued on an array of dime store labels, including Romeo, the house brand for S. H. Kress & Co.

BOTTOM RIGHT: Roosevelt Sykes was no slouch in the alias department. The ebullient piano man masqueraded as Willie Kelly, Dobby Bragg, and Easy Papa Johnson for various labels. Sykes cut "Sister Kelly Blues" for Champion in 1936 as St. Louis Johnny.

RARE BEAUTY: PREWAR 78 LABELS

TOP LEFT: "Muddy Creek Blues" was the first record Mary Johnson made for Brunswick in 1929. Already singing in St. Louis during her teens, she married Lonnie Johnson in 1925. They divorced five years later, but Mary's singing career continued.

BOTTOM LEFT: Two 1929–30 releases comprise the sum total of guitarist Willie Harris's Brunswick output; "West Side Blues" was cut in Chicago.

RIGHT: Brunswick's *Chicago Defender* advertisement from April 1929 spotlighted both its blues and jazz roster, the label proudly plugging new releases by Lucille Bogan and Bo Chatman.

106 THE ART OF THE BLUES

TOP & MIDDLE LEFT: Mistaken at one time for both Barbecue Bob and Charlie Lincoln, guitarist Willie Baker did all of his recording in 1929 for Gennett in Richmond, Indiana. "Mamma, Don't Rush Me Blues" was his first release. Georgia Tom traveled to Indiana in February 1930 for a solo Gennett session that included "Maybe It's the Blues," also out on Champion. In March 1932, he recorded his first spirituals for Vocalion as Thomas A. Dorsey.

BOTTOM LEFT & ABOVE RIGHT: Roosevelt Sykes recorded "Black River Blues" at his second session for OKeh in November 1929. The pianist's "Boot That Thing," featured in a *Baltimore Afro-American* ad, was done at his first date for the label that June.

RARE BEAUTY: PREWAR 78 LABELS

107

TOP LEFT: Guitarist Allen Shaw's tenure at Vocalion only lasted a week in 1934. First he backed singer Hattie Hart at her New York sessions before cutting his own "Moanin' the Blues," probably with Memphis Willie Borum on second guitar.

BOTTOM LEFT: Proficient on piano and guitar, William Bunch adopted the sobriquet of Peetie Wheatstraw, sub-billing himself as the "Devil's Son-in-Law." His 1932 recording of "Police Station Blues" first came out on Vocalion and then Conqueror.

TOP & BOTTOM RIGHT: One of the more influential barrelhouse pianists of his time, Charlie Spand commenced recording for Paramount in 1929. Spand cut "Got to Have My Sweetbread" that September, and "Big Fat Mama Blues" a year later in 1930.

108 THE ART OF THE BLUES

ALL: Whether in partnership with her second husband, guitarist Kansas Joe McCoy (pictured here), as she often was on record from 1929 to 1934, or on her own, Memphis Minnie (born Lizzie Douglas) was the most popular female blues guitarist of the prewar era. Minnie and Joe's Decca release "Hole in the Wall" and her solo "Stinging Snake Blues" for Vocalion both date from 1934. The two divorced in 1935, and Minnie recorded prolifically for several labels into the 1950s. She later married guitarist Ernest Lawlars, also known as Little Son Joe.

RARE BEAUTY: PREWAR 78 LABELS

109

PIONEERING PREWAR A&R MEN H. C. SPEIR AND J. B. LONG

In the 1920s heyday of early blues recording, when record sales as well as the quantity of newspaper advertisements rose precipitously, competition between the leading labels for fresh talent ratcheted up.

SOUTHERN BLUESMEN SELDOM had the means to journey up to New York or Chicago and audition for a record company, so labels largely relied on talent scouts who would scour the South in search of unsigned musicians and then dispatch them to the big city for their debut sessions. None was more successful at his chosen task than H. C. Speir.

In 1925, Speir established a music store on North Farish Street in Jackson, Mississippi. Before long, he was on the hunt throughout the South for fresh talent. Speir installed a recording machine in his emporium—it was not of professional quality, but good enough to cut demos on, which he sent off to A&R directors. A list of the blues artists Speir was involved with looks like a who's who of prewar Mississippi blues: Tommy Johnson, Ishmon Bracey, Charley Patton, Son House, Willie Brown, Skip James, among others. Many Speir discoveries ended up on Paramount, but not all.

Though he did not often engage in A&R work himself, Speir produced a marathon session for OKeh in December 1930 at Jackson's King Edward Hotel that included sides by the Mississippi Sheiks, Bo Carter, and Charlie McCoy. However, the Great Depression led to a major decline in recording activities, so Speir diversified into selling used furniture during the mid-1930s. Robert Johnson made a demo at Speir's shop in 1936, but instead of handling the promising young guitarist himself, Speir passed him along to Ernie Oertle, who produced Johnson's debut dates for ARC in San Antonio late that year. British-born Don Law took over the helm for Johnson's 1937 follow-up session in Dallas.

J. B. Long served in a similar talent scout capacity in the Carolinas. While managing a United Dollar Store in Kinston, North Carolina, Long noticed that spinning 78s for shoppers kept them in the store longer. He held a talent contest in 1934 that uncovered Mitchell's Christian Singers—a black spiritual singing group. Long had a keen ear for blues talent, discovering guitar wizards Blind Gary Davis, Blind Boy Fuller, and Brownie McGhee during the prewar era.

OPPOSITE: A natural showman given to playing his guitar behind his head or on his knees, Charley Patton was seminal to the development of Mississippi Delta blues, his gravel-strewn voice full of harrowing intensity. The diminutive Patton, a longtime denizen of Dockery Plantation, was discovered by H. C. Speir and steered to Paramount Records.

TOP LEFT & ABOVE RIGHT: "Pony Blues" came from Charley Patton's first Paramount session in June 1929. The same date also included "Screamin' and Hollerin' the Blues." Patton left Paramount in 1930 and did not record again until his final early 1934 sessions for Vocalion in Grafton, Wisconsin, when he recorded twenty-six titles in three days. He died that April.

MIDDLE & BOTTOM LEFT: J. B. Long brought Piedmont guitarists Blind Gary Davis and Blind Boy Fuller, finger-pickers of the first order, to New York for their first ARC recording sessions in July 1935. Davis mostly cut spirituals, including "O Lord, Search My Heart." Fuller recorded "Ain't It a Crying Shame" at those sessions and subsequently proved a highly influential and extremely popular figure until his passing in 1941.

RARE BEAUTY: PREWAR 78 LABELS

TOP LEFT: Less than two months before he died on April 29, 1935, at age thirty (alcoholism caught up with him), pianist Leroy Carr made his only session for Bluebird after spending the rest of his hugely successful recording career on Vocalion. "Big Four Blues" was the last song he cut with his longtime accompanist Scrapper Blackwell on guitar.

BOTTOM LEFT & ABOVE RIGHT: Arkansas-born slide guitar master Robert Lee McCoy came to Aurora, Illinois, to record for Bluebird and Lester Melrose in 1937; the first song he cut was "Tough Luck." Bumble Bee Slim found his way to Bluebird several times; his "Everybody's Fishin'" dates from a 1935 Chicago session. Bluebird's August 1938 supplement featured both race and hillbilly recordings.

THE ART OF THE BLUES

TOP LEFT: Josh White was a fine North Carolina guitarist with an exceptionally smooth vocal approach who recorded extensively for ARC's labels (including Melotone). Many were credited to Joshua White, but 1935's "Talking about My Time," a vocal duet with Buddy Moss, was marketed under the moniker of Pinewood Tom. White would find fame as a folk-blues artist and actor, appearing on Broadway and singing at President Roosevelt's inauguration in 1941.

BOTTOM LEFT & ABOVE RIGHT: A towering figure in the evolution of Chicago blues, Big Bill Broonzy's guitar and warm, expressive voice first recorded in 1927 and appeared on a variety of labels for the next three decades, including Vocalion for his 1938 recording "Trucking Little Woman No. 2" with Joshua Altheimer on piano. Broonzy made his first European sojourn in 1951, by then performing solo folk-blues, and toured there frequently until his death in 1958.

RARE BEAUTY: PREWAR 78 LABELS

CHAPTER FIVE

WHAT A NIGHT, WHAT A SHOW!

MUSIC AND MOVIE POSTERS

*"People should hear the pure blues—
the blues we used to have when we had no money."*
MUDDY WATERS

With more websites, e-mail messages, and assorted entertainment sources at our command than anyone can possibly absorb in ten lifetimes, publicizing concerts and films is a relative breeze for contemporary press agents. Prior to computers taking over the world, a promoter really had to work hard to spread the word about an upcoming event, nailing posters to walls and telephone poles while fervently hoping that passersby would make a mental note of the stars soon coming to town as well as the venue, date, and time of the big show.

THE EPHEMERAL NATURE of original promotional posters—once the show was over, they were torn down and transformed into instant landfill—has rendered vintage examples extremely rare. The ones that have survived the decades—plugging long-ago concerts and club gigs by blues and R&B artists who have since taken on legendary status—are revelatory gateways into a bygone age when a touring luminary coming to town was a big deal and dressing up for a night of live music was a real treat.

Posters announcing upcoming musical events date back at least as far as the barnstorming minstrel shows of the nineteenth century. Only after the Civil War ended did African-Americans publically engage in minstrelsy. Prior to that, those pageants—a lowdown mix of comedy, music, and dance—were strictly the province of Caucasians who would rub burned cork on their faces to simulate being black and do their best to imitate African-Americans, probably with limited success.

George Primrose and Billy West were one reason the longstanding blackface tradition fell by the wayside. After quitting J. H. Haverly's minstrel company in 1877, the duo formed their own traveling troupe and opted for a comparatively highbrow presentation (ballet and refined orchestrations were incorporated) that phased out some of the cork. By the mid-1890s, Primrose and West ran an integrated troupe. The cakewalking dandies and their ladies decked out in full regalia for one incarnation of Primrose & West's Big Minstrels all appeared to be African-American, even if some may not have been.

A black vaudeville circuit was organized during the 1910s that culminated in the 1920 establishment of the Theater Owners Booking Association (TOBA), encompassing an estimated hundred plus venues up and down the East Coast and at some points in the West. Though the artists themselves wryly claimed TOBA stood for "Tough On Black Asses" due to the rough working conditions; the circuit provided an uncompromising training ground for a host of future luminaries. If a town was not big enough to have a theater where a black troupe could perform, a tent could be erected for the occasion and the show would go on.

Bessie Smith and "Ma" Rainey were among the earliest blues performers whose gigs were promoted via posters during the 1920s. The printing firm they often turned to for their needs was run by Will T. Hatch in Nashville. Among Hatch's longtime primary accounts were two of the top touring black minstrel shows around—F. S. Wolcott's Rabbit Foot Minstrels and Eph Williams and Charles Collier's Silas Green from New Orleans.

Formed around the turn of the century by Pat Chappelle (Wolcott assumed the reins in 1912 after Chappelle's death), the Rabbit Foot Minstrels presented a wide range of talent over the years, from Ida Cox, Jim Jackson, and Butterbeans and Susie to Meade Lux Lewis, Rufus Thomas, and Louis Jordan. Both companies existed into

THE VARIETY FORMAT POPULARIZED BY THOSE TOURING EXTRAVAGANZAS—SINGERS, DANCERS, COMEDIANS, AND A BAND, PRESENTED ONE RIGHT AFTER ANOTHER—ENDURED FOR DECADES.

the late 1950s. The variety format popularized by those touring extravaganzas—singers, dancers, comedians, and a band, presented one right after another—endured for decades. The extraordinarily vibrant posters Hatch churned out for those all-star aggregations reflected the celebratory nature of the shows. These were genuine events, and the artwork expresssed that.

Hatch employed handcarved woodblocks and a massive letterpress printing machine to manufacture its show posters, the likenesses of the headlining stars meticulously carved by its artisans. Multicolor effects were achieved by inking the posters more than once, giving the portraits an almost 3D effect. By the 1950s, traditional promotional photos were used as an integral ingredient of the artwork for many Hatch posters, as country music acts and then rock 'n' rollers (Elvis was a frequent buyer during his ascension to glory) became prime clients for the Nashville firm. Despite many changes of ownership, Hatch is still thriving today.

Baltimore's Globe Poster Printing Corporation, founded in 1929 by Norman Goldstein and Mike Shapiro, developed a look that was every bit as distinctive. Globe also used the letterpress printing method and employed handcarved woodblocks, initially concentrating on publicizing boxing matches, vaudeville shows, and film releases to make its weekly payroll.

From the mid-1950s on, the company developed a flashy look for its concert posters that really set them apart. Combining artist photos with fat, easy-to-read lettering, and (perhaps most importantly) Day-Glo colors that

TOP: W. C. Handy was a pioneer as a composer, bandleader, arranger, and music publisher, and in September 1917, his was reportedly the second jazz orchestra ever to record for Columbia. Handy's Columbia recordings were referenced on this 1920 show poster for his band's appearance at a society dance in Washington, Pennsylvania.

BOTTOM: The pomp and gaiety of a cakewalk competition is highlighted in this poster for George Primrose and Billy West's Big Minstrels show, circa 1896. Primrose and West ran an integrated troupe by the mid-1890s, phasing out the burned cork that white members had rubbed on their faces to simulate being African-American.

WHAT A NIGHT, WHAT A SHOW!: MUSIC & MOVIE POSTERS

seemed to leap right off the placards, Globe's instantly identifiable artwork mirrored the excitement of the music itself. Multi-artist package shows were one of Globe's poster specialties. The company sold most of its holdings to the Maryland Institute College of Art in 2010.

Globe printed up numerous posters on behalf of various stops on the East Coast chitlin' circuit—the famous string of theaters that presented African-American all-star revues on a weekly basis for decades. Chief among them was the Apollo Theater—the mecca on Harlem's 125th Street that began catering to African-American audiences in 1934. The Apollo never failed to present a cross-section of the hottest black acts of the moment, from Sister Rosetta Tharpe and Erskine Hawkins to Sam Cooke and James Brown (the Hardest Working Man in Show Business cut a supercharged live album at the venue in 1962).

Apollo boss Frank Schiffman was not a blues fan, so few performers along those earthy lines played the theater during the 1930s, Lead Belly being a notable exception. However that policy changed later on; Chess Records mainstays Willie Mabon and Little Walter starred at the Apollo during the mid-1950s. After Schiffman's son Bobby took the helm, one mid-1960s bill starred Muddy Waters, Jimmy Reed, T-Bone Walker, and John Lee Hooker. B. B. King was also a regular headliner.

Typical Apollo bills presented a minimum of half a dozen acts and still followed the timeless TOBA format—current hitmakers alternating stage time with veteran comedians and agile tap dancers. Other primary venues on that circuit included the Royal Theater in Baltimore, the Howard in Washington, D.C., and the Earle and Uptown in Philadelphia. Chicago's Regal Theater followed much the same top-shelf entertainment policy a few hundred miles to the west.

Several regional poster companies did standout work during the 1950s. E. J. Warner Poster Company and Murray Poster Printing Company in New York City, Woolever Press in Los Angeles, and Dallas's American Printing and Lithographing printed spectacular posters for blues and R&B shows that were enough to induce temporary blindness with their wild graphics and blazing colors. Indiana's Tribune Showprint Inc. observed a simpler but no less distinctive layout strategy. Specializing in "boxing style" placards perfect for window display or tying to light poles, Tribune often worked with 1950s and '60s blues clubs on Chicago's South and West sides.

Live shows were not the only African-American entertainment choice that called for attractively designed artwork to bring in patrons. The small studios that produced black movies during the 1930s and '40s designed posters of all sizes to hang in the segregated theaters screening them. Often promising "an all-star colored cast" in their occasionally ribald layouts, these posters sometimes looked better than the flicks they promoted.

E. J. WARNER POSTER COMPANY AND MURRAY POSTER PRINTING COMPANY IN NEW YORK CITY, WOOLEVER PRESS IN LOS ANGELES, AND DALLAS'S AMERICAN PRINTING AND LITHOGRAPHING PRINTED SPECTACULAR POSTERS FOR BLUES AND R&B SHOWS THAT WERE ENOUGH TO INDUCE TEMPORARY BLINDNESS WITH THEIR WILD GRAPHICS AND BLAZING COLORS.

ABOVE LEFT: A breathtakingly vibrant full-color poster for the 1929 MGM film *Hallelujah*, director King Vidor's first talkie. Featuring an all-black cast headed by sixteen-year-old Nina Mae McKinney, the movie was set in the segregated South but intended for mainstream consumption, its music was composed by Tin Pan Alley mainstay Irving Berlin.

ABOVE RIGHT: An atmospheric photo from *Hallelujah* that provided the model for the famous image adorning the cover of Victor's 1930 race music catalog. Pictured here is actor Daniel L. Haynes. *Hallelujah* was one of the earliest films with sound to feature an all-African-American cast.

RIGHT: A very stylized and colorful image of Bessie Smith, christened by Sack Amusement Enterprises "Queen of the Blues" rather than "Empress," dominates this poster for her 1929 film short *St. Louis Blues*. Bessie starred and sang the main theme, its choral arrangements partially the work of composer W. C. Handy himself.

WHAT A NIGHT, WHAT A SHOW!: MUSIC & MOVIE POSTERS

ABOVE LEFT: A veteran of Bennie Moten's Kansas City orchestra, Count Basie formed his own swinging big band after Moten's death in 1935. Thanks to the roaring "One O'Clock Jump" and personnel who included saxophonist Lester Young and singer Jimmy Rushing, Basie's orchestra was scorching when they played the Municipal Auditorium in 1939.

ABOVE RIGHT: Quite an all-star lineup invaded Kansas City's Arena Municipal Auditorium on May 30, 1943: the Bill Kenny-led Ink Spots, renowned for their pristine balladry, were joined by bandleader Lucky Millinder and his vocalists, Trevor Bacon and gospel diva Sister Rosetta Tharpe, whose earthy shouts and wild guitar anticipated rock 'n' roll.

OPPOSITE, TOP LEFT: Director Arthur Dreifuss helmed the 1940 drama *Sunday Sinners*, top-billed by none other than Mamie Smith, two decades after she ignited the classic blues movement with "Crazy Blues."

THE ART OF THE BLUES

TOP MIDDLE & RIGHT: All-black film musicals went mainstream in 1943, thanks to two acclaimed major studio productions. *Stormy Weather* starred Lena Horne, a zoot-suited Cab Calloway, hoofer Bill "Bojangles" Robinson, and piano man Fats Waller, while *Cabin in the Sky* featured Ethel Waters and Eddie "Rochester" Anderson, with appearances by Louis Armstrong and Duke Ellington.

BOTTOM RIGHT: Oscar Micheaux was the leading black filmmaker of the first half of the twentieth century. *The Notorious Elinor Lee* was one of his last features in 1940; Fred Palmer's orchestra appeared in the film and this still is from one of its musical scenes.

WHAT A NIGHT, WHAT A SHOW!: MUSIC & MOVIE POSTERS

TILGHMAN PRESS

Charles Francis Tilghman Jr.'s Oakland, California-based Tilghman Press was the leading black-owned printing company on the West Coast for decades, publishing placards for 1930s Bay Area jazz shows and soul and rock concerts three decades after it was first established. But that was only part of his highly successful business model.

BORN MARCH 11, 1897, in San Francisco, Tilghman was a member of a middle-class African-American family who had long been involved in fighting for racial justice (they moved to Oakland from nearby San Francisco in 1904). His mother, Hettie B. Tilghman, did yeoman charity work benefiting African-American women and children in West Oakland and served as president of the California Federated Colored Women's Clubs as well as several other black organizations.

Charles's father gave him a small printing press of his own when he was only ten, and he learned the basics of the trade while attending public school. He entered the business while still in his teens, publishing the *Colored Directory of the Leading Cities of Northern California* in 1916 on a printing press installed in his Oakland home (at that point, he was a one-man operation). Tilghman opened a commercial printing company in 1919 in the heart of the black community that would blossom into one of the largest African-American printing firms in California.

Tilghman Press took on a wide range of jobs over the decades that ranged from advertisements for businesses and social clubs to publishing a handful of African-American newspapers, notably the *Oakland Sunshine* and *San Francisco Sun-Reporter*. Charles was an innovator in his field, developing a typesetting aid that he christened Tilghman's Expandable Hi-Speed Furniture.

TILGHMAN'S POSTER DESIGNS FOR BAY AREA CONCERTS WERE INEVITABLY DISTINCTIVE, WHETHER HE WAS ADVERTISING BOBBY "BLUE" BLAND'S BLUES AND SOUL REVUE OR A PSYCHEDELIC GRATEFUL DEAD SHOW.

Tilghman's poster designs for Bay Area concerts were inevitably distinctive, whether he was advertising Bobby "Blue" Bland's blues and soul revue or a psychedelic Grateful Dead show. After more than half a century as a printer, Tilghman sold off his business in the mid-1970s following the death of his grandson, although his former company retained his name for some time after that. Tilghman died in December 1985.

RIGHT: The Memorial Auditorium in Sacramento, California, must have rocked non-stop on April 4, 1959, when it was invaded by booming blues shouter Nappy Brown (a former North Carolina gospel singer who recorded for Savoy), the wild Los Angeles-based duo Don & Dewey, and New Orleans blues pianist Champion Jack Dupree and his band.

WHAT A NIGHT, WHAT A SHOW!: MUSIC & MOVIE POSTERS

TOP LEFT: Jump blues pioneer Louis Jordan starred in *Beware* in 1946, his first feature with his Tympany Five.

TOP RIGHT: Veteran comic Dewey "Pigmeat" Markham was top-billed in the 1946 film comedy *House-Rent Party*.

LEFT: The King Cole Trio (featuring guitarist Oscar Moore) contributed a number to *Swing in the Saddle*, a 1944 musical western.

124 THE ART OF THE BLUES

ABOVE LEFT: Apollo Theater perennial "Pigmeat" Markham also starred in *Burlesque in Harlem*, a 1949 feature that delivered what it promised: an African-American burlesque show featuring agile dancers and musical performers including jump blues shouter Jo-Jo Adams, who made a series of records in Chicago during the late 1940s and early '50s.

ABOVE RIGHT: Making his first records for Decca in 1934, singing bandleader Myron "Tiny" Bradshaw was a certified headliner. He enjoyed a series of early 1950s jump blues hits for King Records and stayed with the label until his death in 1958. This early 1950s poster also makes note of his band singer, Jesse "Tiny" Kennedy.

WHAT A NIGHT, WHAT A SHOW!: MUSIC & MOVIE POSTERS

TOP LEFT: Alto saxophonist Eddie "Cleanhead" Vinson's bald pate was his trademark. He came out of Houston in the early 1940s to join Cootie Williams's orchestra, where his unusual vocal approach resulted in three hits before he went solo and had some more on his own with his 1947 Mercury sides "Kidney Stew Blues" and "Old Maid Boogie."

BOTTOM LEFT: Southpaw Chicago blues guitarist Otis Rush was promoting his latest sides on the Cobra label during a 1957 Texas tour. This poster, probably the work of Tribune Showprint, left space at the top to write in the name of the club Otis was appearing at. Rush had a hit with his first Cobra release in 1956, the Willie Dixon-penned "I Can't Quit You Baby."

ABOVE RIGHT: The Greek-American Johnny Otis was a successful jump blues bandleader. Talented on drums, piano, and vibes, Otis led a troupe that included teenaged blues singer Little Esther and smooth balladeer Mel Walker. Johnny's revue hit the R&B charts an amazing ten times in 1950, the same year that they starred at Wichita's Kaliko Kat.

126 THE ART OF THE BLUES

ABOVE LEFT: The 1960s folk-blues revival brought many prewar legends out of retirement to do their thing in front of a new college-age audience. This New York City show brought together three Memphis greats: guitarist Furry Lewis, whose late 1920s sides for Vocalion and Victor included several classics, banjo man Gus Cannon, and Memphis Willie Borum.

ABOVE RIGHT: Mellow blues pianist Charles Brown headlined Chattanooga's Silver Moon Club on December 19, 1952, on a tidal wave of hits for Aladdin Records (before that, he had fronted Johnny Moore's Three Blazers). Also on the bill: jump blues newcomers William "Mr. Sad Head" Thurman and Shirley Haven and the orchestra of trumpeter Billy Ford.

WHAT A NIGHT, WHAT A SHOW!: MUSIC & MOVIE POSTERS

BLACK MUSIC IN MOVIES AND TELEVISION

Often filmed on a microscopic budget, independently made black movies were targeted at audiences eager to see people of their own race appearing in features rivaling Hollywood's far better-financed output for thrills and chills, if not production values. Music was a primary ingredient in many African-American features of the 1930s and '40s. Even if a script did not necessarily call for it, a band or singer would be shoehorned into the action.

AS SOON AS sound could be added to film, black performers were positioned in front of the camera. Whistler and His Jug Band pumped out their 1931 Victor recording "Foldin' Bed," and the Eddie Thomas and Carl Scott duo zipped through "My Ohio Home" as early as 1928. Those were informally filmed performances, but professionally made short features for theatrical showings abounded. RKO Pictures filmed Duke Ellington and his Cotton Club Orchestra starring in *Black and Tan* in 1929, the same year Warner Brothers' Vitaphone Varieties captured Monette Moore and the Washboard Serenaders in *Low Down, a Bird's Eye View of Harlem* and Bessie Smith sang the theme to *St. Louis Blues* in her only film appearance.

In the years immediately following World War I, the center of African-American culture in the United States was located in Harlem, which sits in the upper portion of the New York City borough of Manhattan. The self-contained movement would eventually be known as the Harlem Renaissance and extended from the late 1910s into the 1930s. It encompassed authors (including W. E. B. DuBois), playwrights, activists, dancers, and artists of every kind as they mingled, exchanged important ideas, and fought for racial equality without interference or input from the white mainstream.

Jazz musicians were integral to the Harlem Renaissance. Stride pianists Willie "the Lion" Smith and James P. Johnson and bandleaders Fletcher Henderson and Duke Ellington could be found in the clubs lining Lenox Avenue (Harlem's main nightlife strip), where the Savoy Ballroom attracted Lindy Hoppers by the hundreds. The opulent Sugar Hill district, extending from West 145th Street to 155th and from Edgecombe Avenue on the east to Amsterdam Avenue on the west, was full of luxurious homes and deluxe apartment buildings that housed many of the leaders of the Harlem Renaissance.

Harlem came to represent the ultimate in African-American glamor and style, and black filmmakers used it as the location for many of their storylines, whether they were actually filmed there or not. The most serious of melodramas managed to incorporate musical interludes that featured some of Harlem's greatest stars. There were even westerns made for African-American audiences during this period; Herbert Jeffrey, known as "the Bronze Buckaroo," starred in the first black cowboy movie, *Harlem on the Prairie*, in 1937. He would perform for another seven decades and died at the age of one hundred.

African-American performers made steady musical inroads into mainstream films as the decade progressed. Cab Calloway and the Mills Brothers performed memorably in 1932's *The Big Broadcast*, and Ivie Anderson provided a brief respite from the hilarity in the Marx Brothers' *A Day at the Races* (1937). A watershed came in 1943 when the major studios bankrolled the all-black musicals *Stormy Weather* and *Cabin in the Sky*, Count Basie's orchestra graced *Stage Door Canteen*, and *Reveille with Beverly* had room for both Basie and Ellington.

During the war years, visual jukeboxes invaded restaurants and bars. A coin bought a viewing of a soundie—a one-song film that played on a machine called a Panoram. Every genre of music was represented, including a wide range of African-American performers. These mini-movies showcased Johnny Moore's Three Blazers (featuring pianist Charles Brown), Louis Jordan & His Tympany Five, the King Cole Trio, Maurice Rocco, Una Mae Carlisle, and many more, usually abetted by a few scantily clad female dancers.

Renowned as the unofficial mayor of Harlem, ex-bandleader Willie Bryant was the emcee at the Apollo Theater when he handled the same role in the twin 1955 features *Rhythm and Blues Revue* and *Rock 'n' Roll Revue*. They contained amazing live performances by R&B stars Amos Milburn, Ruth Brown, Dinah Washington, and Big Joe Turner interspersed with time-honored chitlin' circuit comedy routines and loose-limbed hoofers. Seamlessly edited in were 1951–52 Snader big band telescriptions disguised as freshly filmed efforts.

The 1956 musical *Rockin' the Blues* was one of the last examples of the filmed black variety show, the accompanying ad copy claimed that it was "exploding with talent." Its cast was headed by mugging comic Mantan Moreland and featured R&B artists Linda Hopkins and the Harptones. There was a fresh blast of black music movies during the early 1970s led by *Wattstax* (with Albert King and Little Milton), *Soul to Soul*, and *Save the Children*, but those slickly produced concert films were a far cry from the primordial days of African-American cinema.

RIGHT: Vaudeville comedian Dusty Fletcher's "Open the Door, Richard" routine had made him famous enough to headline the 1948 musical comedy *Boarding House Blues*. The film had star power galore: bandleader Lucky Millinder, his resident crooner Bull Moose Jackson, pianist Una Mae Carlisle, and the always hilarious Jackie "Moms" Mabley.

WHAT A NIGHT, WHAT A SHOW!: MUSIC & MOVIE POSTERS

CHAPTER SIX

THAT SUNNY ROAD

POSTWAR BLUES 78 LABELS

*"I don't try to just be a blues singer—
I try to be an entertainer. That has kept me going."*
B. B. KING

During the prewar years, a handful of record labels led by full-service Columbia and Victor and their subsidiaries controlled a large proportion of the blues recording industry. That changed once World War II ended and commercial recording resumed. Precious shellac was freed up for 78 manufacturing again—although vinyl soon began to replace it as a primary ingredient in LPs and 45 rpm records.

SMALL BUT FEISTY entrepreneurs with a hunch about what might sell to African-American consumers emerged by the dozens within the industry, often operating on a shoestring as they searched high and low for the song and artist that would ensure their label's future. Some succeeded, a few on an epic scale. The great majority did not. Nevertheless, even the most minuscule independent labels left us irreplaceable blues and R&B sides to fondly remember them by.

Some of the first postwar indie R&B imprints to make their mark on the charts were headquartered in Los Angeles—a new frontier for the record industry. Pianist Cecil Gant, a US Army private, recorded the dreamy blues ballad "I Wonder" for the Gilt-Edge label (he had previously recorded it for Leroy Hurte's even tinier Bronze logo) and it sailed to the top of the race record charts in early 1945. Gilt-Edge anticipated the future on a later pressing of Cecil's smash—a picture disc bearing photos of a grinning Gant in his GI uniform.

Inspired by the success of "I Wonder," brothers Jules, Saul, and Joe Bihari formed Modern Music Records in 1945, soon shortening the name of their enterprise to the simpler Modern. The Los Angeles firm commenced operations with the powerful boogie piano stylings of local chanteuse Hadda Brooks, subsequently recruiting hitmaking guitarists Pee Wee Crayton and John Lee Hooker. A young B. B. King signed with Modern's RPM subsidiary in 1950.

Art Rupe's Specialty Records was another Los Angeles-based winner with a roster featuring jump blues titans Roy Milton and brothers Joe and Jimmy Liggins. Eddie and Leo Mesner's Aladdin logo amassed a star-studded lineup including pianists Amos Milburn and Charles Brown and guitarist Lightnin' Hopkins. Home to New Orleans piano pounder Fats Domino from 1949 on, Lew Chudd's Imperial imprint drew its early R&B roster from local gin joints before finding New Orleans's talent pool equally attractive thanks to the keen ears of its Crescent City A&R man, trumpeter Dave Bartholomew.

A substantial number of postwar labels based in Los Angeles were owned by African-Americans. Leon Rene, a popular local orchestra leader during the 1920s, and his brother Otis, were successful songwriters, and each had an imprint to call his own. Leon's Exclusive logo enjoyed hits in 1945 with Joe Liggins's "The Honeydripper" (another song previously cut for Bronze) and Ivory Joe Hunter's "Blues at Sunrise." Leon would later run the Class label. Otis owned the Excelsior imprint—home of some of the King Cole Trio's earliest releases. Dootsie Williams owned the Dooto label, Jake Porter had Combo, and Jack Lauderdale ran Down Beat and Swing Time— where Ray Charles and Lowell Fulson recorded early hits.

On the East Coast, Herman Lubinsky's Savoy Records was up and running in Newark, New Jersey, by 1942. Its roster was deep in jazz (including bebop classics by Charlie Parker, Fats Navarro, and Dexter Gordon) as well as R&B and blues talent: Brownie McGhee, Johnny Otis

A SUBSTANTIAL NUMBER OF POSTWAR LABELS BASED IN LOS ANGELES WERE OWNED BY AFRICAN-AMERICANS.

and his teenaged discovery Little Esther, and sax honkers Paul "Hucklebuck" Williams and Big Jay McNeely. Linden, New Jersey, was home to David and Jules Braun's Regal and DeLuxe imprints—jump blues shouter Roy Brown and pianist Paul Gayten (with Annie Laurie as his vocalist) registered a batch of late 1940s hits for the firm.

New York's Apollo Records sprang from a Harlem record shop in 1944. It was blessed with gospel diva Mahalia Jackson's lofty eminence, but the other side of the stylistic coin was represented by pianist Champion Jack Dupree, brash shouter Wynonie Harris, and the "5" Royales—whose early 1950s rockers betrayed their sanctified roots. Ahmet Ertegun and former National Records A&R man Herb Abramson got their Atlantic label rolling on a nurturing diet of jazz and blues, gaining traction in 1949 due to "Drinkin' Wine, Spo-Dee-O-Dee" by guitarist "Stick" McGhee (Brownie's younger brother). They went on to have an avalanche of smashes by booming vocalist Big Joe Turner and the incomparable Ruth Brown, indeed the latter had so many that the label became known as "the House That Ruth Built."

Syd Nathan set up King Records in a Cincinnati factory building large enough to manufacture recordings from start to finish. Nathan installed a recording studio, mastered and pressed King's records, and had album jackets designed and printed all under that one expansive roof. From its 1943 inception, King grew into one of the leading postwar independent labels—an equally potent force in country and western and R&B. Horn-fueled jump blues was a King strength with huge-voiced Wynonie Harris, Roy Brown, Tiny Bradshaw, Eddie "Cleanhead"

ALL: Aaron "T-Bone" Walker was the father of electric blues guitar, profoundly influential to an army of disciples from B. B. King to Chuck Berry and up to the present day. The Texan played acoustic guitar on his first record in 1929 for Columbia as Oak Cliff T-Bone, but he had switched to electric by 1945, when he cut "Sail on Boogie" for Rhumboogie and "She Is Going to Ruin Me," belatedly released in 1949 on Old Swing-Master.

THAT SUNNY ROAD: POSTWAR BLUES 78 LABELS

ABOVE: Marion Post Wolcott's 1941 photo of a general store, juke joint, and living quarters for migratory laborers near Canal Point, Florida.

Vinson, and Bull Moose Jackson. Nathan established his Federal subsidiary in 1950, Billy Ward's Dominoes registering a 1951 blockbuster with their ribald "Sixty Minute Man." James Brown with the Famous Flames pleaded "Please, Please, Please" on Federal in 1956, and blues guitar powerhouse Freddy King registered no fewer than seven chart hits there in 1961.

Down in Houston, nightclub owner Don Robey founded Peacock Records in 1949 to showcase his protégé, fleet-fingered blues guitarist Clarence "Gatemouth" Brown, though Peacock's biggest seller was Big Mama Thornton's growling original version of "Hound Dog." When he founded Duke Records in Memphis in 1952, WDIA radio program director David James Mattis drew up his label's purple-on-yellow logo himself with a drafting kit—envisioning the grille of a Cadillac with its sleek headlights and V design. Mattis had Bobby "Blue" Bland and Johnny Ace under contract when Robey bought him out the next year and made Bland into a blues luminary of the first order.

Lillian McMurry's Jackson, Mississippi-based Trumpet label released the first recordings of harpist Sonny Boy Williamson (a.k.a. Rice Miller) and slide guitar great Elmore James. Ernie Young already had his Ernie's Record Mart operating in Nashville when he started Excello Records in 1952. The store advertised extensively over 50,000-watt WLAC, as did Young's competitor Randy Wood of Randy's Record Shop; Wood also had his own successful label, Dot Records. Excello produced much of its blues output in Nashville, but its "swamp blues" sides by Lightnin' Slim, Slim Harpo, and Lazy Lester were recorded in Crowley, Louisiana, by producer J. D. Miller.

Thanks to its Million Dollar Quartet of gilt-edged rockabillies—Elvis Presley, Johnny Cash, Carl Perkins,

RURAL SOUTHERN JUKE JOINTS WERE NOT THE ONLY PLACE TO SOAK UP LIVE BLUES. THE PULSATING MUSIC COULD BE HEARD SWIRLING DOWN GLITTERING BEALE STREET IN MEMPHIS AND INSIDE NEW ORLEANS'S DEW DROP INN ON A NIGHTLY BASIS.

and Jerry Lee Lewis—Memphis-based Sun Records is surely the most famous 1950s indie label of all. Yet founder Sam Phillips went into business in 1952 to release blues tunes. Sun hosted Southern bluesmen Little Junior Parker, Rufus Thomas, Joe Hill Louis, Doctor Ross, and Billy "the Kid" Emerson before Sam decided Elvis and his rocking ilk were the future.

The smaller seven-inch 45 rpm record gradually killed off 78s over the course of the 1950s, and by the end of the

decade the format was all but history. The beauty of postwar 78 labels remains undimmed by the half-century plus since they rolled out of the nation's pressing plants, ready to take jukeboxes by storm.

In reality, records were not how postwar blues and R&B artists made what money they managed to earn. Touring was a reasonably lucrative proposition for stars with a hit record or two under their belts, but the majority of performers stuck close to home, focusing on local engagements. Fortunately, more bars and nightclubs than ever before welcomed blues singers onto their bandstands. Rural Southern juke joints were not the only place to soak up live blues. The pulsating music could be heard swirling down glittering Beale Street in Memphis and inside New Orleans's Dew Drop Inn on a nightly basis.

In postwar Los Angeles, the Central Avenue strip boasted more incredible talent per square foot than any other thoroughfare in America. Jazz and R&B intermingled up and down Central Avenue, providing an irresistible soundtrack to landmarks including the Club Alabam, Jack's Basket Room, and Elks Hall. Johnny Otis, who would head his own Dig label in the mid-1950s, co-owned the Barrelhouse in nearby Watts, where weekly amateur contests turned up some important discoveries.

Chicago's nightlife circuit jumped just as hard, though it was spread over a wider area. You could take in a full floor show at the classy Club DeLisa on the city's South Side, complete with drummer Red Saunders's mighty orchestra and a leggy chorus line, or opt for something a bit grittier and down-home—Muddy Waters's peerless aggregation at the Club Zanzibar on the near West Side or tough little combos sweating on the bandstands at the 708 Club, Smitty's Lounge, and Sylvio's. Electric blues broke out all over postwar Chicago, amplified to the nines and snarling like a ravenous tiger.

ABOVE LEFT: In demand for decades as one of the most reliable pianists on the postwar Los Angeles scene, J. D. Nicholson was born in Louisiana but migrated to the West Coast and made his first recordings as a band leader in 1948. During the 1950s, he cut occasional singles of his own but specialized in session work.

ABOVE RIGHT: His career going back to the late 1920s, alto saxophonist Pete Brown was a busy session man during the 1930s, recording with Jimmie Noone and many others and making his own sides from 1939. A regular on New York's 52nd Street scene, he headed a sextet on his 1945 Savoy single "Midnite Blues."

THAT SUNNY ROAD: POSTWAR BLUES 78 LABELS

ALL: DeLuxe Records was founded in 1944 in Linden, New Jersey. Discovered in Baltimore, the Four Blues recorded both secular and sanctified group harmony for DeLuxe. The self-contained unit's "swing spiritual," "I Couldn't Hear Nobody Pray" was curiously paired in 1945 with a jazz number by Billy Eckstine's orchestra.

136 THE ART OF THE BLUES

TOP & BOTTOM LEFT: DeLuxe got lucky when searching for young talent in New Orleans. Singer Roy Brown wrote and recorded "Good Rockin' Tonight" in 1947, the first of his many DeLuxe hits (he specialized in rollicking fare that anticipated rock 'n' roll). "New Rebecca," cut in Cincinnati in 1950, was the flip side of his smash "Hard Luck Blues."

ABOVE RIGHT: Another of DeLuxe's Crescent City discoveries was Annie Laurie, who sang with pianist Paul Gayten's combo. Their 1947 revival of "Since I Fell for You" was a major hit. The Atlanta native resurfaced without Gayten in 1957 to enjoy another strong seller for DeLuxe, "It Hurts to Be in Love."

THAT SUNNY ROAD: POSTWAR BLUES 78 LABELS

ROY MILTON RECORD COMPANY AND THE MILTONE LABEL

No postwar label specializing in jump blues equaled Miltone Records and its predecessor, Roy Milton Record Company, for innovative illustrations on its 78s. Thanks to William "Alex" Alexander's sly, humorous cartoons—gracing each unique pressing on the majority of both labels' releases—the two small Los Angeles indies occupy a special place in collectors' hearts.

BANDLEADER ROY MILTON named his venture into the record business in 1946 after himself. Milton was born July 31, 1907, in Wynnewood, Oklahoma, and spent some of his youth in Tulsa, Oklahoma. He sang with Ernie Fields's band and took up drums one evening when Fields's regular player was arrested. He never left the kit, becoming one of the few singing drummers in the genre. However, Milton did leave Fields and moved to Los Angeles around 1935, eventually developing a small combo he called the Solid Senders, anchored by pianist Camille Howard. They recorded for Lionel Hampton's Hamp-Tone label in 1945, but it was two songs he recorded for the Juke Box label that made Milton a star. The mid-tempo "R.M. Blues" and a jumping "Milton's Boogie" were 1946 smashes, their buzzing saxes and steady beat marking out Milton as a genuine R&B pioneer.

That same year, Milton took recording matters into his own hands, partnering with record presser Forrest "War" Perkins and artist manager Ben Waller to establish Roy Milton Record Company in 1946. African-American cartoonist William "Alex" Alexander's unique artwork was front and center on most of Roy's self-named label 78s (many of which were by Milton) as well as those of its successor Miltone, which came into existence in 1947.

Other artists were Miltone's primary focus, since Roy had by then settled in for a long run at Art Rupe's Specialty Records. Urban blues singers Jimmy Grissom, Effie Smith, and Little Miss Cornshucks were signed to Miltone, as were country blues guitarists Wright Holmes and Jesse Thomas. Alexander's exquisitely drawn vignettes, full of suited hep cats and red-hot mamas, vividly summarized each song in cartoon form, and were signed or initialed with his distinctive scrawl. Great as they looked, what was in the grooves did not inspire widespread sales or much chart action. Miltone sold its masters to Ivin Ballen's Gotham Records in 1950, and the label disappeared.

ABOVE: A tiny photo of Roy Milton decorated his 1946 rendition of "I'll Always Be in Love with You" for his self-named record company. The singing drummer used this Los Angeles-based label exclusively for his own releases with his band, the Solid Senders, featuring pianist Camille Howard.

ALEXANDER'S EXQUISITELY DRAWN VIGNETTES, FULL OF SUITED HEP CATS AND RED-HOT MAMAS, VIVIDLY SUMMARIZED EACH SONG IN CARTOON FORM, AND WERE SIGNED OR INITIALED WITH HIS DISTINCTIVE SCRAWL.

Milton posted seventeen R&B chart entries on Specialty stretching into 1953, he and the Solid Senders ranking as one of the hottest R&B combos of the pre-rock 'n' roll era, before the band moved onto the Dootone and King labels midway through the decade.

ALL: The majority of Miltone Records' 1947–48 releases featured the artwork of William Alexander. Milton was still on the label, recording "Grooving with Joe," joined by Paul Jones ("No Good Woman"), Jimmie Grissom ("Ice Cold Love"), and trumpeter Walter Fuller, a former member of Earl Hines's orchestra who settled in San Diego in 1944 and made the Club Royal his homebase.

THAT SUNNY ROAD: POSTWAR BLUES 78 LABELS

ABOVE LEFT & BOTTOM RIGHT: Pictured here in the late 1940s, St. Louis pianist Walter Davis recorded "I Would Hate to Hate You" for Bullet in 1949 with guitarist Henry Townsend. Davis's plaintive vocals, imaginative songwriting, and instantly recognizable piano were so popular that he cut nearly 200 sides. He made his last session for RCA Victor in 1952.

TOP RIGHT: From 1948, Lowell Fulson's "Western Union Blues" on Swing Time featured the guitarist with only his brother Martin on second guitar rather than fronting the small bands he usually favored in the studio. Fulson's concise guitar style and expressive vocals remained popular as he spent from 1954 to 1963 on the Checker label, and enjoyed a 1967 hit with "Tramp" for Kent.

MIDDLE RIGHT: Atlanta guitarist Curley Weaver's recording career commenced in 1928 on Columbia. Recording for ARC at the height of the Great Depression, the sympathetic accompanist made a series of masterful sides with guitarists Blind Willie McTell and Fred McMullen. He reemerged in 1949 with "My Baby's Gone" for Sittin' in With.

OPPOSITE, TOP TO BOTTOM LEFT: Before he cut "The Bible's Being Fulfilled Every Day" for Aristocrat in 1949, Rev. Gatemouth Moore was a popular blues singer. Blues shouter Big Joe Turner recorded "Adam Bit the Apple" in 1949 for Houston's Freedom label, which also delved into gospel with Rev. Frank M. Johnson. Pianist Todd Rhodes was a Detroit staple, Sensation issuing his 1949 rendition of "Teardrops."

OPPOSITE, TOP & BOTTOM RIGHT: The Soul Stirrers' Robert H. Harris led his group away from the old-fashioned jubilee style of singing spirituals toward a hard gospel approach that revolutionized African-American sanctified music. Harris's lead tenor soared on "My Life Is in His Hands," cut in 1948 in Chicago for Aladdin. This photograph of them was taken at the Chicago studios of Maurice Seymour, actually run by two brothers, Maurice and Seymour Zeldman.

THE ART OF THE BLUES

THAT SUNNY ROAD: POSTWAR BLUES 78 LABELS

TOP & BOTTOM LEFT: The massive legacy of blues shouter Jimmy Witherspoon included a wealth of sides for Modern, including 1948's "Pinocchio Blues." Guitarist Pee Wee Crayton and pianist Little Willie Littlefield each hailed from Texas and recorded late 1940s hits separately for Modern in Los Angeles.

TOP & BOTTOM RIGHT: Modern Records was one of the top indie labels to emerge on the postwar Los Angeles scene. Its 1952 catalog made it clear that its specialty was rhythm and blues. The firm also recruited an impressive contingent of down-home blues guitarists, including Little Son Jackson, who cut "Talkin' Boogie" in Houston in 1950.

142 THE ART OF THE BLUES

TOP LEFT & RIGHT: Amos Easton adopted the alias of Bumble Bee Slim from his first Paramount recordings in 1931. A gifted songwriter, he moved freely between Vocalion, Bluebird, and Decca during the prewar years, recording extensively for all three. His 1951 Specialty single "Strange Angel" was his first postwar release with an R&B band.

BOTTOM LEFT & RIGHT: West Coast blues singer Jimmy Wilson made some of his best sides for the Big Town label, notably his 1953 version of Curtis Jones's "Tin Pan Alley," which became the most influential recording of the song. Equally conversant on tenor and baritone sax, Big Jim Wynn stayed busy in postwar Los Angeles, recording as a leader for a variety of independent labels and backing T-Bone Walker in the studio.

THAT SUNNY ROAD: POSTWAR BLUES 78 LABELS

CHICAGO'S BLUES LABELS

An unequaled talent lineup of Muddy Waters, Howlin' Wolf, Jimmy Rogers, harmonica genius Little Walter, and visionary guitarist Bo Diddley ensured Chess Records' long and prosperous reign as Chicago's top postwar blues label. Chicago itself became synonymous with the blues during this period and remains so to this day.

LEONARD CHESS AND HIS BROTHER PHIL were Polish immigrants who arrived in the United States in 1928. They opened the Macomba Lounge, a Chicago South Side nightspot with live entertainment, in 1946. Leonard also wanted to get into the music business and became involved with Aristocrat Records the following year. Pianist Sunnyland Slim introduced Leonard to his first great discovery in the fall of 1947 when he invited Muddy Waters to play on his debut Aristocrat session. At their next shared date in April 1948, Waters unveiled his slide guitar work for the first time on "I Can't Be Satisfied"—instantly defining his trademark sound. Leonard and Phil were out of the bar business by the time they launched their self-named Chess label in 1950. Its sister logo, Checker Records, was born in 1952. Chess was later described as "America's greatest blues label."

During the mid-1940s, a wealth of young talent flooded Chicago from the same Southern regions as the old guard—Tampa Red, Big Bill Broonzy, Memphis Minnie—and their brand of blues fell out of favor. Lester Melrose, the leading blues producer in town, had also fallen behind the times. He could have secured Muddy Waters from the outset; Melrose produced a 1946 debut session of Waters and fellow guitarist Johnny Shines for Columbia, but thought it too down-home and shelved the recordings.

Melrose may not have been interested in the newcomers, but the veteran musicians themselves were quick to lend a hand, initially hiring them as sidemen and later featuring them on their recording sessions. Especially helpful was harmonica innovator John Lee "Sonny Boy" Williamson, still a very popular artist, who hired Waters as a sideman and assisted many up and comers including a teenaged Little Walter. Unfortunately, that encouragement ended abruptly when Williamson was tragically murdered by robbers while he was walking home from a South Side gig on June 1, 1948. He was only thirty-four.

Many young bluesmen gravitated to Maxwell Street, Chicago's fabled open-air market. Live blues provided a highly atmospheric soundtrack while vendors of every stripe hawked their merchandise. Bernard Abrams's Maxwell Radio Record Company was located in the heart of the bustling strip. Abrams installed a disc cutter in his store so musicians could cut amateur recordings, leading to a brief plunge into the record business in 1947. Abrams's Ora Nelle label put out two historic releases, the first marking the debut of Little Walter and the other showcasing mandolinist Johnny "Man" Young. Ora Nelle 78s were basically only available for sale at Abrams's little store, so his label did not last long enough to release the sides Abrams cut of Jimmy Rogers, Johnnie Temple, and Sleepy John Estes.

Particularly notable about Chicago's spate of postwar start-up labels was how many were owned by African-Americans. This was not a new development; indeed J. Mayo Williams had founded his short-lived Black Patti label there in 1927 and continued in the business after World War II, launching his own Ebony Records in the city. Chicago record store owner Chester Scales ran the Marvel and Planet labels during the late 1940s; like Ora Nelle, his minuscule enterprises issued a handful of landmark 78s by the duo of Snooky Pryor and Moody Jones as well as Moody's cousin, Floyd Jones. In addition to being the top-rated African-

ABOVE: No Chicago blues band hit harder than that of Muddy Waters, whose tight ensemble approach provided the indelible blueprint for the city's postwar blues sound. Many of Muddy's early Aristocrat and Chess sides prominently featured his unique slide guitar as well as the spectacular harmonica of Little Walter, by far the most innovative harpist of the era. This early 1950s photograph of his band shows (left to right) Muddy Waters, unknown, pianist Otis Spann, harpist Henry Strong, drummer Elgin Evans, and fellow Chess guitarist Jimmy Rogers. Rogers and Spann became blues stars in their own right.

144 THE ART OF THE BLUES

American disc jockey in Chicago (he spun blues daily on WGES), pioneering radio host Al Benson found time to operate a series of labels beginning with his involvement with Old Swing-Master (his on-air nickname) and then his own prolific Parrot and Blue Lake labels.

LIVE BLUES PROVIDED A HIGHLY ATMOSPHERIC SOUNDTRACK WHILE VENDORS OF EVERY STRIPE HAWKED THEIR MERCHANDISE.

The single greatest local rival to Chess's supremacy was also African-American-owned. Vivian Carter and Jimmy Bracken's Vee-Jay Records originally opened its offices in Gary, Indiana, in 1953 but soon relocated to Chicago's South Side, where Chess was situated. Vee-Jay's best-selling artist during its early years was laconic harp blower Jimmy Reed (its first blues signing), who racked up a slew of hits from 1955 to 1961.

The popularity of B. B. King began to influence Chicago blues during the mid-1950s when a fresh group of young lead guitarists, led by Jody Williams, Otis Rush, and Magic Sam, altered the ensemble approach that had long defined the city's signature sound. With bassist Willie Dixon (on temporary hiatus from Chess) providing material and A&R expertise, Cobra Records—established in 1956 on the West Side by Eli Toscano and Howard Bedno—gave Otis and Sam their first recording contracts. In 1958, the label added another hot newcomer, Buddy Guy, who would eventually achieve massive blues stardom that endures to this day.

With such a rich and varied musical history encompassing nearly a century of recorded African-American music, it is no wonder that Chicago is known worldwide as the home of the blues.

ABOVE LEFT: Snooky Pryor (one of the earliest Chicago bluesmen to amplify his instrument) and guitarist Moody Jones backed singer/guitarist Floyd Jones on the 1948 classic "Stockyard Blues," released on the Old Swing-Master label. Renowned for his boogie tempos and penchant for showmanship, Chicago guitarist J. B. Lenoir's "Man Watch Your Woman" was out on Parrot in 1955. Several of Lenoir's compositions were political in nature, especially during the civil rights era.

ABOVE RIGHT: Guitarist Robert Lee McCoy had changed his stage billing to Robert Nighthawk and gone electric by the time he made "Annie Lee Blues" for Aristocrat in 1949, which was released under the Nighthawks moniker. The 1957 single "Little Girl" was the only Cobra release by harmonica ace Little Willie Foster, a native of Clarksdale, Mississippi, who had made his first recording, "Falling Rain Blues," for Blue Lake in 1953.

ALL: Clarence "Gatemouth" Brown's guitar style often displayed equal blues and jazz influences. The Texas multi-instrumentalist began recording in 1947 and was still going strong into the 2000s. His Peacock labelmates included the Spirit of Memphis, a gospel group that included Willmer "Little Axe" Broadnax and Silas Steele on 1953's "Since Jesus Came into My Heart," and Atlanta blues shouter Billy Wright, a major influence on Little Richard who cut "Bad Luck, Heartaches and Trouble" in 1955.

146

THE ART OF THE BLUES

ABOVE: In 1959, Belgian blues fan George Adins photographed Elmore James and his longtime bandmate, saxophonist J. T. Brown, performing at a Chicago tavern. James played guitar on Brown's "Sax-Ony Boogie" in 1952 for the Meteor label.

LEFT: Chicago guitarist Jody Williams was a modernist who played with Bo Diddley, soloing memorably on Bo's "Who Do You Love." He was only twenty years old when he cut "Easy Lovin'" as his first single for Blue Lake in 1955 under the alias of Little Papa Joe.

THAT SUNNY ROAD: POSTWAR BLUES 78 LABELS

CHAPTER SEVEN

THE BLUES ROLL ON

ALBUM COVERS PART 1

"I wanna show that gospel, country, blues, rhythm and blues, jazz, rock 'n' roll are all just really one thing. Those are the American music and that is the American culture."

ETTA JAMES

To many people it is a mystery why record albums are called albums when they consist of a solitary twelve-inch microgroove disc housed in a simple cardboard sleeve, rather than several discs as the term obviously implies. The answer is that they did not start out that way. Early in the medium's lifespan, an album really was an album.

RECORD COMPANIES INTRODUCED 78 rpm discs in the first decade of the twentieth century, and they would remain the industry norm into the 1950s. The diameter of those records varied: while most discs measured either ten or twelve inches in circumference, there were also seven-inch and sixteen-inch varieties (the latter were most often used for radio transcriptions and classical fare).

Columbia Records art director Alex Steinweiss created the first illustrated 78 rpm album package in 1939 for a collection showcasing the compositions of Richard Rodgers and Lorenz Hart. Steinweiss proceeded to render gorgeous illustrations for early 1940s collections by jazz bassist John Kirby and pianist Teddy Wilson with vocalist Billie Holiday. Steinweiss brought Jim Flora on board in 1942 to take over art design duties for Columbia's jazz product. As the decade progressed, Flora drew whimsical, brightly colored characters that adorned 78 rpm collections by Louis Armstrong and Sidney Bechet.

Labels began widely marketing 78s in classy-looking binders housing three or four separately sleeved discs. Artwork was situated on the front of the package, which sometimes included a separate inserted booklet containing liner notes that were often reasonably in-depth. Consumers with a few extra bucks in their pockets could thus purchase as many as eight songs by the same artist or stylistically related musicians in one attractive album. These collections also looked great on a shelf or coffee table and kept the 78s safe and organized to boot. The term would stick around long after the format itself faded out.

During the 1940s, labels lucky enough to control sizable back catalogs plumbed their 1920s and '30s archives to compile what amounted to early greatest hits collections of 78s. Columbia curated a series of collections memorializing Bessie Smith. Classic sides by Louis Armstrong and Duke Ellington were dusted off and reassembled in 78 rpm album form. Victor reissued the work of McKinney's Cotton Pickers under a *Hot Jazz* banner. Brunswick put compilations together on Jimmie Noone's Apex Club Orchestra as well as a *Boogie Woogie Piano* set featuring one 78 apiece by prewar blues greats Montana Taylor, Speckled Red, Romeo Nelson, and Cow Cow Davenport.

The playing field changed in 1948 when Columbia officially introduced 33⅓ rpm long-playing discs, also referred to from the outset as albums. At first, the preferred circumference was ten inches, the same as standard-issue 78s. The new vinyl format would soon dispatch the bulky book-style 78 rpm album package to oblivion, though not every major label was eager to hop onto the microgroove bandwagon.

CONSUMERS WITH A FEW EXTRA BUCKS IN THEIR POCKETS COULD THUS PURCHASE AS MANY AS EIGHT SONGS BY THE SAME ARTIST OR STYLISTICALLY RELATED MUSICIANS IN ONE ATTRACTIVE ALBUM THAT LOOKED GREAT ON A SHELF OR COFFEE TABLE AND KEPT THE 78S SAFE AND ORGANIZED TO BOOT.

RCA in particular was not convinced of the 33⅓ rpm album's potential, stubbornly opting instead to bring forth new seven-inch pressings that spun at 45 rpm and held one song on each side. RCA finally relented and started releasing 33⅓ rpm product in early 1950 after fellow major labels Capitol and Decca commenced pressing LPs, though 45s would prove every bit as popular and durable a format in years to come.

Eye-catching artwork would become an essential component of album sales. Ten-inch LPs generally held eight songs, four to a side—the same number of selections that 78 rpm album sets had previously offered. The major labels pressed up a slew of ten-inchers in every conceivable musical genre, though blues and related styles were a fairly low priority on their release slates. Fortunately, a new crop of independent companies emerged following World War II to serve African-American record buyers hankering to buy rhythm and blues recordings as the idiom's popularity exploded. Those enterprising entrepreneurs cautiously found their way into the album field after concentrating primarily on scoring hit singles at first.

Atlantic, Aladdin, King/Federal, and a host of other indie R&B firms assembled ten-inch LPs that sported bright artwork, sometimes bordering on the garish. During the mid-1950s, the ten-inch format died off almost overnight, replaced by more expansive twelve-inch

TOP: Stride piano virtuoso Thomas "Fats" Waller was the complete entertainer. He composed the jazz standards "Ain't Misbehavin'" and "Honeysuckle Rose." From 1944, this posthumous RCA Victor 78 rpm album included both hits, along with Waller's immortal "Your Feet's Too Big" and "The Joint Is Jumpin'."

BOTTOM: Alex Steinweiss designed the artwork for Columbia's 1941 collection *Boogie Woogie*, released at the height of the boogie-woogie craze. The four-record set featured pioneering boogie pianists Albert Ammons, Meade Lux Lewis, and Pete Johnson as well as shouter Big Joe Turner and Count Basie with Jimmy Rushing.

THE BLUES ROLL ON: ALBUM COVERS, PART 1

records that reigned supreme for decades until the CD rose to power. The extra circumference meant that each side of a 33⅓ rpm LP held five or six songs. The roomier covers allowed art directors for labels both large and small a more expansive canvas to work their visual magic upon. Work it they did, creating a great deal of genuine art in the service of musical commerce.

Many labels did not bother to place designer or photographer credits on their releases during the 1950s, but certain names did tend to pop up on a recurring basis. Whether they were properly credited or not, the covers those talented artists created went a long way towards giving R&B and its unkempt offspring rock 'n' roll a look as daring and cutting-edge as the sound of the music that resided within their jackets.

At Atlantic Records in New York, Marvin Israel created classy LP designs that expertly alternated color, space, and artist photos in visually pleasing ways. Chicago's Chess Records brought in *Playboy* magazine photographer Don Bronstein to handle the layouts on the majority of their blues, rock 'n' roll, and jazz releases.

The seven-inch 45 rpm format spawned what was known as the EP—short for "extended play." There were two songs on each side of these generously programed 45s, giving consumers twice the music for a slightly higher list price. They came housed in a secure cardboard cover that looked exactly like a miniature LP. Sometimes EPs were nothing more than an album divided into three equal installments, their graphics clearly adapted from their original source. Others were unique releases in their own right. They often sported their share of gorgeous artwork, shrunk down for the smaller format.

Since blues in its purest form was more like folk music than a commercial entity, indie labels such as Folkways that concentrated on that genre and its offshoots sometimes used stark, striking black-and-white photos for their covers. Folkways was also in the vanguard of compiling 1920s masters in new 33⅓ rpm packages, which introduced prewar classics to a fresh generation of listeners. Over in Great Britain, blues albums that were comprised of vintage US masters repackaged for a new demographic often featured evocative drawings that sometimes had very little to do with their down-home contents, yet possessed considerable artistic charm.

ABOVE LEFT & RIGHT: The boogie piano of Hadda Brooks was the catalyst for the formation of Modern Records in Los Angeles, the label compiling an album of her popular 78s. Columbia cover designer Jim Flora's colorful artistic sense was showcased on 78 albums by Louis Armstrong's Hot Five and this 1947 collection by New Orleans trombonist Edward "Kid" Ory, a key figure in the early development of jazz.

THE ROOMIER COVERS ALLOWED ART DIRECTORS AT LABELS BOTH LARGE AND SMALL A MORE EXPANSIVE CANVAS TO WORK THEIR VISUAL MAGIC UPON. WORK IT THEY DID, CREATING A GREAT DEAL OF GENUINE ART IN THE SERVICE OF MUSICAL COMMERCE.

By the end of the 1950s, album cover artwork had matured greatly. Beautiful full-color photos had become the norm for blues artists as well as for related genres. These music pioneers had achieved first-class treatment worthy of their music.

ABOVE: Verve Records hired Chicago-born artist David Stone Martin to design many of its LP covers, including this one by alto sax genius Charlie Parker featuring 1953 recordings. The bebop pioneer's Kansas City-bred style was very blues-oriented; he initially emerged in pianist Jay McShann's Kansas City orchestra in 1938.

THE BLUES ROLL ON: ALBUM COVERS, PART 1

ABOVE: Dinah Washington tackled Bessie Smith's songbook on this 1958 album for Mercury's EmArcy imprint. Dinah joined Lionel Hampton's orchestra at the end of 1942 and stayed with him into 1945, when she went on her own. Dinah joined Mercury Records the next year and was known as the Queen of the Jukeboxes for her twenty years of hits.

OPPOSITE, TOP LEFT: Veteran bandleader Tiny Bradshaw specialized in hard-swinging jump blues at King Records, with Tiny usually handling his own vocals. The label went heavy on Bradshaw's instrumental output when it assembled this 1956 long-playing collection from his early 1950s masters.

OPPOSITE, BOTTOM LEFT: When rock 'n' roll first swept the nation during the mid-1950s, labels of every size scoured their vaults for vintage masters to repackage under the new banner. This ten-inch Allegro Elite LP combined five-year-old sides from the Derby label by a pair of veteran bandleaders—trumpeter Cootie Williams and saxophonist Jimmy Preston.

OPPOSITE, TOP & BOTTOM RIGHT: Rock 'n' roll fans couldn't get enough Chuck Berry during the guitarist's golden decade on Chess. 1957's *After School Session*, a four-song 45 rpm EP, was followed by *Rock and Roll Music* in 1958. As a witty tunesmith and foremost creator of the rock 'n' roll guitar style, Berry's reign has endured more than six decades.

THE ART OF THE BLUES

THE BLUES ROLL ON: ALBUM COVERS, PART 1

155

BLUES FIELD RESEARCHERS

The blues world remains indebted to a number of individuals who dedicated themselves to tracking down the original blues pioneers and taking the time to record their music and stories to be heard by generations to come. Through the work of these field researchers, we have reached a deeper understanding of the origins of the blues.

THE INTREPID A&R men H. C. Speir and J. B. Long did yeoman work in locating unheard blues talent during the prewar years, introducing their discoveries to record label executives so they could be heard via commercial 78s. But there was another breed of researcher unaffiliated with record labels who scoured Southern backroads and prisons to document folk music forms for non-commercial purposes. They uncovered some of our best-known bluesmen while hauling along "portable" disc recording equipment weighing hundreds of pounds to commit their songs to posterity.

Father-and-son researchers John and Alan Lomax undertook a July 1933 field trip on behalf of the Library of Congress. They came across Huddie Ledbetter, better known as Lead Belly, incarcerated at Louisiana State Penitentiary in Angola. His booming voice and dexterous guitar work were immediately recorded in the field, the bounty including his first rendition of "(Goodnight) Irene." The Lomaxes returned a year later to record him again. That August, their petition to the governor helped ensure the release of Lead Belly. The twelve-string guitar specialist recorded extensively for ARC in early 1935, commencing a prolific career that extended to his death in 1949.

Again working for the Library of Congress, Alan Lomax and Fisk University researcher John Work III embarked on a field trip in the summer of 1941 that uncovered McKinley Morganfield on Stovall's Plantation in Mississippi. Recording with fiddler Son Simms and his cohorts, the slide guitar wizard cut three songs for the musicologists that day as well as giving an interview. A year later, Lomax was back for much more. In 1943, Morganfield departed for Chicago, where he ascended to regal status as blues king Muddy Waters.

That same bountiful July 1942 jaunt through Mississippi also encompassed sessions with Muddy's primary influence Son House, whose thundering voice and slashing slide work had not been heard on record since he participated in a historic 1930 Paramount session in Grafton, Wisconsin, with Charley Patton and Willie Brown. Young guitarist David "Honeyboy" Edwards was also discovered by Lomax during the same trip; nearly seven decades later, he would still be playing the blues in Chicago.

Lomax was no longer in the employ of the Library of Congress when he revisited the Mississippi Delta in 1959, armed with a considerably less bulky state-of-the-art stereo tape recorder. Among his blues finds on that excursion were guitarist Mississippi Fred McDowell and harpist Forest City Joe Pugh. Unlike previous endeavors, their recordings came out commercially on Atlantic and Prestige.

Dr. Harry Oster, an instructor at Louisiana State University, ventured into Angola in January 1959 with his tape recorder and fellow researcher William B. Allen. They were looking for prisoners possessing blues talent; among the standouts Oster recorded there was guitarist Robert Pete Williams, who became a professional bluesman after his parole (some of this material came out on Oster's own Folk-Lyric label). Oster also made the first

> **THEY UNCOVERED SOME OF OUR BEST-KNOWN BLUESMEN WHILE HAULING ALONG "PORTABLE" DISC RECORDING EQUIPMENT WEIGHING HUNDREDS OF POUNDS TO COMMIT THEIR SONGS TO POSTERITY.**

solo recordings of brilliant New Orleans street singer/guitarist Snooks Eaglin in 1958, then released on Folkways Records.

Founded by Moses Asch in New York City in 1948, Folkways was a tremendously prolific repository of folk music of all kinds (over its thirty-eight-year lifespan, the label issued more than two thousand albums). Lead Belly, Sonny Terry and Brownie McGhee, Elizabeth Cotten, and Memphis Slim were among the greats whose work appeared on the logo's albums during the 1940s and '50s.

ABOVE LEFT: Alan Lomax traversed the rural South in 1959, searching for fresh blues and folk talent. Guitarist Mississippi Fred McDowell, one of Lomax's greatest discoveries, was subsequently showcased on the Lomax-curated Atlantic LP *The Blues Roll on*, which also included the music of harpist Forest City Joe Pugh and Roland "Boy Blue" Hayes. Lee Friedlander shot McDowell's cover photograph.

TOP RIGHT: Sightless guitarist Snooks Eaglin was recorded for the first time by Dr. Harry Oster in 1958. Folkways Records released the amazing results under the title of *New Orleans Street Singer*, its cover illustration adapting Oster's photo of Eaglin. Those recordings captured Eaglin in a solo context, but his 1960–63 sides for Imperial found him backed by a full band, his Ray Charles-influenced vocals and daring guitar work setting him well apart.

BOTTOM RIGHT: Folkways memorialized guitarist Huddie "Lead Belly" Ledbetter in 1953 with *Rock Island Line*, its contents dating from 1947. First recorded at the Louisiana State Penitentiary in 1933 by John and Alan Lomax, Ledbetter became a cornerstone of New York's folk-blues movement.

THE BLUES ROLL ON: ALBUM COVERS, PART 1

ABOVE LEFT: The art of Kansas City blues shouting can be traced directly back to Jimmy Rushing. He began recording with Bennie Moten, then gained fame singing with Count Basie during the 1930s and '40s. "Mr. Five by Five" recorded several solo albums including the 1957 Columbia LP *The Jazz Odyssey of James Rushing, Esq*. Tom Allen supplied the cover art.

ABOVE RIGHT: They called Ray Charles "the Genius" for good reason. His groundbreaking 1950s hits welded blues lyrics to gospel feeling and defined soul. Charles's first recordings owed a debt to the mellow style of pianist Nat King Cole before he developed his own sanctified sound. Marvin Israel was in charge of the artwork for Brother Ray's first Atlantic album in 1957.

ABOVE: Chicago's premier blues harpist Little Walter Jacobs exploded out of Muddy Waters's band to become a certified headliner in his own right. Easily the most influential harmonica player in the history of the genre and to this day, Walter's astonishing instrumental virtuosity was spotlighted time and again on his many hits for Checker Records. The 1957 album *The Best of Little Walter* gathered together a dozen of his classics, including "My Babe."

THE BLUES ROLL ON: ALBUM COVERS, PART 1

159

TOP LEFT: With a voice as imposing as her physique, Big Maybelle's 1958 Savoy LP *Big Maybelle Sings* contained some of her best work. She first recorded in 1947 for King; most of her 1950s hits were on OKeh.

BOTTOM LEFT: Often sporting a turban onstage, Atlanta blues shouter Chuck Willis was also a prolific songwriter who penned many of his top sellers for OKeh and Atlantic as well as hits for Ruth Brown and others. His OKeh catalog was anthologized on the 1958 Epic album *Chuck Willis Wails the Blues*.

TOP RIGHT: Nine-string Delta guitarist Big Joe Williams began recording for Bluebird in 1935, where he did "Baby Please Don't Go." Still going strong in 1958, he recorded *Piney Woods Blues* for Delmark.

BOTTOM RIGHT: Sax honker Joe Houston did some *Rockin' at the Drive In* on his 1957 Combo Records LP, its cover photo of Houston taken at a Los Angeles landmark in the company of deejay Art Laboe.

TOP LEFT: Chicago boogie pianist Cripple Clarence Lofton started out as a tap dancer despite his moniker. He began recording in 1935 and appeared on a variety of labels, recording several versions of his trademark song "I Don't Know," later revived by pianist Willie Mabon. The artwork on this 1959 British Vogue reissue EP was the work of British trad jazz guitarist Diz Disley.

BOTTOM LEFT: Innovative Chicago pianist Jimmy Yancey, who made his first sides in 1939 and recorded for Bluebird, Vocalion, and Atlantic, was cited as a primary influence by several boogie-woogie specialists. Monty Sunshine, the clarinetist in Chris Barber's popular British traditional jazz combo, handled the artwork for this ten-inch LP in British Vogue's *Jazz Immortals* reissue series (its contents were from 1943).

ABOVE RIGHT: Jimmy Yancey's rock-solid left hand was the foundation for his thoughtful, deeply satisfying piano approach. The four songs on his posthumous 1958 EP for Vogue were done for the American Session label in 1943 (Yancey died in 1951). Once again, Vogue chose Diz Disley to create the set's cover illustration.

THE BLUES ROLL ON: ALBUM COVERS, PART 1

DON BRONSTEIN OF CHESS RECORDS

Don Bronstein worked his magic on a myriad of blues covers. His inimitable brand of humor and his ability to tell a story in a single shot revolutionized the world of album artwork.

THE PHOTOGRAPHIC IMAGES that graced many of Chess Records' album covers during the 1950s and '60s were largely the work of Don Bronstein. Simultaneously the head staff photographer at *Playboy* magazine, he had no problem whatsoever switching gears between snapping shots of sexy Playmates and earthy bluesmen. Occasionally those two interests overlapped when Bronstein incorporated cheesecake shots of well-endowed models into his album artwork.

Bronstein allowed his artistic imagination to run at full throttle, capturing a straw hat-wearing Little Miss Cornshucks forlornly sitting on her suitcase next to a train for the cover of her 1961 Argo set *The Loneliest Gal in Town*. Sweat glistened on the supersized profile of Chicago's blues king on the front of *The Best of Muddy Waters* in 1957—Bronstein's first of many entries in the Chess catalog. A guitar-toting Muddy looked appropriately pensive mourning a fallen mentor on the front of *Muddy Waters Sings "Big Bill"* in 1960—another Bronstein-lensed gem.

Howlin' Wolf's 1962 "rocking chair" cover, which propped an acoustic guitar against an old-fashioned rocker and dispensed with Wolf's imposing presence entirely, was one of Bronstein's most iconic cover photos. His atmospheric picture of a rural shack decorated the 1959 John Lee Hooker collection *House of the Blues*.

More Bronstein triumphs included an intense close-up head shot of Etta James for her 1966 Argo set *Call My Name*, and the entire run of black-and-white cover photos distinguishing Chess's mid-1960s *The Real Folk Blues* and *More Real Folk Blues* LPs—featuring entries by Memphis Slim and Sonny Boy Williamson. Instead of Sonny Boy's grizzled face, Bronstein pictured a bowler hat with a harmonica propped against it on his first entry in the series and a well-worn shoe on the second.

SIMULTANEOUSLY THE HEAD STAFF PHOTOGRAPHER AT *PLAYBOY* MAGAZINE, HE HAD NO PROBLEM WHATSOEVER SWITCHING GEARS BETWEEN SNAPPING SHOTS OF SEXY PLAYMATES AND EARTHY BLUESMEN.

Bronstein's sense of humor surfaced when he placed a moonshine jug next to four ears of corn to neatly summarize the contents of *Jug and Sonny* by jazz saxophonists Gene Ammons and Sonny Stitt on a 1960 album cover. When Chess vigorously hopped on the rock 'n' roll oldies bandwagon, it afforded Bronstein a chance to pose his pinup lovelies in alluring cover shots that probably sold quite a few copies on visual appeal alone.

Despite all the work he did for the firm, Chess apparently held no exclusive on Bronstein's services. ABC-Paramount bought his photo of the Impressions pushing the back end of a red Jaguar in their stage suits for their 1964 ABC-Paramount LP *Keep on Pushing* and one of B. B. King for his *Confessin' the Blues* set the next year. Bronstein's cover artwork is easy to identify on Chess albums—it usually bears his distinctive signature in a lower corner.

Although he drowned in Mexico in 1968 at the height of his success, Bronstein's legacy as Chicago's leading blues album cover shutterbug had been cemented long before.

TOP LEFT: *Moanin' in the Moonlight* was Howlin' Wolf's first Chess album in 1959. The Mississippi native first recorded in Memphis in 1951 and moved to Chicago the next year, where he made most of his classics.

BOTTOM LEFT: The melodramatic photo on the front of Clarence "Frogman" Henry's 1961 Argo album *You Always Hurt the One You Love* contrasted with the bouncy, engaging New Orleans R&B that he has long specialized in. He is still performing today.

TOP RIGHT: Harpist Sonny Boy Williamson's seminal 1959 Checker LP *Down and Out Blues* featured his hit "Don't Start Me Talkin'." Sonny Boy joined the label in 1955 and remained until his death in 1965.

BOTTOM RIGHT: Ike Turner brought guitarist Little Milton to Sun for his first session in 1953. Milton later recorded for Bobbin in St. Louis. He blended blues and soul on his 1965 Chess LP *We're Gonna Make It*.

THE BLUES ROLL ON: ALBUM COVERS, PART 1

TOP LEFT: Pianist Memphis Slim's 1959 Vee-Jay album *At the Gate of Horn*, featuring Matt Murphy on guitar, was one of the last LPs Slim cut in the States before he permanently relocated to Paris, France.

BOTTOM LEFT: Born in 1895, guitarist Mance Lipscomb was unrecorded in the pre-war era but cut *Texas Sharecropper and Songster* in 1960 for Chris Strachwitz's Arhoolie label (Strachwitz took the cover photo).

TOP RIGHT: Muddy Waters closed out the 1960 Newport Jazz Festival with a spectacular set that was taped by Chess and issued as *Muddy Waters at Newport 1960*. It was embraced by a new young demographic, expanding Waters's fan base.

BOTTOM RIGHT: Guitarist Otis "Lightnin' Slim" Hicks was the father of south Louisiana swamp blues whose first album for Excello in 1960, *Rooster Blues*, featured the soulful harmonica of Lazy Lester.

THE ART OF THE BLUES

ABOVE: Texas was originally home to guitarist Pee Wee Crayton, although he was on the West Coast in the late 1940s when his T-Bone Walker-influenced guitar work gave him several hits. Crown Records put together an eponymous 1960 compilation of Pee Wee's Modern label sides in 1961, including "Texas Hop" and "Blues after Hours."

THE BLUES ROLL ON: ALBUM COVERS, PART 1

CHAPTER EIGHT

HANG IT ON THE WALL

PHOTOGRAPH GALLERY

*"I have heartaches, I have blues.
No matter what you got, the blues is there."*
JOHN LEE HOOKER

Vintage photographs of musicians are as timeless and enduring as the seminal music that their subjects left us. Each image captures for posterity the men and women who made blues music what it is and each one also offers an insight into how they and their record labels wanted them to be seen. Promotional photography was about cultivating an artist's brand and image, while some of the candid, informal shots give us a glimpse into the artist absorbed in the world of music.

RECORD LABELS AND artist managers hired some of the best portrait photographers in the country to create a great many of the images that have become iconic today. Other images that have survived were informal shots taken by photographers roaming through nightclubs where the musicians posed with patrons between sets (the in-house shutterbugs would quickly develop the film and sell the finished photos to the customers). Family members have supplied candid snapshots that are sometimes the only ones we have of obscure blues greats. Indelibly imprinted in our collective psyche, these priceless photos are the way we will forever visualize our heroes. Blues fans owe much to the photographers who captured them.

Memphis was particularly rich in African-American photographers who brilliantly documented their own environment, including its vibrant music scene and the many artists who defined it. Along with the pioneering Hooks Brothers, the Bluff City was home to Ernest C. Withers, whose striking images were not limited to his portrait studio. Withers commenced his career after leaving the army in 1946, where he had received training in his future vocation. He tirelessly captured Memphis's black nightlife with his trusty camera for several decades, regularly covering Nat D. Williams's weekly amateur contests at the Palace Theater, all-star shows at the Club Paradise, Club Handy, and Hippodrome, and doings at WDIA radio (the city's top black station, where B. B. King, Rufus Thomas, Joe Hill Louis, and other future stars held down air shifts early in their careers). Withers also chronicled general news in the black community and Negro League baseball.

By the time he turned to photography, New Yorker Carl Van Vechten was in his early fifties. He had already made a reputation as an author, a music and dance critic, and a patron of the arts whose essay "Negro 'Blues' Singers" appeared in a 1926 issue of *Vanity Fair*. A Caucasian native of Cedar Rapids, Iowa, Van Vechten was exposed to black entertainment as a lad when he saw soprano Sissieretta Jones, later the inspiration for the naming of the Black Patti label. Even though he was white, Van Vechten participated in the Harlem Renaissance of the 1920s and '30s, championing writers Langston Hughes and Zora Neale Hurston and throwing parties at his Manhattan home where people from all races freely intermingled. Van Vechten did not limit himself to photographing African-American entertainers, but they were frequently his portrait subjects.

The name of Maurice Seymour graced countless Windy City showbiz portraits, but few outsiders knew that the moniker actually covered the work of two brothers, Maurice and Seymour Zeldman—and that was even the case when they worked in different cities. The Russian émigrés established a studio atop Chicago's St. Clair Hotel in 1929. They primarily focused on ballet dancers, though their 1934 photo of Duke Ellington in a top hat was exquisite. Seymour Zeldman relocated to New York in 1950 and widened his artistic scope to encompass other entertainers, including a fair number of black musicians. Though it may have appeared from a check of the name and location at the bottom of their photos that a single photographer was simultaneously working out of New York and Chicago, each man did business separately under one hybrid professional name: Maurice Seymour.

Few performers coming through New York on a consistent basis avoided the studios of James J. Kriegsmann because without a Kriegsmann promotional photo, they had not really made it in the business. Kriegsmann arrived in the States from Vienna at age twenty unable to speak English but already thoroughly conversant in photography. He established a Broadway studio on West 46th Street in 1929. Kriegsmann's open-door policy extended to black artists; Harlem's fabled Cotton Club hired him as its photographer. His logo with its big "K" graced photos of countless R&B, soul, and jazz performers over the decades; one estimate had Kriegsmann conducting 35,000 photo sessions over forty-two years. More often than not, his portrait subjects posed next to his favorite props—fake Grecian columns.

Benny Joseph filled much the same role in Houston that Withers did in Memphis. The native of Lake Charles, Louisiana, served overseas in the army during World War II, then attended photography school after returning to Houston. Joseph's beat was Houston's thriving nightlife scene, including local R&B radio stations, the Eldorado Ballroom, the Club Matinee, and City Auditorium, where twenty-five-year-old piano-playing blues crooner Johnny Ace lost his life backstage while foolishly playing with a revolver on Christmas Day, 1954. Don Robey's Duke and Peacock labels were prominent in Houston, and Joseph lensed their stars in dynamic studio portraits. There was even one of Robey himself preparing to dine on his chapeau after declaring, "If it's not a hit, I'll eat my hat!" about one of his unsuccessful releases.

TOP: This photo of Benny Moten's Kansas City Orchestra dates from 1923, the same year that they began recording for OKeh. The pianist led the most successful and influential jazz band in the Midwest, recording abundantly for a variety of labels throughout the 1920s and serving as a training ground for Hot Lips Page, Count Basie, and Jimmy Rushing.

BOTTOM: Along with all of his other duties as composer, bandleader, music publisher, and A&R man, Clarence Williams served as piano accompanist for many of the greatest classic blues singers of the 1920s. Here he is with Sara Martin and Eva Taylor, circa 1925.

HANG IT ON THE WALL: PHOTOGRAPH GALLERY

When young blues researchers headed to the South to search high and low for their prewar heroes during the early 1960s, they were now at a decided disadvantage. If any photos of their quarry existed at all, they were at least thirty years old. Once those long-lost artists started reemerging from the shadows like a blues variation on *Field of Dreams*, a new generation of photographers flocked to document their comebacks as they dazzled college-age crowds at folk festivals and coffee houses.

Accounts of those rediscoveries are as fascinating as any detective story. Nick Perls, Phil Spero, and Dick Waterman departed from New York on a quixotic hunt for legendary guitarist Son House, whose debut recordings had been done in May 1930 at Paramount's Grafton studios during a historic marathon session shared with his traveling partners Charley Patton and Willie Brown. The bountiful 1941–42 Mississippi field sessions for Alan Lomax and the Library of Congress were House's only other recordings at that point.

Waterman (a talented photographer himself who continues to exhibit his work to this day), Perls, and Spero stopped off in Memphis, where they came across prewar great Robert Wilkins, by then a preacher (he would relaunch his musical career as well, exclusively singing religious material), then scoured the Mississippi Delta for House, only to have the trail lead all the way back north to Rochester, New York. The determined trio finally found House in June 1964, relaxing on the front porch of his apartment building (he had been in Rochester since 1943). Plans were immediately laid to get the sixty-two-year-old House back in playing shape. He went on to make an acclaimed album for Columbia in 1965.

Tom Hoskins's method for locating guitarist Mississippi John Hurt, the first of the long-lost prewar greats to seemingly materialize out of thin air the year before, was less arduous. Hoskins carefully considered the lyrics of Hurt's 1928 OKeh classic "Avalon Blues" and logically set out for Avalon, Mississippi, where Hurt, as it turned out, still lived. His gentle vocals and rolling guitar technique had pre-blues songster roots and were unique. Hurt's entire discography up to then consisted of three splendid 1928 sessions for OKeh in Memphis and New York. When Hoskins offered to bring his new friend up to Washington, D.C., to jump-start a career that had never taken Hurt far away from home apart from those recording sessions thirty-five years earlier, Hurt felt he had no choice but to accompany him—he thought Hoskins was with the FBI!

ABOVE LEFT: No pre-war blues guitarist was more adept on a twelve-string than Atlanta's Blind Willie McTell. He began recording for Victor in 1927 and was still going strong on Regal and Atlantic in 1949.

ABOVE RIGHT: Pictured here in 1929, Walter Barnes and most of his Royal Creolians were killed in a 1940 fire that destroyed the Rhythm Club in Natchez, Mississippi— a tragedy immortalized in Howlin' Wolf's 1956 recording "The Natchez Burning."

FAMILY MEMBERS HAVE SUPPLIED CANDID SNAPSHOTS THAT ARE SOMETIMES THE ONLY ONES WE HAVE OF OBSCURE BLUES GREATS.

The title of Bukka White's 1940 recording "Aberdeen Mississippi Blues" inspired John Fahey to send him a

170 THE ART OF THE BLUES

ABOVE: The rollicking Memphis Jug Band was one of the first self-contained units to record blues. Their personnel was fluid, but harpist/guitarist Will Shade was the band's leader and was on all of their 1927–30 Victor sides and 1934 OKeh/Vocalion sessions. This 1929 photo includes Shade, pianist Jab Jones, fiddler Will Batts, and Dewey Corley on jug.

postcard in 1963 simply addressed to "Bukka White (Old Blues Singer) c/o General Delivery, Aberdeen, Mississippi." Although White did not live in Aberdeen by then, the missive somehow found its way to the powerful guitarist in Memphis. White's catalog was a little more extensive; he had made two 78s for Victor in 1930, another for Vocalion seven years later, and a half-dozen for Lester Melrose in Chicago during a two-day layover in 1940 that came out on Vocalion and OKeh. Like Hurt, White had never abandoned his blues-playing ways altogether, so he was still ready to perform. Before long, White, who had a cousin by the name of B. B. King, had his first album out on Fahey and ED Denson's Takoma label.

Fahey and Bill Barth followed a long and circuitous path to locate Skip James, ultimately finding him confined to a hospital bed in Tunica, Mississippi, in 1964. James, whose vaunted reputation then rested solely on the brilliant titles he had recorded for Paramount up in Grafton in February 1931 (thirteen with James on blindingly fast guitar and the rest on piano, all boasting his haunting high-pitched vocals), recovered sufficiently from his medical woes to embark on his own comeback. There were no vintage photos extant for Hurt, James, or House (White was pictured in a prewar Victor catalog), but when George Wein showcased them at the Newport Folk Festival, a legion of photographers descended en masse to remedy that injustice in a hurry.

The importance of that annual folk festival in Newport, Rhode Island, as a vehicle to introduce long-absent blues legends to the masses cannot be overstated. Wein had already been wide open to presenting blues sets at his Newport Jazz Festival, featuring Dinah Washington, Big Maybelle, and Chuck Berry (the latter backed by a jazz band) at the 1958 edition, immortalized in the feature film *Jazz on a Summer's Day*. Ray Charles, Muddy Waters, Otis Spann, John Lee Hooker, and pianist Sammy Price were all presented at Newport in 1960.

The elfin Hurt was introduced to an appreciative Newport Folk Festival throng in 1963, as were John Lee Hooker, Sonny Terry, and Brownie McGhee. Hurt was joined there the following year by James, Rev. Wilkins, Jesse "Lone Cat" Fuller, Elizabeth Cotten, Sleepy John Estes, and Mississippi Fred McDowell. House was originally slated to appear, too, but illness forced him to postpone his set until the following year. He made it worth the wait, sharing the 1965 bill with Hurt, Rev. Gary Davis, Josh White, Mance Lipscomb, and the duo of Memphis Slim and Willie Dixon. Son was back the next year, joined by James, White, and the mighty Howlin' Wolf, whose nightclub-honed full-band approach contrasted markedly with the acoustic presentations of the previous generation.

As color photography became the standard, these black-and-white images seem to encapsulate another—golden—era of music. For die-hard fans, vintage blues photos are the equivalent of the Mona Lisa.

HANG IT ON THE WALL: PHOTOGRAPH GALLERY

171

ABOVE: This 1942 photo shows harpist Rice Miller, better known as Sonny Boy Williamson Number 2, and guitarist Robert Lockwood, Jr. (Robert Johnson's stepson) at KFFA radio in Helena, Arkansas, where they broadcast *King Biscuit Time* daily. Sonny Boy would not make it into a recording studio until 1951, when he cut "Eyesight to the Blind" for Trumpet Records. Lockwood established himself as an uncommonly versatile Chicago guitarist during the 1950s and remained musically active until his death in 2006.

THE ART OF THE BLUES

TOP: Sister Rosetta Tharpe brought a strong blues feel and an aggressive lead guitar attack to her heavenly gospel innovations, making her one of the genre's first major stars during the late 1930s and a huge influence on the secular world as well.

BOTTOM: Drummer Armand "Jump" Jackson led a jumping combo that recorded for Specialty and Aristocrat during the 1940s and frequently found himself in the studio as a sought-after session drummer.

HANG IT ON THE WALL: PHOTOGRAPH GALLERY 173

TOP LEFT: Saxophonist Louis Jordan was the hottest thing on the 1940s hit parade, his jumping sound providing a blueprint for R&B and ultimately rock 'n' roll.

BOTTOM LEFT: Singer Mabel Scott was part of the postwar Los Angeles jump blues scene; she was known as "the Boogie Woogie Elevator Girl" because of her 1948 hit "Elevator Boogie."

ABOVE RIGHT: Taken at Bloom Studios in Chicago, this 1947 photo of classically trained Maurice Rocco shows him pounding out one of his trademark thundering boogies.

THE ART OF THE BLUES

TOP: Wynonie "Mr. Blues" Harris sang about the wild side of life on his late 1940s/early 1950s jump blues hits for King Records, typified by "Bloodshot Eyes." Harris was photographed in 1948 performing at the Baby Grand on Harlem's 125th Street.

BOTTOM: Far less famous was singing saxman King Perry, but he recorded jump blues on a regular basis for Melodisc and Excelsior during the late 1940s in Los Angeles.

HANG IT ON THE WALL: PHOTOGRAPH GALLERY

175

THE HOOKS BROTHERS

The Hooks Brothers captured numerous blues luminaries on camera and documented life in the Bluff City for many years, bringing the activity in the vibrant music scene and African-American community to a wider audience.

ABOVE: Henry (left) and Robert (right) Hooks, the two brothers who founded Memphis's pioneering African-American photography studio.

THERE HAVE ONLY been two photos of the revered Robert Johnson ever released to the public. One was a dime store booth shot with a cigarette dangling from his lips. The other is much more formal—a spectacular image of the ill-fated blues guitarist decked out in a spiffy suit and hat with a smile on his face and a guitar in his hands. It is credited to Hooks Brothers Photographers in Memphis, circa 1935.

Fourteen years later, a young B. B. King, his guitar sporting a hand-painted plug for his WDIA radio program (the 'n' in King was painted on backwards), posed for the Hooks siblings—and it was not the last time he would stop by their studio for a fresh portrait. Memphis Minnie had reigned as a glamorous blues luminary for many years when the brothers posed her in front of their camera. She wore plenty of jewelry for the occasion and carefully cradled her National electric guitar.

African-Americans Henry and Robert Hooks opened their first Memphis studio on Main Street in 1907 before relocating to wide open Beale Street, where their business thrived for decades. They chronicled black life all over the Bluff City at a time when there was no real competition. They were already on the job in 1910, lining up a wide shot of W. C. Handy's expansive orchestra as they sat ready to play in front of an anonymous building. The brothers caught up with the Memphis Jug Band on the streets of their segregated hometown during the late 1930s, photographing the band at the corner of Third and Beale as well as in Handy Park, where blues performers were always making music.

The siblings hailed from a musical household. Their mother, Julia A. B. Hooks, was an accomplished pianist and organist who was a public schoolteacher and directed choral groups at her local church. Hooks Brothers Photographers was eventually handed over to the family's next generation, although not everyone followed the path laid down by their fathers. Robert's son Benjamin Hooks, a Baptist minister and lawyer, battled for civil rights during the volatile 1960s and was named executive director of the National Association for the Advancement of Colored People (NAACP) in 1976.

MEMPHIS MINNIE HAD REIGNED AS A GLAMOROUS BLUES LUMINARY FOR MANY YEARS WHEN THE BROTHERS POSED HER IN FRONT OF THEIR CAMERA. SHE WORE PLENTY OF JEWELRY FOR THE OCCASION AND CAREFULLY CRADLED HER NATIONAL ELECTRIC GUITAR.

During its decades of operation, it was the second oldest continuously active black-owned business in Memphis. A fire in 1979 finished off the last incarnation of the family business, by then located on McLemore Avenue; there now stands a plaque outside the building where the studios were located on Beale Street—a testament to their importance in the community long after they had gone. More importantly, the Hooks Brothers' historic photographs will live on indefinitely.

ABOVE LEFT: One-man-band Joe Hill Louis was also known as "the Be-Bop Boy" when he performed regularly on Memphis's WDIA radio. Combining harmonica, guitar, and drums as well as vocals, Louis was on the Modern, Sun, and Meteor labels during the early 1950s. The Hooks Brothers photographed Louis with a shoeless comic, probably at WDIA.

ABOVE RIGHT: This Hooks Brothers photo of B. B. "Blues Boy" King, probably from the mid-1950s, presents the King of the Blues in a more pensive mood than usual. B. B. was in the midst of a non-stop run of hits for RPM Records that included "You Upset Me Baby" and "Every Day I Have the Blues."

HANG IT ON THE WALL: PHOTOGRAPH GALLERY 177

TOP: Pianist Memphis Slim put together a combo he christened the House Rockers and had several hits on Chicago's Miracle label during the late 1940s. Slim wrote several standards during this period, including "Nobody Loves Me," which became "Every Day I Have the Blues," and recorded for a great many Chicago record companies.

BOTTOM: The 708 Club on Chicago's South Side was a celebrated blues hangout. Howlin' Wolf (born Chester Burnett) and Little Hudson welcomed B. B. King to the 708 during the mid-1950s. Wolf arrived in Chicago in 1954 after first recording in Memphis for Chess and Modern in 1951. He reigned as a Chicago blues giant until his death in 1976.

178 THE ART OF THE BLUES

ABOVE LEFT: Chess Records had a photogenic young guitarist on its roster who should have found rock 'n' roll stardom prior to Chuck Berry's arrival. Danny Overbea emerged on Checker in 1953 with "40 Cups of Coffee," the song that became most associated with him. Overbea recorded intermittently into 1961 but never gained the fame he deserved.

TOP RIGHT: An ultra-dynamic showman who strolled through his audience blasting gloriously distorted solos that represented the future of blues guitar, Guitar Slim cut an instant standard in 1954, "The Things That I Used to Do," in New Orleans for Specialty. Born Eddie Jones in Mississippi, he died in 1959 aged thirty-two.

BOTTOM RIGHT: Los Angeles singer Etta James, aged sixteen, turned around her first name of Jamesetta and became a star for more than half a century. Her career went through several phases, from straight R&B during the 1950s to violin-enriched pop standards and gritty Muscle Shoals soul. Hollywood photographer John E. Reed took this early promo picture of James.

HANG IT ON THE WALL: PHOTOGRAPH GALLERY

RAEBURN FLERLAGE

Raeburn Flerlage may not be as well-known as Ernest Withers or Carl Van Vechten, but his contribution to blues photography is arguably as important, with his atmospheric images recreating the vibe of Chicago's club scene.

NO PHOTOGRAPHER COVERED the Chicago blues scene of the 1960s quite as devotedly as Raeburn Flerlage. He seemed to be everywhere at once, setting up his tripod inside West Side holes-in-the-wall, funky folk clubs with peanuts scattered on the floor, stately concert halls with perfect acoustics, and the spacious old inner-city theaters where one R&B star after another held throngs in the palms of their hands with their galvanizing onstage antics. The smoke, the intimate settings, and an unequaled selection of blues and soul musicians to focus his tools of the trade on made for some truly unforgettable Flerlage images.

Born July 13, 1915, in Cincinnati, Ohio, Flerlage worked on the outskirts of the music business as a reviewer—including writing a column for *The Magic Groove*—and a record shop manager before moving to Chicago's South Side in 1944. He initially sold automotive insurance, sometimes lectured on folk music, and for a time was the Midwest Executive Secretary for People's Songs, a populist organization that brought him into contact with Lead Belly and Josh White. He also worked in radio publicity for a time, and interviewed a number of well-known artists.

Flerlage then accepted a job as sales representative for the wholesale distributor of Folkways Records in 1955. Folkways owner Moses Asch gave him his first photography assignment in 1959, though Flerlage had only begun studying photography a short time before that. The photo shoot was for a Memphis Slim album cover; Flerlage snapped away while Slim rumbled the ivories just for him at the Pershing Hotel on the South Side. There would be many more similar assignments in years to come, Flerlage taking photos in a freelance capacity for Folkways, Delmark, Prestige/Bluesville, and Testament.

Flerlage's specialty was candid shots of his musical subjects, both offstage and on. He documented Chicago's blues royalty as they fronted their bands on their home turf: Howlin' Wolf at Sylvio's, Otis Rush at Pepper's, Junior Wells at Theresa's. No less fascinating was his fly-on-the-wall coverage of late 1960s Delmark recording sessions that made viewers feel as though they were there, soaking up the sweat and soul. His work also appeared in *Down Beat*, the *Chicago Daily News*, and other publications.

Placing his photography career on the back burner to launch a record distributorship in 1971 that occupied nearly all of his time until it folded in 1984, Flerlage rekindled his interest in his vast archives during his golden years. He curated a book of his blues photographs and another concentrating on folk artists that cemented his place in Chicago music history before he passed away on September 28, 2002.

NO LESS FASCINATING WAS HIS FLY-ON-THE-WALL COVERAGE OF LATE 1960S DELMARK RECORDING SESSIONS THAT MADE VIEWERS FEEL AS THOUGH THEY WERE THERE, SOAKING UP THE SWEAT AND SOUL.

ABOVE: A mid-1960s Ray Flerlage group photo. Left to right: Big Walter Horton (whose harmonica brilliance was on the same level as Little Walter's), Floyd Jones, Sunnyland Slim, and Big Joe Williams. As a constantly in-demand pianist in the studio and on the bandstand, Sunnyland was pivotal in shaping late 1940s and '50s Chicago blues.

ABOVE: Jimmy Reed's high-end harmonica, sparse rhythm guitar, and languid drawl added up to a string of often-covered hits on Vee-Jay in the 1950s and early '60s anchored by longtime playing partner Eddie Taylor's intricate guitar. Taylor also recorded as a leader, remaining prominent in Chicago into the 1980s. This Flerlage photo of Reed is from 1964.

HANG IT ON THE WALL: PHOTOGRAPH GALLERY

TOP LEFT: Slim Harpo's 1957 recording of "I'm a King Bee" exemplified the harpist's often-copied brand of laidback Louisiana swamp blues. Harpo had a Number 1 R&B hit in 1966 with his atmospheric "Baby Scratch My Back."

BOTTOM LEFT: His recording career commencing in 1930, Mississippi slide guitarist Bukka White cut two sessions for Vocalion in 1937 and 1940, the latter producing his well-known "Parchman Farm Blues." This photo of White comes from his acclaimed European tour with the 1967 American Folk Blues Festival.

ABOVE RIGHT: Sam "Lightnin'" Hopkins was the personification of Texas blues. He acquired his nickname at his first session for Aladdin in 1946 and recorded for a staggering array of labels, including Gold Star and Herald. The second phase of his recording career began in 1959; a few years later he was playing festivals worldwide (including the 1965 Newport Folk Festival where this photo was taken). One of the most emulated postwar guitarists, Lightnin' was a genuine blues giant.

ABOVE LEFT: Mississippi John Hurt's gentle approach reflected his songster roots. He made a series of prized recordings for OKeh in 1928; his 1963 rediscovery was marked by two Library of Congress recording sessions that committed much of the guitarist's vast repertoire to tape. He is pictured here performing at the University of Chicago in 1965.

ABOVE RIGHT: Skip James's 1964 reemergence brought another prewar legend back into the spotlight. Prior to then, the Mississippi native's legacy rested on the sides he had cut for Paramount in 1931, his falsetto vocals and open E-minor guitar tuning making him unique in Delta blues. Valerie Wilmer snapped this 1967 concert photo in London.

HANG IT ON THE WALL: PHOTOGRAPH GALLERY 183

CHAPTER NINE

I'M TALKING 'BOUT YOU

PUBLICATIONS AND PROMOTIONS

"The blues are the true facts of life expressed in words and song, inspiration, feeling, and understanding."
WILLIE DIXON

Once experts in the blues field began to properly chronicle their passion for the music on paper, their carefully researched labors of love progressed from long-form features in magazines to full-length books that expanded our knowledge of the genre many times over.

PERHAPS THE FIRST book to specifically focus on the blues was assembled by one of its earliest pioneers, Memphis bandleader W. C. Handy. His 1926 work *Blues—An Anthology* contained music and lyrics for fifty songs as well as eight attractive black-and-white illustrations by artist Miguel Covarrubias that captured the beauty and grace of African-American orchestras and dancers seduced by the exciting sounds. Handy subsequently published a 1941 autobiography, *Father of the Blues*, that offered rare insights into his central role in shaping and popularizing the genre, as well as the pre-blues musical tributaries that went into its birth.

Alan Lomax extensively interviewed pioneering New Orleans pianist Jelly Roll Morton in 1938 for the Library of Congress, eventually transforming those priceless recordings into the 1950 biography *Mister Jelly Roll* (Morton had died nine years earlier). David Stone Martin supplied the book's accompanying illustrations; his detailed, highly attractive line drawings also appeared on many 1950s album covers for Norman Granz's Clef label, including several classics by Billie Holiday and a collaboration between Charlie Parker and Dizzy Gillespie.

It was all but unheard of for a blues artist to write an autobiography prior to the 1955 publication of *Big Bill Blues—William Broonzy's Story*, which purported to tell the amazing tale of Arkansas-born blues guitarist Big Bill Broonzy (as told to Belgian scribe Yannick Bruynoghe). The slim book played fairly loose with the facts at times, but as a warmhearted and atmospheric first-person account of Big Bill's rowdy life and times, it was a page-turner.

The golden era of blues books commenced in 1959 with the publication of Samuel Charters's *The Country Blues*—the first in-depth historical examination of rural blues. Since there was very little in the way of reliable biographical information then available on figures such as Blind Lemon Jefferson, Blind Boy Fuller, or Tampa Red, Charters's work provided a wealth of fresh material on blues legends that had by then been largely forgotten—their music long out of print. To that end, Charters compiled a reissue album under the same title for Folkways, gathering fourteen prewar gems for a new audience probably unfamiliar with the majority of its contents. However, Charters was not finished—in between producing such blues landmarks as the three-album 1966 series *Chicago/The Blues/Today!* for Vanguard, he wrote *The Bluesmen* in 1967, and *Sweet as the Showers of Rain* was published a decade later while Charters was living in Sweden.

British author Paul Oliver was responsible for several landmark blues tomes, beginning with *Blues Fell This Morning* in 1960. Similar to *The Country Blues*, the volume offered extensive enlightenment on the development of the idiom from its prewar beginnings

BRITISH-BORN RESEARCHERS DUG DEEP INTO VARIOUS REGIONAL STYLES IN SOME OF THE MOST IMPORTANT BLUES BOOKS OF THE 1970S.

into the 1950s. Oliver transformed interviews he taped during a lengthy US field trip for various BBC Radio documentaries into his 1965 book *Conversation with the Blues*, and provided another exhaustive history lesson with *The Story of the Blues* in 1969.

Charles Keil zeroed in on the contemporary side of the electric blues experience in his 1966 book *Urban Blues*, devoting a sizable portion of his manuscript to profiles of B. B. King and Bobby "Blue" Bland and their ultra-polished stage presentations. British-born researchers dug deep into various regional styles in some of the most important blues books of the 1970s. Bruce Bastin's examination of the Piedmont tradition *Crying for the Carolines*, John Broven's *Rhythm & Blues in New Orleans*, and Mike Rowe's *Chicago Breakdown*—all published during the first half of the decade—were comprehensive overviews then and remain so today.

For blues mavens whose record-collecting interests demanded much more than in-depth factual information on the artists themselves, *Blues Unlimited* co-founder Mike Leadbitter teamed with Neil Slaven to assemble the 1968 discography *Blues Records 1943–1966*—listing a wealth of postwar single releases by artist and date and including labels, release numbers, and sidemen. Four years earlier, Robert M. W. Dixon and John Godrich had assembled the equally essential prewar discography *Blues & Gospel Records 1902–1943*.

Brian Rust beat them to the punch with his massive work *Jazz Records 1897–1942*—first published in 1952 as a

RIGHT: Chemist John Steiner was living in Chicago when he got into the record business in 1943. He leased Paramount sides for his S/D label and was behind this 1947 reprint of *The Paramount Book of the Blues*, which the label had originally published two decades earlier. The book contained artist bios and photos as well as their lyrics and melodies, as shown in the following pages (pp.189–91).

I'M TALKING 'BOUT YOU: PUBLICATIONS AND PROMOTIONS

single-volume loose-leaf labor of love that only went up to 1931; the third edition (released in 1972) was a weighty two-volume hardcover affair. From the start, Rust's project established the template for discographical compilation and was recognized as the standard reference source for the genre. All three of those works hailed from Great Britain, but Ohio-born author Sheldon Harris was responsible for the 1979 *Blues Who's Who: A Biographical Dictionary of Blues Singers*. Organized like an encyclopedia, it alphabetized thumbnail bios and other vital information on hundreds of artists into a phone directory-sized work.

Long before books on blues and its practitioners became commonplace, occasional information on blues artists could be found in the pages of the jazz magazine *Down Beat*. Launched in 1934 in Chicago, it started out as little more than a newsletter for local musicians. Under the editorial supervision of Dave Dexter, it soon gained a national profile, attracting knowledgeable writers including Leonard Feather and John Hammond. Editors came and went, and there were changes in editorial direction from time to time. The end of the big band era necessitated a refocus, as did the mid-1950s rise of rock 'n' roll. In the early 1970s, the magazine tried to expand its audience base by raising its coverage of blues and adding rock to the mix—it is still going strong today.

Competition to *Down Beat* came from *Metronome*, a magazine founded back in 1881 that altered its editorial content to emphasize big bands during the 1930s. Particularly popular was its annual poll, which debuted in 1939, inviting its readership to vote for their favorite musician on each instrument (the aggregation would then record as the Metronome All-Stars). The poll was conducted until the publication folded in 1961. From 1939 to 1941, *Jazz Information* covered the hot jazz scene, coalescing at Milt Gabler's Commodore Music Shop in New York. Its tiny staff included future music reviewing legend Ralph Gleason.

Esquire debuted in 1933 as "the Magazine for Men," but it heroically championed jazz during the war years. Its annual jazz critics' poll honored far more black musicians than *Metronome* did—the winners (including Louis Armstrong and Lionel Hampton) assembling at New York's Metropolitan Opera House in January 1944 for the Esquire All-American Jazz Concert. From 1944 to 1947, the magazine published an annual *Esquire's Jazz Book*, including a pocket-sized edition for the armed services during World War II. The 1945 edition included a foldout map of New Orleans jazz landmarks.

The African-American community relied on a pair of lively publications, *Ebony* and *Jet*, for a wide range of general interest stories as well as the latest entertainment scoops. Roughly the size of *Life* magazine, *Ebony* was launched in Chicago by John H. Johnson in 1945. He added the digest-sized *Jet*, known as "the weekly Negro news magazine," to his publishing empire in 1951; its cover usually featured a photo of a hot young actress or singer in a sexy pose for heightened newsstand appeal. Both magazines frequently published spreads on blues, jazz, and R&B artists, splashing across their pages plenty of animated action photographs and humorous posed shots. The last printed *Jet* hit newsstands in 2014, but *Ebony* is still published monthly.

A magazine specifically devoted to blues and nothing else was published in Great Britain long before anyone took similarly proactive steps in the land where the genre was born. Such was the devotion of a group of young, highly motivated experts in the field. Mike Leadbitter and Simon Napier spearheaded the launch of *Blues Unlimited* in 1963. Early issues were little more than mimeographed sheets, but the quality of the graphics grew to equal its editorial excellence as time went on. By the mid-1970s, *Blues Unlimited*'s cover art was a selling point in its own right. The magazine was published on a regular basis into 1987. From 1985 onwards, another high-quality British publication, *Juke Blues*, covered much the same editorial and pictorial ground with similarly appealing graphics (it remains a prime source for blues news and features).

Jim O'Neal, his then-wife Amy, and Alligator Records owner Bruce Iglauer were among the Chicago-based founders of *Living Blues*, which gave the US a blues magazine to be proud of in the spring of 1970. From the beginning, its editorial policy strictly focused on the African-American blues tradition, ignoring blues-rock and the crossover bucks that it represented altogether. Along with exhaustive interview features and a sizable

ITS COVER USUALLY FEATURED A PHOTO OF A HOT YOUNG ACTRESS OR SINGER IN A SEXY POSE FOR HEIGHTENED NEWSSTAND APPEAL.

record review section in every issue, the publication was particularly strong from the outset on news from various blues hotspots across the country that was submitted by faithful correspondents. Since 1983, *Living Blues* has been headquartered at the University of Mississippi.

Over the last few decades, comprehensive full-length biographies have been published on a wealth of blues legends, from T-Bone Walker, B. B. King, and Muddy Waters to Little Walter, Memphis Minnie, and John Lee Hooker. Magazines by the dozens documenting blues happenings in all four corners of the world have come—and in many cases gone as interest in the idiom has ebbed and flowed.

However, it is the blues books that were written when those original blues pioneers were still alive to share their stories that endure as highly informative accounts of the music's glory years.

"Ma" Rainey

FROM the Bottoms of Georgia came the mother of the blues, the Gold Neck Mama of Stageland—Ma Rainey. From earliest childhood — Gertrude Rainey felt that the blues were expressive of the heart of the south, and the sad hearted people who toiled from sun-up to sundown — crooning weird tunes to lighten their labors. She took up the stage, as a profession — making friends, and gaining popularity, — not for a moment losing sight of her life ambition — to bring to the north, the beautiful melodies of the south — and a better understanding of the sorrow filled hearts of its people. After many years of appearing in theatres of the south, Ma Rainey went to New York — astounding and bewildering the northerners with what they called "queer music." She left, and still they did not understand. After a while, they began to hear more and more of the delightful music sung as only Ma Rainey can sing it — and gradually they began to love this type of music as she did. Ma Rainey taught many blues singers who are so popular today.— and is looked up to and worshipped as the true mother of the blues by all of her large following.

Blind Lemon Jefferson

CAN anyone imagine a fate more horrible than to find that one is blind? To realize that the beautiful things one hears about — one will never see? Such was the heart-rending fate of Lemon Jefferson, who was born blind and realized, as a small child, that life had withheld one glorious joy from him — sight. Then — environment began to play its important part in his destiny. He could hear—and he heard the sad hearted, weary people of his homeland, Dallas — singing weird, sad melodies at their work and play, and unconsciously he began to imitate them — lamenting his fate in song. He learned to play a guitar, and for years he entertained his friends freely — moaning his weird songs as a means of forgetting his affliction. Some friends who saw great possibilities in him, suggested that he commercialize his talent — and as a result of following their advice — he is now heard exclusively on Paramount.

ABOVE LEFT: By the time J. Mayo Williams brought her onto Paramount in 1923, Gertrude "Ma" Rainey had accrued plenty of stage experience. Billed as "the Mother of the Blues," her plaintive style helped make Rainey Paramount's top classic blues diva until she left the label in 1928. She retired from the music business in 1935 and went home to Georgia.

ABOVE RIGHT: Paramount's most popular male blues guitarist was Blind Lemon Jefferson, whose influence on several generations of Texas musicians was vast. Jefferson cut his first blues session in March 1926 and made over ninety sides for the label. His only non-Paramount release was a version of "Match Box Blues" for OKeh. Jefferson died in a blizzard in Chicago in 1929.

Blind Blake

WE have all heard expressions of people "singing in the rain" or "laughing in the face of adversity," but we never saw such a good example of it, until we came upon the history of Blind Blake. Born in Jacksonville, in sunny Florida, he seems to have absorbed some of the sunny atmosphere — disregarding the fact that nature had cruelly denied him a vision of outer things. He could not see the things that others saw—but he had a better gift. A gift of an inner vision, that allowed him to see things more beautiful. The pictures that he alone could see made him long to express them in some way — so he turned to music. He studied long and earnestly — listening to talented pianists and guitar players, and began to gradually draw out harmonious tunes to fit every mood. Now that he is recording exclusively for Paramount, the public has the benefit of his talent, and agrees, as one body, that he has an unexplainable gift of making one laugh or cry as he feels, and sweet chords and tones that come from his talking guitar express a feeling of his mood.

ALL: Blind Blake was another of Paramount's brightest stars, a spectacular guitarist and engaging singer who recorded "Too Tight" in the fall of 1926. *The Paramount Book of the Blues* retitled it "Too Tight Drag." Influential to Rev. Gary Davis and a host of other ragtime guitar finger-pickers, Blake left Paramount in late 1932.

Charlie Jackson

FROM the ancient.—historical city of New Orleans, came Charlie Jackson — a witty—cheerful—kind hearted man —who, with his joyous sounding voice and his banjo, sang and strummed his way into the hearts of thousands of people. When he first contracted to sing and play for Paramount — many pessimistic persons laughed, and said they were certain no one wanted to hear comedy songs sung by a man strumming a banjo. But it wasn't long before they realized how wrong they were. Charlie and his records took the entire country by storm, and now — people like nothing better than to come home after a tiring and busy day and play his records. His hearty voice and gay, harmonious strumming on the banjo, causes their cares and worries to dwindle away, and gives them a careful frame of mind, and makes life one sweet song.

Ida Cox

BORN and Bred in Knoxville, in the hills of sunny Tennessee. At an early age she began to sing and delighted the ears of her listeners with her sweet melodious music. Singing always —humming at her work and play —thru joy or sorrow. She appeared on the stage, when a mere child, and insinuated herself into the hearts of her audience in such a way, that the booking agencies of the south found their offices swamped with requests for Ida Cox — queen of the blues. A few years ago, she was brought to the notice of the Paramount Company, by virtue of her ever-growing popularity, and was contracted to sing exclusively for Paramount. The public hailed her advent into the record world, with delight, and the wondering north opened its arms to welcome the Queen of the Blues who had already captured the south.

ABOVE LEFT: One of the earliest self-accompanied bluesmen, Papa Charlie Jackson and his guitar banjo first appeared on Paramount in 1924 (he remained with the label into 1930). Papa Charlie hailed from New Orleans. He did a legendary 1926 session as a vocalist with cornetist Freddie Keppard's Jazz Cardinals.

ABOVE RIGHT: Unlike many of her peers, Ida Cox recorded well after the classic blues era concluded, notably a 1939 session for Vocalion and a 1961 album for Riverside. But the bulk of the Georgia native's recordings appeared on Paramount—she was there from 1923 to 1929—and she was often accompanied by pianist Lovie Austin.

RHYTHM AND BLUES AND EBONY SONG PARADE MAGAZINES

The burgeoning blues scene spawned a range of publications aimed at keeping enthusiasts up-to-date with their favorite artists' latest recordings and shows. They also introduced new and hot talent to a wider audience. These magazines played a vital part in the way in which blues music presented itself to the world.

BILLBOARD DID AN excellent job of covering postwar rhythm and blues news on a weekly basis as it had with other African-American musical forms for many years prior. From 1942 on, it was in fierce competition with a new rival—*Cash Box*. But their readership was primarily limited to industry types whose bottom line relied on the weekly sales charts that *Billboard* and *Cash Box* each tabulated and published.

Another pair of less celebrated magazines that were strictly dedicated to R&B popped up during the 1950s, their editorial content aimed at the music's rapidly growing legion of fans rather than those already in the know. Charlton Publications of Derby, Connecticut, positioned its *Rhythm and Blues* as a hipper answer to its longstanding pop music publication *Hit Parader*. Debuting in August 1952, the pages of *Rhythm and Blues* offered breezy features on current hitmakers, informative columns, reviews of recent shows, stories about nightspots and fashion trends, and a hefty section of lyric transcriptions for the many hits of the day. Artist interviews in the magazine may have in some cases been the only ones that they gave for the print trade back then.

THE PAGES OF *RHYTHM AND BLUES* OFFERED BREEZY FEATURES ON CURRENT HITMAKERS, INFORMATIVE COLUMNS, REVIEWS OF RECENT SHOWS, STORIES ABOUT NIGHTSPOTS AND FASHION TRENDS.

Charlton gave itself some stiff competition on the R&B front by introducing its sister publication *Ebony Song Parade* in 1956. Lyrics to then-current smashes again dominated a good portion of the editorial mix. The magazine did not last as long as *Rhythm and Blues*, which was still going strong in 1961 with features on Jimmy Reed and Jimmy Witherspoon. Both of these pioneering magazines anticipated a need for concrete information on blues artists and their songs that would only blossom with time.

ALL: *Ebony Song Parade* enticed a wide variety of African-American music fans with its editorial content. For younger readers, its inaugural June 1955 issue offered an interview with Billy Ward, leader of the Dominoes, and photos of actress Dorothy Dandridge. Veteran jazz fans would find much to like about the magazine's choices for its "All-Star Bandstand," featuring saxophonists Charlie Parker, Earl Bostic, and Illinois Jacquet and singers Joe Turner and Ella Johnson. There was also a piece about gospel queen Mahalia Jackson for the devout segment of the publication's fan base.

ABOVE LEFT: *Jazz Information* was born in September 1939 in the back room of Milt Gabler's Commodore Music Shop, located on 52nd Street in Manhattan. Its four creators, including Ralph J. Gleason, dedicated their editorial focus to hot jazz and often covered blues. The magazine was published through to November 1941.

ABOVE RIGHT: RCA Victor published *In the Groove* monthly during the postwar years to publicize its artists and releases, covering everything from pop and hillbilly to jazz. The cover of the August 1947 issue featured trumpeter Erskine Hawkins, whose hits for the label included the 1946 instrumental "After Hours," featuring pianist Avery Parrish.

RIGHT: From the same publisher as *Ebony Song Parade*, *Rhythm and Blues* focused on its namesake idiom and rock 'n' roll. The stars of Atlantic Records, including Ivory Joe Hunter and LaVern Baker (she started as a Chicago blues singer before having several R&B hits for Atlantic), dominated the cover of the September 1957 issue.

I'M TALKING 'BOUT YOU: PUBLICATIONS AND PROMOTIONS

TOP: The Christian and Missionary Alliance Gospel Quintette came together in 1914 in Cleveland and recorded for Columbia in 1923–24. This photo of the vocal group appeared as a promotional postcard that identified all five members by name. The quintet toured England in 1930 and spent the next six years performing overseas.

BOTTOM: A 1933 flyer for Vocalion Records featured a photo of veteran bandleader, music publisher, and A&R man Clarence Williams, by then working for the label in a supervisory capacity. Williams remained highly active in the business during this period, leading a jug band on Vocalion as well as recording for other labels.

196 THE ART OF THE BLUES

ABOVE LEFT & BOTTOM RIGHT: New Orleans was where Nat Towles learned the music business, playing bass with Red Allen before leading his own Creole Harmony Kings. In 1934, Towles put together a new swing orchestra, basing it in Omaha, Nebraska, for the next quarter century. They promoted their upcoming shows with these postcards.

TOP RIGHT: Bandleader Fletcher Henderson wished his fans season's greetings with this classy autographed card. Henderson's skills as an arranger kept him busy during the 1930s when he was not leading his own orchestra; he contributed many charts to Benny Goodman's book and eventually joined the clarinetist's band as pianist and staff arranger.

I'M TALKING 'BOUT YOU: PUBLICATIONS AND PROMOTIONS 197

An exclusive Variety Record artist

JOE LIGGINS
Leader of the Famous
HONEYDRIPPERS

ABOVE LEFT: Hi-De-Ho Man Cab Calloway plugged his 1937 recordings for his manager Irving Mills's short-lived Variety label with this postcard. The exuberant bandleader maintained his mainstream popularity in decades to come, starring in a number of Broadway musicals and appearing in several films.

ABOVE RIGHT: "The Honeydripper" was Joe Liggins's first record in 1945, and it made the pianist a star. Naming his band after the song, Liggins was a Los Angeles-based jump blues perennial with a series of major hits for Exclusive and then Specialty, where his "Pink Champagne" was another blockbuster in 1950.

RIGHT: Jimmy Liggins & His Drops of Joy rocked just a little harder than his older brother Joe's combo, their 1947 Specialty recording of "Cadillac Boogie" inspiring Jackie Brenston's 1951 smash "Rocket '88'." The guitarist survived being shot in the mouth in 1949, his singing ability remaining intact for more Specialty and Aladdin recordings.

JIMMY LIGGINS and his DROPS OF JOY

José Antonio

PERSONAL DIRECTION
Harold F. Oxley
8848 SUNSET BOULEVARD

I'M TALKING 'BOUT YOU: PUBLICATIONS AND PROMOTIONS

THE OVERSEAS BLUES

Not only were European audiences enthralled by jazz and blues, the musicians themselves found the social environment far more welcoming and racially tolerant than the often horrendous conditions back home.

SIDNEY BECHET, EDDIE South, Coleman Hawkins, Benny Carter, and Fats Waller spent considerable time touring and recording across the pond prior to the outbreak of World War II, Carter becoming staff arranger for the British Broadcasting Company's dance orchestra. However, they were not the first black Americans to bring their music overseas.

Orchestra leader James Reese Europe made history in 1912 by leading one of the first bands to play ragtime and proto-jazz at Carnegie Hall, New York City. He embarked for Europe during World War I, heading the 369th Infantry Jazz Band (also known as the Hellfighters) to play for soldiers and civilians alike. Sadly, a year later, James Europe, by then back stateside, was stabbed to death by one of his own musicians. Singer/dancer Josephine Baker enchanted Paris in 1925 with her dazzling performances in *La Revue Nègre* (the cast hailed from Harlem) and quickly ascended to superstardom there, reportedly earning more than any performer in Europe. Baker ultimately became a French citizen, going undercover for the French Resistance during World War II.

Blues and jazz journalism was well underway in Europe prior to World War II. Charles Delaunay and Hugues Panassié founded the pioneering French magazine *Le Jazz Hot* in 1935; Delaunay authored *Hot Discography* the next year. After the fighting ceased, Sinclair Traill launched *Jazz Journal* in 1948 and served as the magazine's editor-in-chief until his death in 1981.

A handful of bluesmen followed the trail of these early pioneers during the 1950s, beginning with Big Bill Broonzy, who toured in Europe on a regular basis until he became ill in 1957 (he died the following year). Sonny Terry and Brownie McGhee made an overseas jaunt in 1958, as did Muddy Waters, who brought pianist Otis Spann and his electric guitar along and was roundly criticized for not sticking with his acoustic axe à la Broonzy. When Muddy came back in 1963 dutifully carrying an acoustic, a new young legion of fans lamented the absence of his electric model.

Horst Lippmann and Fritz Rau's American Folk Blues Festival barnstormed Europe every year from 1962 to 1972, opening the floodgates for US blues artists to tour overseas widely. The legends they presented influenced a slew of young blues-rockers. With Willie Dixon acting as

SINGER/DANCER JOSEPHINE BAKER ENCHANTED PARIS IN 1925 WITH HER DAZZLING PERFORMANCES IN *LA REVUE NÈGRE* (THE CAST HAILED FROM HARLEM) AND QUICKLY ASCENDED TO SUPERSTARDOM THERE, REPORTEDLY EARNING MORE THAN ANY PERFORMER IN EUROPE.

their talent scout, Lippman and Rau booked the very best talent—T-Bone Walker, Memphis Slim, and John Lee Hooker headlined in 1962; Muddy Waters, Lonnie Johnson, and Sonny Boy Williamson the following year; and Howlin' Wolf, Lightnin' Hopkins, and Sunnyland Slim in 1964.

Several of America's foremost blues pianists engaged in what amounted to a European exodus of their own. New Orleans native Champion Jack Dupree made his first overseas sojourn in 1959 and liked it so much that he settled there permanently. Memphis Slim went over the next year in the company of bassist Dixon; before long Slim had made his own move and became a Parisian. Chicagoans Curtis Jones and Eddie Boyd found the improved climate for bookings and comparative lack of racism they encountered in Europe irresistible and permanently bid their homeland adieu.

By the end of the 1960s, European jaunts were relatively common for American blues artists.

TOP LEFT: Still in operation to this day, *Jazz Journal* magazine was founded in 1948. Its June 1951 cover featured Lonnie Johnson, underscoring the guitarist's lifelong connection to the jazz world.

BOTTOM LEFT: British blues researcher Mike Leadbitter journeyed to Louisiana to write the 1969 booklet *From the Bayou* with Eddie Shuler, tracing the history of Goldband Records.

ABOVE RIGHT: German artist Carlo Boger drew this 1936 portrait of singer and trumpeter Valaida Snow. Born in Tennessee, Snow toured Europe and the Far East extensively during the 1920s and '30s, and earned the deep respect of Louis Armstrong, who stated that Snow was the world's second greatest trumpeter (after himself, of course).

I'M TALKING 'BOUT YOU: PUBLICATIONS AND PROMOTIONS

TOP & MIDDLE LEFT: Amos Milburn came out of Houston with a boogie piano style that made him one of the hottest jump blues stars of the postwar era on Aladdin, scoring several Number 1 hits. Partying and booze were Amos's favorite subjects to sing about. He rocked Chattanooga's Memorial Auditorium, where tickets sold for $1.75.

BOTTOM LEFT: Roanoke Auditorium headliner Benjamin "Bull Moose" Jackson's vocal versatility made him a late 1940s star on King Records as he alternated between ballads and ribald houserockers. Jackson had joined Lucky Millinder's orchestra in 1943 as a saxophonist before emerging as a singer.

ABOVE RIGHT: From 1934 on, Harlem's Apollo Theater presented the very best in African-American entertainment. A double bill of blues guitar star T-Bone Walker and alto saxman Tab Smith's band was followed the next week by the great jazz singer Ella Fitzgerald with saxophonists Gene "Jug" Ammons and Sonny Stitt.

202 THE ART OF THE BLUES

HARLEM'S HIGH SPOT APOLLO
125th ST. near 8th Ave · Tel. UNiversity 4-4490

ONE GALA WEEK ONLY

Master Drummer-Blues Singer

★ ROY MILTON ★

AND HIS BAND FEATURING

CAMILLE HOWARD
LILLIE GREENWOOD
AND
MR. T-99 BLUES"
Jimmie NELSON

RUBY RING

HARLEM'S HIGH SPOT APOLLO
125th ST. near 8th Ave · Tel. UNiversity 4-4490

BEG. FRI., JAN. 18th

Recording Artist - Sax Star

★ JOHNNY HODGES ★

AND HIS BAND with AL SEARS

ROLL and TAPP

EXTRA!
BILL COOK
NEW JERSEY'S POPULAR RADIO AND TV STAR!

COMPLIMENTARY TICKET

Lucius Huntley presents Decoration Day Eve Concert Style Dance

Ruth "Mama" Brown

Fats Domino and his **Blues Orchestra**

T-Bone "Guitar" Walker

Buddy Griffin & his Griffin Bros. **Orchestra**
Featuring Claudia Swan Vocalist

PLUS

The Jets — The Angels — The Barons
Singing Chicken "FlipFlapFly" "Luccille"

SUN., MAY 29, 1955 CIVIC AUDITORIUM
This Ticket plus **$1.00** for Ser. chg. & tax will admit one at door

TOP: This Apollo ad promotes Roy Milton and his Solid Senders as headliners, with Jimmie Nelson, then a hot commodity thanks to his 1951 hit "'T' 99 Blues," as support act. They were followed into the entertainment mecca by saxophonist Johnny Hodges.

BOTTOM: Ruth Brown, the Virginia-born singer whose great run of early 1950s hits put Atlantic Records on the map, was joined in an amazing 1955 concert at the Civic Auditorium by Fats Domino's band, T-Bone Walker, and pianist Buddy Griffin's orchestra.

CHAPTER TEN

THE BIG TIME

ALBUM COVERS PART 2

*"Blues is a natural fact, is something that a fellow lives.
If you don't live it you don't have it."*
BIG BILL BROONZY

The 1960s ushered in a new era in blues music that was accompanied by a fresh approach and attitude to blues album artwork. With spectacular images from the enigmatic Fazzio and stunning photographs portraying the kings and queens of the blues, mainstream audiences took to the music like never before.

WITH THE FOLK-BLUES revival in full swing at the dawn of the 1960s, a new approach to album cover artwork came into vogue: gritty black-and-white photos of the artists that dispensed with any pretense of slick glamor. The concept brilliantly captured the dignity and grace of the veteran guitarists, harpists, and piano players working their home turf in full performance mode. At the same time, liner notes grew more serious and scholarly in tone. They were no longer just puff pieces situated on the back of the jacket to help sell the disc to undecided consumers, but set out to inform readers of the artist's background, accomplishments, and their exalted place in blues history.

The young white blues enthusiasts that doggedly tracked down and subsequently recorded their prewar heroes, sometimes in the field with handheld microphones feeding into portable tape recorders, often worked on behalf of a new generation of labels that were as committed to the music itself as they were to turning a profit (in some cases, more so). Some of them owned their small companies, while others were salaried employees or freelancers. Whatever their employment status, the commitment these blues lovers displayed was absolute.

In Chicago, Bob Koester's Delmark Records (originally christened Delmar when Koester began recording traditional jazz bands in St. Louis in 1953), a label every bit as devoted to jazz as it was to blues from the outset, shuttled most of its early blues design work to W. Hopkins, including album covers for Speckled Red and Sleepy John Estes. Later in the 1960s, Zbigniew Jastrzebski designed some of Delmark's most distinctive blues album covers, including layouts for Junior Wells's *Hoodoo Man Blues* (its cover photo was the work of producer Koester) and two classic Magic Sam LPs. Koester's Jazz Record Mart—which continues in business to this day, as does Delmark Records—employed several future blues label owners on its staff during its early years, most notably Bruce Iglauer of Alligator Records.

Pete Welding handled a fair amount of the cover photography himself for his Chicago-based Testament label's output. The Philadelphia native's thoughtful, well-informed writing on blues and other musical genres was often spotlighted in the pages of *Down Beat* magazine and in a wealth of liner notes. Welding launched Testament in 1963, his early output encompassing LPs by Mississippi-born guitarist/harpist Doctor Ross, who had previously recorded for Chess and Sun, and the first

THE CONCEPT BRILLIANTLY CAPTURED THE DIGNITY AND GRACE OF THE VETERAN GUITARISTS, HARPISTS, AND PIANO PLAYERS WORKING THEIR HOME TURF IN FULL PERFORMANCE MODE.

revelatory reissue album of Muddy Waters's seminal 1941–42 Library of Congress recordings.

Bob Weinstock founded the Prestige label in 1949 as an outgrowth of his jazz-focused record store in Manhattan. Prestige lived up to its name by recording jazz giants Miles Davis, Gene Ammons, and many more before introducing its Bluesville subsidiary in 1959. An extremely prolific source of fresh blues into the mid-1960s, Bluesville followed an uncommonly varied stylistic path, extensively recording acoustic traditionalists Sonny Terry and Brownie McGhee, and Rev. Gary Davis, as well as more modern electric blues artists.

Bluesville's artwork was largely the domain of Don Schlitten and Esmond Edwards, both talented cover photographers. The Kingston, Jamaica-born Edwards was something of a blues renaissance man, producing Bluesville LPs by Detroit-based guitarist Eddie Kirkland (a frequent musical cohort of John Lee Hooker) and other artists before moving on to A&R posts at Verve and Chess. Schlitten later produced some excellent blues reissues at RCA Victor, including the first historic overview of Arthur "Big Boy" Crudup's early output in 1971.

Since its inception in 1960, German-born Chris Strachwitz's Bay Area-based Arhoolie Records has been a bountiful source of roots music of all stripes: from blues to Cajun, from country to zydeco. It remains in operation to this day. Strachwitz arrived in the US in 1947, when he was still in his teens. He developed a love for jazz and blues and honed his recording skills prior to

ABOVE LEFT: At the age of forty-eight, Georgia blues harpist Buster Brown became an R&B star. Deeply influenced by Sonny Terry, Brown made two recordings for the Library of Congress in 1943, then disappeared until he cut "Fannie Mae" for Fire Records in 1959. Brown's infectious harmonica sound and whooping vocals made it a major hit.

ABOVE RIGHT: Bo Diddley's trademark African-derived rhythms and tremolo-soaked rhythm guitar became known around the world as the "Bo Diddley beat." His many Checker recordings melded Chicago blues with rock 'n' roll in a way that was his alone. Bo dreamed up the iconic cover photo for his 1960 album *Bo Diddley Is a Gunslinger*.

unveiling Arhoolie (fellow Texas blues expert Mack McCormick suggested the name of the label). Strachwitz recorded Lightnin' Hopkins frequently as well as less celebrated Texas bluesmen; he released albums by guitarist Black Ace and pianist Alex Moore, both of whom boasted prewar discographies. On top of all his other Arhoolie duties, Strachwitz did some of his own album cover photography.

If classy artist photographs tended to be the norm for independent blues labels to use on their album covers, the country's leading R&B companies did not always take the same route—though often this was due to unfortunate commercial considerations. New York's Atlantic Records, one of the top R&B and soul imprints in the country, often used bland, abstract paintings of young people dancing, kitschy illustrations, or photos of attractive young Caucasian women to decorate its 1960s releases.

Similarly, the graphic designers at Chicago's Vee-Jay Records seemed to be obsessed with shots of young white lovers, or sometimes just splattered a slogan or lengthy title on the front of an album and left it at that. Sadly, there was a practical reason for all of these generic LP covers: it was the only way their product could be prominently displayed on segregated Southern record racks. Even as soul music muscled its way into millions of Southern white households, breaking down barriers with every exciting, sweaty groove, racial unrest forced such unhappy artistic compromises into the mid-1960s.

SADLY, THERE WAS A PRACTICAL REASON FOR ALL OF THESE GENERIC LP COVERS: IT WAS THE ONLY WAY THEIR PRODUCT COULD BE PROMINENTLY DISPLAYED ON SEGREGATED SOUTHERN RECORD RACKS.

Reissue albums became commonplace during the 1960s as labels combed their vaults for vintage performances that had been out of print for decades or never released at all. Some labels granted their reissue subjects stately packages enhanced with vintage photos. Others injected fun into their presentations by placing a humorous illustration on their jacket covers. No cartoonist brought more in-depth knowledge of the blues to his drawings than Robert Crumb, a musician himself, who drew witty, beautifully rendered covers for a slew of albums during the 1970s on the Yazoo and Blue Goose labels.

THE ART OF THE BLUES

SMOKEY HOGG SINGS THE BLUES

GOOD MORNIN LITTLE SCHOOL GIRL
COMING BACK HOME TO YOU AGAIN
LOOK IN YOUR EYES PRETTY MAMA
YOU CAN'T KEEP YOUR BUSINESS STRAIGHT
WORRYIN MIND
RUNAWAY
YOU JUST GOTTA GO
IT'S RAINING HERE
I GOT YOUR PICTURE
WHEN YOU GET OLD
GOIN BACK TO CHICAGO

CROWN RECORDS

Photography: Shostal, N.Y.C.

HIGH FULL COLOR FIDELITY CLP 5226

OPPOSITE, ABOVE LEFT: *Two Steps from the Blues* was where Bobby "Blue" Bland was right at home. It was also the name of his hit-filled 1961 album for Duke Records. The Memphis blues singer developed into a soulful and intense R&B vocalist, posting a steady stream of hits from 1957 into the 1980s, and touring widely until his death in 2013.

OPPOSITE, ABOVE RIGHT: An imposingly powerful pianist with a commanding voice who was a force on the Chicago blues scene from the 1940s until he passed away in 1995, Sunnyland Slim made *Slim's Shout* in 1960 for Prestige/Bluesville with King Curtis on sax. Sunnyland was a mentor to many local up-and-comers, including singers Bonnie Lee and Big Time Sarah.

ABOVE: Crown Records issued a series of budget blues albums that included the 1961 *Smokey Hogg Sings the Blues*. It anthologized the late 1940s/early 1950s Modern label sides of Texas guitarist Andrew "Smokey" Hogg, the LP including Hogg's popular "Good Morning, Little School Girl." Hogg recorded for a multitude of postwar labels.

TOP LEFT: Equally comfortable on harp and guitar, Frank Frost's sound was a throwback when *Hey Boss Man!* emerged on the Sun subsidiary Phillips International in 1962. He had apprenticed with Sonny Boy Number 2 before forming his own band with guitarist Big Jack Johnson and drummer Sam Carr to make juke joint blues.

BOTTOM LEFT: Arthur "Big Boy" Crudup wrote more than his share of future standards during his 1940s stay on Victor and Bluebird. The Mississippi guitarist recorded those hits in Chicago but had quit music when Fire Records boss Bobby Robinson tracked him down to make *Mean Ol' Frisco* in 1962 (that is not Arthur on its cover).

ABOVE RIGHT: The 1953–66 Duke Records tenure of harpist Little Junior Parker produced definitive versions of past classics in addition to his own original material. He started recording in Memphis for Modern and Sun before joining Duke, where he released his *Driving Wheel* album in 1962.

210 THE ART OF THE BLUES

ABOVE LEFT: The cover photo for Piedmont guitarist Doug Quattlebaum's solo 1962 Prestige/Bluesville album *Softee Man Blues* was true to life. The South Carolina native drove around the streets of Philadelphia selling ice cream with his guitar plugged into his truck's PA system to attract customers. He had previously recorded for Gotham in 1953.

ABOVE RIGHT: Released in 1962 on Prestige/Bluesville, *Mr. Scrapper's Blues* should have propelled imaginative Indianapolis guitarist Scrapper Blackwell to a new level. He had accompanied Leroy Carr on his 1928–35 recordings and cut as a leader during the same time frame. His comeback ended when he was killed in a robbery in October 1962.

THE BIG TIME: ALBUM COVERS, PART 2

THE REALISTIC PORTRAITS OF THE ENIGMATIC FAZZIO

Whoever he may have been, the artist who signed his work "Fazzio" clearly knew how to paint an accurate portrait, although his work was not destined to be appreciated by art critics. He was instead commissioned to decorate the covers of close to fifty album releases during 1963–64 on the Crown label, their contents spanning blues, R&B, pop, and country.

BY ANY STANDARD, Crown Records was a bargain basement affair. The label was one of several operated by brothers Jules, Saul, and Joe Bihari, who played a major role in the rise of the independent record business in Los Angeles. Jukebox operators keen on making their own 78s to help fill their machines, the Biharis debuted their first label (initially known as Modern Music) in 1945 with the sophisticated boogie piano stylings of Hadda Brooks.

Sometime in 1947, the Biharis shortened their company's name to Modern and inaugurated a series of subsidiaries—RPM, Flair, Meteor (based in Memphis and headed by older brother Lester Bihari), and Kent—as the 1950s progressed. Between them, the labels built a huge catalog that ranged from polished urban rhythm and blues to raw country blues, including hits by John Lee Hooker, B. B. King, and Etta James. When the album market opened up, Modern jumped in with a handful of ten-inch albums in 1950, then got serious about full-sized long-players in 1956. The Biharis shifted their LP action onto budget-priced Crown in 1957, reissuing Modern's recent album catalog on the new logo at vastly reduced list prices before assembling a steady stream of fresh releases.

Crown's albums were more often found for sale on racks at grocery stores and drug stores than at top-shelf record emporiums, the pressings themselves so poor that they sounded awful from the very first play. But Fazzio's glossy cover illustrations were first class all the way.

Obviously using promotional 8 x 10 (eight- by ten-inch) head shots as his guide, the artist painted uncannily accurate color versions of those photos that any recording artist would have been proud to see adorning his or her album. Like the artist himself, little is really known about his technique, but it has been suggested that he used the original photographs and then airbrushed or colorized over them to make them appear to be original oil paintings. With a massive back catalog of Modern/RPM blues and R&B masters at the Biharis' disposal, there was plenty for Fazzio to wet his paintbrush on as Crown mined its archives mercilessly for reissue material.

Fazzio's true identity seems destined to remain an eternal mystery, but his unique artwork is coveted by record collectors worldwide.

THE ART OF THE BLUES

TOP LEFT: Kansas City blues shouter Big Joe Turner roared alongside pianist Pete Johnson during the 1938 boogie-woogie craze and reinvented himself as a 1950s rock 'n' roll star at Atlantic Records with his blues-based anthem "Shake, Rattle and Roll."

BOTTOM LEFT: A monumental talent on piano and guitar who played an incalculable role in blues, R&B, and soul, Ike Turner was crucial in launching the careers of Howlin' Wolf, Jackie Brenston, and Elmore James, and served as a talent scout and studio musician.

TOP RIGHT: Detroit was John Lee Hooker's home when he emerged with his 1948 smash "Boogie Chillen" for Modern. The Boogie Man was bigger than ever in his golden years, collaborating with a variety of rock superstars prior to his death in 2001.

BOTTOM RIGHT: Although he never had a national hit, Los Angeles jump blues singer/guitarist Gene Phillips recorded a substantial body of swinging work for Modern from 1946 to 1950. Pianist Lloyd Glenn and saxophonist Maxwell Davis were among his sidemen.

THE BIG TIME: ALBUM COVERS, PART 2

TOP LEFT: From 1949 to 1962, New Orleans pianist Fats Domino made gold records aplenty for Imperial (he wrote most of them with producer Dave Bartholomew). Fats's blues-rooted rhythms and charming Creole accent rendered him a rock 'n' roll superstar. The cover image on his 1964 ABC-Paramount LP *Fats on Fire* was by Forshee Photography.

BOTTOM LEFT: Harpist Billy Boy Arnold's *More Blues on the South Side*, produced by Sam Charters in 1964 for Prestige, was one of the first complete albums recorded by an electric Chicago blues band rather than a collection of singles. Arnold played with Bo Diddley before recording "I Wish You Would" for Vee-Jay in 1955. He is still performing today.

TOP RIGHT: The greatest blues rediscovery of all unfolded in 1964 when Mississippi Delta slide guitar powerhouse Son House was located in Rochester, New York, and persuaded to resume his career. House's vaunted reputation was primarily the result of his 1930 Paramount sides, but his 1965 Columbia LP *Father of Folk Blues* made him a legend.

BOTTOM RIGHT: Savoy Records scoured its archives in 1964 to assemble *Living with the Blues*, containing a dozen 1940s/'50s rarities ranging from urban sounds by Sunnyland Slim and Papa Lightfoot to country blues by Pee Wee Hughes and Frank Edwards. The striking cover art was by the mysterious Harvey.

214 THE ART OF THE BLUES

ABOVE LEFT: Willie Mae "Big Mama" Thornton's original reading of "Hound Dog" was a massive hit in 1953 on the Peacock label. While touring overseas in 1965, Big Mama cut *Big Mama Thornton in Europe* for Arhoolie with an all-Chicago band. Arhoolie also released her original 1968 version of "Ball and Chain." Arhoolie owner Chris Strachwitz snapped the cover photo; Wayne Pope was the art designer.

ABOVE RIGHT: Nearly every blues guitarist in Chicago admired Earl Hooker. His light touch and boundless imagination were already startling during the 1950s, when he recorded for King and Sun. Hooker cut some of his best sides for the Chief and Age labels in the early 1960s, but the 1967 album *The Genius of Earl Hooker* came out on Cuca Records.

ABOVE LEFT: Chicago's West Side had a blues sound all of its own, much of it due to the inventive guitar of Magic Sam. Samuel Maghett arrived from Mississippi in 1950, and by 1957 he was recording for Cobra. Cut in 1967, *West Side Soul* was his first Delmark masterpiece. Zbigniew Jastrzebski's design incorporated a photo of Sam by Jack Bradley.

ABOVE RIGHT: Now the unchallenged king of Chicago blues, Buddy Guy made many of his hottest recordings not long after he came to town from Louisiana in 1957—especially the fleet-fingered guitarist's 1960–67 output for Chess and his riveting 1968 Vanguard LP *A Man & the Blues*, the cover of which shows the psychedelic movement touching on the blues.

216 THE ART OF THE BLUES

TOP LEFT: When Junior Wells made his initial sides for Chicago's States Records in 1953, his harmonica style showed the influences of the first Sonny Boy Williamson and Little Walter. By the time he made his 1968 Blue Rock LP *You're Tuff Enough*, Junior was in more of a soul bag.

BOTTOM LEFT: Lonnie Brooks was known as Guitar Jr. on the Gulf Coast when he recorded "Family Rules" in 1957, but after migrating to Chicago he played high-energy blues, especially after joining Alligator Records in 1978. He revived Guitar Jr. one more time for *Broke an' Hungry* on Capitol in 1969.

TOP RIGHT: Koko Taylor long wore the crown as Queen of Chicago Blues. Her 1966 hit rendition of her mentor Willie Dixon's "Wang Dang Doodle" was a highlight of her first Chess album in 1969. Don Wilson created the album cover image. Taylor's reign endured until she passed away in 2009.

BOTTOM RIGHT: *Somebody Loan Me a Dime,* issued on Alligator in 1974, was the album of a lifetime for Chicago's "mellow blues genius" Fenton Robinson, who debuted in 1957 on Meteor in Memphis. Jan Loveland designed artwork for the LP, which spotlighted Robinson's jazz-tinged guitar.

THE BIG TIME: ALBUM COVERS, PART 2

THE THREE KINGS

During the 1960s, electric guitar ascended to the throne it holds today as king of the blues world. Intriguingly, the three most influential and popular blues guitarists of that decade and well beyond all shared the same regal surname of King. B. B., Albert, and Freddie each brought their own inimitable touch and signature licks to their powerhouse playing, and their assured vocals were the equal of their instrumental technique. Their influence was immense, and not just in the blues world; blues-rockers all over the world adapted their innovations to their own fretwork.

OF THE THREE blues Kings it was B. B. who came first. Born outside of Itta Bena, Mississippi, he made his way to Memphis (where his cousin Bukka White lived) and snagged a few minutes of daily airtime on WDIA radio. That led to King's first recordings in 1949 for Jim Bulleit's self-named Bullet label and then a long-term pact with the Bihari brothers' Los Angeles-based Modern label. B. B.'s first Modern sides were done at Sam Phillips's fledgling Memphis Recording Service, but by the mid-1950s he was cutting most of his hits at the Biharis' West Coast home base. Most of King's albums for the Crown budget imprint sported attractive portraits of B. B. and his best gal Lucille on their covers. When King moved over to the major ABC-Paramount label in 1962, the quality of his LP pressings improved markedly. Until his death in 2015, King reigned as a global ambassador for the blues, becoming the most recognizable proponent for the music on the planet.

Albert King's legal surname was actually Nelson, but the Indianola, Mississippi native had changed it by the time he debuted on wax. He took his place in the regal triumvirate on the strength of his upside-down attack on his Flying V guitar and his burnished baritone vocals. The massively constructed southpaw absorbed the standard blues influences plus an unusual one: Hawaiian music, which informed his mile-wide string bending. Albert honed his sound in Arkansas, made his first record in Chicago in 1953 for Al Benson's Parrot label, and emerged as a force during the late 1950s in St. Louis. Yet his career did not take off until he signed with Memphis-based Stax Records in 1966. Backed by Booker T. & the MG's, Albert scored with "Crosscut Saw" and "Born under a Bad Sign," his sound taking the blues world by storm.

Although he was born in Gilmer, Texas, and spent his last years in the Lone Star State, Freddie King was to a great extent a product of Chicago's West Side, which spawned a slashing sound all of its own. King arrived in the Windy City in 1950. Big for his age, he was able to venture into the city's blues bars to see his heroes up close long before reaching twenty-one. After debuting on Chicago's minuscule El-Bee label in 1956, Freddie signed

BIG FOR HIS AGE, HE WAS ABLE TO VENTURE INTO THE CITY'S BLUES BARS TO SEE HIS HEROES UP CLOSE LONG BEFORE REACHING TWENTY-ONE.

with Cincinnati's Federal Records in 1960 and began recording with producer Sonny Thompson. His searing guitar and booming vocals were so persuasive that he scored seven chart entries in 1961, including his imaginative signature instrumental "Hide Away." Freddie's early albums for Syd Nathan's parent King Records usually pictured him with his guitar, the label saving a few cents by using the same photo on two different covers. Keyboardist Leon Russell escorted Freddie in more of a blues-rock direction on three early 1970s albums for his Shelter label. Freddie died at the height of his popularity in 1976, aged only forty-two.

All three Kings benefited from a blossoming interest in blues by the white rock demographic, both stateside and overseas. They shared various late 1960s bills in the rock palaces of the day with the young Caucasian bands who idolized them, spreading recognition of their mastery into the mainstream like never before. B. B.'s violin-enriched minor-key blues "The Thrill Is Gone" broke into the Top 15 on *Billboard*'s pop hit parade in 1970—its crossover success gaining King a prestigious guest slot on an episode of *The Ed Sullivan Show*, America's top television variety program.

Blues had hit the big time at last.

ABOVE LEFT: *Singin' the Blues* was B. B. King's first album in 1957, packed with his most influential hits from the RPM label including "Three O'Clock Blues." Gene Lesser was responsible for its cover photo. B. B.'s ascension to superstardom was underway; he would prove to be the most important electric blues guitarist of all, an ambassador to the world. He passed away in 2015.

ABOVE RIGHT: Born in Texas but largely a product of Chicago's West Side, Freddie King was a fierce vocalist and devastating guitarist whose Federal recordings, especially his instrumental "Hide Away," were extremely popular. The impact of Freddie's instrumental 1961 LP *Let's Hide Away and Dance Away* for the King label was immense when it was first released, and remains so today.

BOTTOM RIGHT: Stardom did not come overnight for southpaw guitarist Albert King. The Mississippi native made a 1953 record in Chicago for Parrot and crafted his own sound at Bobbin Records in St. Louis before arriving at Memphis-based Stax. King took the blues world by storm in 1966–67 with "Crosscut Saw" and "Born under a Bad Sign."

THE BIG TIME: ALBUM COVERS, PART 2

SOURCES

Beaumont, Daniel. 2011. *Preachin' the Blues: The Life and Times of Son House.* Oxford, U.K.: Oxford University Press.

Bernard, Emily. 2012. *Carl Van Vechten and the Harlem Renaissance: A Portrait in Black and White.* New Haven, Connecticut: Yale University Press.

Bowean, Lolly. "Chicago Defender Goes Back to Bronzeville." *Chicago Tribune,* May 27, 2009.

Broven, John. 2009. *Record Makers and Breakers: Voices of the Independent Rock 'n' Roll Pioneers.* Illinois: University of Illinois Press.

Bryant, Clora, Buddy Collette, William Green, Steve Isoardi, and Marl Young. 1999. *Central Avenue Sounds: Jazz in Los Angeles.* Oakland, California: University of California Press.

Calt, Stephen. 1994. *I'd Rather Be the Devil: Skip James and the Blues.* New York: Da Capo Press.

Cogdell DjeDje, Jacqueline, and Eddie S. Meadows. 1998. *California Soul: Music of African-Americans in the West.* Berkeley, California: University of California Press, 1998.

Cohodas, Nadine. 2000. *Spinning Blues Into Gold: The Chess Brothers and the Legendary Chess Records.* New York: St. Martin's Press.

Collins, Tony. 1995. *Rock Mr. Blues: The Life and Music of Wynonie Harris.* Milford, New Hampshire: Big Nickel Publishers.

Danchin, Sebastian. 2001. *Earl Hooker, Blues Master.* Jackson, Mississippi: University Press of Mississippi.

Dixon, Robert M. W., and John Godrich. 1982. *Blues and Gospel Records 1902–1943.* Essex, U.K.: Storyville Publishers and Co. Ltd.

Dixon, Willie, with Don Snowden. 1989. *I Am the Blues: The Willie Dixon Story.* New York: Da Capo Press.

Escott, Colin, with Martin Hawkins. 1991. *Good Rockin' Tonight: Sun Records and the Birth of Rock 'n' Roll.* New York: St. Martin's Press.

Feather, Leonard. 1977. *Inside Jazz.* New York: Da Capo Press.

Flerlage, Raeburn. 2000. *Chicago Blues As Seen From the Inside: The Photographs of Raeburn Flerlage.* Toronto, Ontario: ECW Press.

Fox, Ted. 2003. *Showtime at the Apollo.* Rhinebeck, New York: Mill Road Enterprises.

Garon, Paul and Beth. 1992. *Woman with Guitar: Memphis Minnie's Blues.* New York: Da Capo Press.

Gart, Galen, and Roy C. Ames. 1990. *Duke/Peacock Records: An Illustrated History with Discography.* Milford, New Hampshire: Big Nickel Publishers.

Govenar, Alan. 1995. *Meeting the Blues: The Rose of the Texas Sound.* New York: Da Capo Press.

Guralnick, Peter. 2015. *Sam Phillips: The Man Who Invented Rock 'n' Roll.* New York: Little, Brown and Company.

Harris, Sheldon. 1979. *Blues Who's Who.* New York: Da Capo Press.

Hartley Fox, Jon. 2009. *King of the Queen City: The Story of King Records.* Illinois: University of Illinois Press.

Janega, James, and Donna Freedman. "Raeburn 'Ray' Flerlage, 87, Photographer of '60s Blues Scene." *Chicago Tribune,* October 4, 2002.

King, B. B., with David Ritz. 1996. *Blues All Around Me: The Autobiography of B. B. King.* New York: Avon Books.

Leadbitter, Mike, and Neil Slaven. 1987. *Blues Records 1943–1970: A Selective Discography, Volume One, A to K.* London: Record Information Services.

Leadbitter, Mike, Leslie Fancourt and Paul Pelletier *Blues Records 1943–1970: Volume Two, L to Z.* London: Record Information Services.

Marovich, Robert M. 2015. *A City Called Heaven: Chicago and the Birth of Gospel Music.* Urbana, Springfield, and Chicago, Ilinois: University of Illinois Press.

McGrath, Jim. 2005–07. *The R&B Indies.* West Vancouver, British Columbia: Eyeball Productions Inc.

Meeker, David. 1981. *Jazz in the Movies.* New York: Da Capo Press.

Morgan, Thomas, and William Barlow. 1992. *From Cakewalks to Concert Halls: An Illustrated History of African American Popular Music From 1895 to 1930.* Montgomery, Alabama: Black Belt Press.

"Obituary: James J. Kriegsmann; Theatrical Photographer, 85." *New York Times,* May 1, 1994.

Praetzellis, Mary, and Adrian Praetzellis "'Black Is Beautiful:' From Porters to Panthers in West Oakland." https://www.sonoma.edu/asc/cypress/finalreport/Chapter10.pdf.

Riesman, Bob. 2011. *I Feel So Good: The Life and Times of Big Bill Broonzy.* Chicago: University of Chicago Press.

Rowe, Mike. 1975. *Chicago Breakdown.* New York: Drake Publishers Inc.

Russell, Tony. "Samuel Charters Obituary." *The Guardian,* March 26, 2015.

Ryan, Marc. 1992. *Trumpet Records: An Illustrated History with Discography.* Milford, New Hampshire: Big Nickel Publishers.

Salem, James M. 1999. *The Late Great Johnny Ace and The Transition from R&B to Rock 'n' Roll.* Illinois: University of Illinois Press.

Sampson, Henry T. 2014. *Blacks in Blackface: A Sourcebook on Early Black Musical Shows, Volume One.* Plymouth, U.K.: The Scarecrow Press, Inc.

Seroff, Doug, "Roy Milton's Miltone Records." *Blues Unlimited,* Number 115, September/October 1975.

Wald, Gayle F. 2007. *Shout, Sister, Shout! The Untold Story of Rock-and-Roll Trailblazer Sister Rosetta Tharpe.* Boston: Beacon Press.

Wexler, Jerry, and David Ritz. 1994. *Rhythm and the Blues: A Life in American Music.* New York: St. Martin's Press.

Wolff, Daniel. 2001. *Ernest C. Withers: The Memphis Blues Again.* New York: Viking Studio.

Internet Resources

78 Discography website: http://www.78discography.com
Ace Records website: http://acerecords.co.uk/queen-of-the-boogie-and-more.com
AllMusic Guide website: http://www.allmusic.com
Arhoolie Records website: http://www.arhoolie.com/about-us.html
Both Sides Now website: http://www.bsnpubs.com/discog.html
Chicago Defender website: http://chicagodefender.com
Delta State University website: http://www.deltastate.edu/academics/libraries/university-archives-museum/web-exhibits/hooks-brothers-web-exhibit/hooks-studio.com
Dick Waterman Music Photography website: http://www.dickwaterman.com
DownBeat website: http://www.downbeat.com
Hatch Show Print website: http://hatchshowprint.com/ContentPages/history-of-hatch
HistoryGrandRapids.org website: http://www.historygrandrapids.org/article/2192/the-hooks-brothers-african-ame
International Center of Photography website: http://www.icp.org/browse/archive/constituents/benny-a-joseph?all/all/all/all/0
Internet Movie Database website: http://www.imdb.com
Interview with Charles H. Tilghman, Printer and Owner of Tilghman Press, by Ruth Beckford: https://archive.org/details/caolaam_000050
Jazz Lives website: https://jazzlives.wordpress.com/tag/washboard-serenaders
Jim Flora website: http://www.jimflora.com
Jug Band Hall of Fame website: http://www.jughall.org/main/nominee_view.html?ID=3
Juke Blues website: http://www.jukeblues.com/about-us.html
Library of Congress website: https://www.loc.gov
Living Blues website: https://livingblues.com
Maryland Institute College of Art website: https://www.mica.edu/News/MICA_to_Purchase_Historic_Globe_Poster_Collection.html
Mississippi Blues Trail website: http://www.msbluestrail.org/blues-trail-markers/rabbit-foot-minstrels
"My Life in Recording" by Lester Melrose: http://talk-music.proboards.com/thread/188/lester-melrose
OpalNations.com website: http://opalnations.com/files/Spirit_of_Memphis_Acrobat_CD_3007_Liner_Notes.pdf
ParamountsHome.org website: http://paramountshome.org
PosterCentral.com blog: http://blog.postercentral.com
Red Hot Jazz Archive website: http://www.redhotjazz.com
Storyville New Orleans website: http://www.storyvilledistrictnola.com/district.html
The Birka Jazz website: http://www.birkajazz.com
The Mainspring Press Record Collectors' Blog blogpage: https://78records.wordpress.com/tag/race-records
The Red Saunders Research Foundation website: http://myweb.clemson.edu/~campber/rsrf.html
"The Roy Milton and Miltone Record Labels," by Opal Louis Nations: http://opalnations.com/files/Miltone_Records_Roy_Milton_Blues_Rhythm_235_Dec.08_Jan.09.pdf
"The Trilon Records—Rene T. LaMarre Story" by Opal Louis Nations: http://opalnations.com/files/Trilon_Records_Story_Blues_Rhythm_231_Aug.2008.pdf
The Vocal Group Harmony website: http://www.vocalgroupharmony.com/4ROWNEW/StudyWar.htm
The Delta Blues website: http://www.tdblues.com/2010/08/h-c-speir-the-legend
VinylBeat.com website: http://vinylbeat.com/album-42-Fazzio.html
Voices of East Anglia website: http://www.voicesofeastanglia.com/2012/05/thats-entertainment-the-kriegsmann-files.html

PICTURE CREDITS

Key: t: top; b: bottom; l: left; r: right; c: center; a: above

Images are courtesy of the following collections:

Courtesy 33RPM Collection: 153, 159, 160br, 163tr, 208l, 214bl, 216l;

African American Sheet Music Collection, John Hay Library, Brown University, Providence R.I.: 14l, 15r, 16br;

Afro-American Newspaper (National Edition): 45r (Apr 2, 1927), 47l (Feb 19, 1927), 47r (May 28, 1927), 48 (Aug 13, 1927), 49l (May 28, 1927), 49r (Nov 26, 1927), 50l (Jun 18, 1927), 51r (May 21, 1927), 53l (Jun1, 1929), 53r (Nov 9, 1929), 54tl (Oct 20, 1928), 54r, 54bl (Dec 1, 1928), 55l, 101l (Feb 9, 1929), 55r (Nov 10, 1928), 58c (Jun 29, 1929), 58r (Jun 8, 1929), 58l (May 24, 1930), 59l (Jan 26, 1929), 59r (Jul 20, 1929), 64l (Jul 7, 1928), 64r (Sep 18, 1926), 69tl (May 17, 1930), 77l (Mar 31, 1928), 99l (May 18, 1929), 103br (May 4, 1929), 107r (Oct 26, 1929);

Alamy: 111r (Pictorial Press);

Beinecke Library, Yale University: 13 (Carl Van Vechten, used by permission of the Van Vechten Trust);

Courtesy of the Blues Archive, J. D. Williams Library, University of Mississippi: 154, 155tl, 157tl, 160tr, 160tl, 164tl, 208r, 209, 210tl, 210bl, 211r, 211l, 213tr, 215r, 216r, 217tl, 217tr, 217br, 219tr;

Mark Berresford Collection: 7l, 7r, 66bc, 100l, 102t, 118r, 169t, 169b, 170r, 171, 196b, 201r;

The Cache Agency: 144, 178b, 219b (Bill Greensmith), 179br (Billy Vera Collection), 113br (Consolidated Image Foundation), 133t (Pictorial Press), 180, 181, 183l (Ray Flerlage), 213bl, 219tl (Rudy Calvo Collection), 183r (Val Wilmer);

Chicago Defender **Newspaper (National Edition):** 43 (Oct 4, 1924), 45l (May 29, 1926), 46 (May 28, 1927), 52l (Jul 7, 1928), 52r (Sep 29, 1928), 57 (Nov 24, 1923), 106r (Apr 20, 1929), 108tr (Apr 26, 1930);

Bill Dahl: 38, 163bl, 163br, 201bl, 210r, 213tl, 213br, 214tl, 214br, 217bl;

Mitch Diamond (www.Kardboardkid.com): 117t, 123, 125r, 126tr, 126l, 126br, 127r, 127l, 202r, 202tl, 202bl, 203b, 203t;

© The Heirs of James Flora, courtesy JimFlora.com: 152r;

Getty Images: 68 (Archive Photos/New York Historical Society), 44 (LIFE Picture Collection/Alfred Eisenstadt), 89tl (LIFE Picture Collection/William C Shrout), 109tr, 110, 141tr, 142bl, 147t, 170l, 173t, 177l, 178r, 179tr, 182tl, 182r (Michael Ochs Archives), 119, 121tr, 121tl, 121b, 129 (Moviepix/John D Kisch/Separate Cinema), 118l, 121tc (Moviepix/Movie Poster Image Art), 182bl (Redferns/Chris Morphet), 175t (Redferns/Gilles Petard);

Courtesy of Rob Gillis: 207r;

Heritage Auctions: 207l;

Chris James Collection (photography by Todd Barnes): 8l, 15l, 16l, 17l, 17r, 19t, 19b, 21l, 21r, 22, 23l, 24b, 24t, 25b, 25t, 27l, 27r, 28, 29, 30r, 30l, 31, 32, 33l, 33r, 34, 35l, 35r, 36l, 36r, 37, 39, 63l, 63r, 65, 66tl, 66tr, 66br, 66bl, 67br, 67tr, 69r, 70l, 71l, 71r, 72l, 72r, 73r, 73l, 74tl, 74ttr, 75l, 75r, 77r, 78, 79l, 79tr, 79bl, 80, 81tl, 81tr, 81bl, 81br, 82r, 82l, 83l, 83tr, 83br, 84l, 84r, 85tr, 85tl, 86tl, 86cl, 86bl, 86tr, 87tl, 87cl, 87bl, 87tr, 88tl, 88cl, 88tr, 89tl, 89bl, 89br, 90tl, 90tr, 90bl, 90br, 91, 92tl, 92tr, 92br, 92bl, 93r, 93l, 94, 95r, 95l, 99tc, 99cr, 99br, 100tr, 101r, 103bl, 105tl, 105bl, 105br, 107cl, 107bl, 108bl, 109br, 109tl, 112br, 112bl, 112tr, 112tl, 113tl, 113tr, 124tr, 124b, 124tl, 125l, 133br, 133bl, 135tr, 136l, 136r, 137bl, 137tl, 137tr, 138, 139tl, 139tc, 139tr, 139cl, 139c, 139cr, 139bl, 139bc, 139br, 140tr, 140cr, 140br, 141br, 141acl, 141bl, 141bcl, 141tl, 142tl, 142tr, 142br, 143tl, 143bl, 146bl, 146br, 147bl, 147br, 151t, 152tl, 155tr, 155br, 155bl, 165, 172, 174tr, 187, 189l, 189r, 190tl, 190tr, 191tl, 191tr, 192, 193tl, 193tr, 193br, 194l, 194r, 195, 196t, 197tl, 197br, 197tr, 198l, 198r, 201tl;

Izumi Kinoshita: 67l, 70r, 74br, 99bm, 99tr, 102br, 103tl, 103tr, 105tr, 106tl, 106bl, 107tl, 108tl, 108br, 111tl, 111ml, 111bl, 190bl;

Charlie Lange Collection: 135r, 140tl, 143tr, 143br, 146t, 173b, 174tl, 174bl, 175b, 177r, 179l, 199;

Lester Public Library/Jeff Dawson: 9t;

Library of Congress: 14r (ref. 202033247), 9b, 134 (Marion Post Wolcott, Farm Security Administration—Office of War Information Collection), 117b (Minstrel Poster Collection);

Memphis and Shelby County Room, Memphis Public Library & Information Center: 176;

Used by permission of the University of Missouri-Kansas City Library, Dr. Kenneth J. LaBudde Department of Special Collections: 120r, 120l;

Tom Moon: 145l, 145cr, 145cl, 145r;

Sylvia Pitcher Photo Library: 164bl, 164br;

Private Collection: 158r, 161, 163tl, 164tr, 215l;

Smithsonian Institution: 157br, 157tr (Moses and Frances Asch Collection, Ralph Rinzler Folklife Archives and Collections), 18 (Sam DeVincent Collection of Illustrated American Sheet Music, ca. 1790-1980, Archives Center, National Museum of American History);

Courtesy of Sony Music Archives: 8r, 151b, 158l, 160bl, 214tr;

York University Toronto Libraries, Clara Thomas Archives & Special Collections, John Arpin fonds: 16tr, 23r;

With grateful thanks also to all the the record companies and their talented graphic designers, without whom this book would not have been possible: Aladdin, Allegro Elite, Alligator, Argo, Arhoolie, Aristocrat, Atlantic, Big Town, Black Patti, Bluebird, Blue Lake, Blue Note, Brunswick, Bullet, Capitol, Champion, Checker, Chess, Clef, Cobra, Columbia, Combo, Conqueror, Crown, Cuca, Decca, Delmark, DeLuxe, Duke, Epic, Excello, Fire, Folkways, Freedom, Gennett, Herald, Master, Melotone, Mercury/EmArcy, Meteor, Modern, Okeh, Old Swing Time, Oriole, Paramount, Parrot, Peacock, Perfect, Phillips, Prestige Bluesville, QRS, RCA Victor, Romeo, Rhumboogie, Savoy, Sensation, Sittin' in With, Specialty, Sunshine, Trilon, Vanguard, Variety, Vee-Jay, Verve, Vocalion, Vogue.

Every effort has been made to trace and credit the copyright holders of material reproduced in this publication. Any omissions are unintentional, and will be corrected in future editions.

CONTRIBUTOR BIOGS

Bill Dahl is a freelance music journalist who writes regularly for the *Chicago Tribune*, *Living Blues*, and *Goldmine*. He has written or cowritten liner notes for countless albums—including the boxed set, *Ray Charles—Genius and Soul: The 50th Anniversary*, for which he received a Grammy nomination. He is the author of *Motown: The Golden Years*.

Chris James is an award-winning recording artist and music historian with over thirty years' experience in the music business. He has toured the world, performing and recording alongside many of the most celebrated artists in blues and jazz history. With multiple critically acclaimed albums under his belt, Chris James's music has topped domestic and international radio charts, and was featured prominently in the Martin Scorsese-produced PBS documentary, *The Blues*. He has spent decades researching and collecting blues artwork and ephemera.

ACKNOWLEDGMENTS

Many people helped put this book together and deserve my heartfelt thanks. Will Steeds, Joanna de Vries, and Sally Claxton gave me the chance to embark on a fascinating journey. I would never have been able to complete this project without the extremely knowledgable input of Chris James, whose advice was as essential to its success as are the many incredible images that he has contributed. Todd Barnes's expert photographic skills made those images even more beautiful than they already were.

Thanks are also due to Mark Berresford, Izumi Kinoshita, and Charlie Lange for the loan of some of the rarest images in the book. Rob Gillis and D. Thomas Moon also contributed images. Lisa Miller and Quartet Digital Printing and Kate Moss helped by scanning album covers, Felix Wohrstein offered valuable source material, and Leslie Keros and Patrick Rynn lent welcome support. Ruthie Bailey and Lola Bailey contributed just by being themselves. Grateful thanks also go to Paul Palmer-Edwards of Grade Design for displaying these beautiful blues artworks to their best advantage.

INDEX

"5" Royales, the, 132
4 Aces, the, 93

Abbey, Leon, 24
ABC-Paramount, 162, 214, 218
Abrams, Bernard, 144
Abramson, Herb, 132
Ace, Johnny, 134, 168
Adams, Jo-Jo, 125
Adins, George, 147
Age Records, 215
Ajax Records, 42
Aladdin Records, 127, 132, 140–41, 150, 182, 199, 202
Alexander, Alger "Texas," 44, 58, 79
Alexander, William "Alex," 138–39
Allegro Elite Records, 154–55
Allen, Norman, 74
Allen, Red, 197
Allen, Tom, 158
Allen, William B., 156
Alligator Records, 188, 206, 217
American Folk Blues Festival, 182, 200
American Printing & Lithographing Co., 118
American Record Corporation (ARC), 31, 44, 45, 50, 104–05, 110, 111, 113, 140, 156
Ammons, Gene "Jug," 162, 202, 206
Anderson, Eddie "Rochester," 121
Anderson, Ivie, 128
Apollo Records, 132
Apollo Theater, Harlem, 118, 125, 202
Arhoolie Records, 164, 206, 208, 215
Aristocrat Records, 140–41, 144, 145, 173
Armstrong, Louis, 6, 17, 20, 27, 34, 41, 44, 55, 59, 62, 66, 98, 99, 121, 150, 152, 188, 201
Arnold, Billy Boy, 214
Arto Records, 16, 42
Asch, Moses, 156, 180
Atlantic Records, 38, 132, 150, 151, 156, 158, 160, 161, 170, 195, 203, 208, 213
Austin, Lovie, 14, 15, 18, 57, 191

Baker, Josephine, 200
Baker, LaVern, 15, 38, 195
Baker, Willie, 107
Ballen, Ivin, 138
Baltimore Afro-American, 42, 54, 69, 76, 107
Banner Records, 104
Barber, Chris, 161
Barker, Blue Lou, 87
Barnes, Walter, 53, 170
Barrel House Five, the, 20
Barth, Bill, 171
Bartholomew, Dave, 132, 214
Basie, Count, 11, 23, 120, 128, 151, 158, 169
Bastin, Bruce, 186
Beale Street Sheiks, the, 74
Beale Street, Memphis, 12, 135, 176
Bechet, Sidney, 20, 150, 200
Beck, Blind James, 46
Becky, Son (Leon Calhoun), 85
Bedno, Howard, 145
Belle, Blue (St. Louis Bessie), 48
Benson, Al, 145, 218
Berlin, Irving, 24, 118
Berliner, H. S., 42
Berry, Chuck, 8, 15, 39, 133, 154–55, 171
Berry, Leon "Chu," 30, 98
Bertrand, Jimmy, 44, 77
Big Maceo, 26, 64, 83, 98
Big Town Records, 143
Bihari Brothers, 132, 212, 218
Black Patti Records, 42, 46, 62, 102, 144, 168
Black Swan Records, 12, 42

Blackwell, Scrapper, 54, 112, 211
Blake, Arthur "Blind," 42, 47, 103, 105, 190
Blake, Eubie, 14, 15
Bland, Bobby "Blue," 122, 134, 186, 209
Blue Five, the, 20, 21
Blue Goose Records, 208
Blue Lake Records, 145, 147
Blue Note Records, 94
Blue Rock Records, 217
Bluebird Records, 20, 26, 62, 64, 68, 80, 81, 82, 83, 87, 88, 89, 98, 112, 143, 160, 161, 210
Bluesville Records, 98, 180, 206, 209, 211
Bobbin Records, 163, 219
Bogan, Lucille, 106
Bogan, Ted, 79
Boger, Carlo, 201
Borum, Willie, 108, 127
Boyd, Eddie, 200
Bracey, Ishmon, 110
Bracken, Jimmy, 145
Bradford, Perry, 14, 16
Bradley, Jack, 216
Bradshaw, "Tiny," 95, 125, 132, 154–55
Brenston, Jackie, 199, 213
Broadnax, Willmer "Little Ace," 146
Bronstein, Don, 152, 162–63
Bronze Records, 132
Brooks, Hadda, 132, 152, 212
Brooks, Lonnie "Guitar Jr.," 217
Broonzy, Big Bill, 7, 26, 64, 81, 104, 113, 144, 186, 200, 205
Broven, John, 186
Brown, Buster, 206
Brown, Charles, 127, 132
Brown, Clarence "Gatemouth," 134, 146
Brown, J. T., 147
Brown, James, 118, 134
Brown, Lee, 87
Brown, Nappy, 123
Brown, Pete, 135
Brown, Roy, 132, 137
Brown, Ruth, 128, 132, 160, 203
Brown, Willie, 42, 110, 156, 170
Brunswick Records, 26, 30, 33, 44, 45, 53, 58, 59, 73, 78, 84, 99, 104, 106, 150
Bruynoghe, Yannick, 186
Bryant, Willie, 128
Bulleit, Jim, 218
Bullet Records, 218
Burnett, Rev. J. C., 65

Calicott, Joe, 45
Calloway, Cab, 15, 34, 78, 121, 128, 198
Cameo Records, 16, 62, 104
Cannon, Gus (Banjo Joe), 103, 127
Capitol Records, 36, 150, 217
Cardinal Records, 64
Carlisle, Una Mae, 128, 129
Carr, Leroy, 44, 54, 112, 211
Carter, Benny, 98, 200
Carter, Bo (Armenter Chatmon), 64, 82, 106, 110
Carter, Vivian, 145
Casey, Lawrence (Papa Egg Shell), 59
Cash, Johnny, 134
Challenge Records, 104
Champion Records, 62, 105, 107
Chappelle, Pat, 116
Charles, Ray, 132, 157, 158, 171
Charters, Sam/Samuel, 186, 214
Checker Records, 140, 144, 159, 163, 207
Chess Records, 39, 81, 118, 144, 145, 162–63, 164, 178, 179, 206, 216, 217
Chess, Leonard, 144
Chess, Phil, 144
Chicago 7, 12, 20, 53, 54, 55, 56, 62, 64, 80, 82, 90, 98, 105, 110, 113, 140–41, 144–45, 162, 178, 181, 188, 189, 195, 207, 209

Chicago Defender 42, 45, 46, 55–56, 76, 106
Chief Records, 215
Christian, Charlie, 7, 94
Class Records, 132
Clayborn, Rev. E. W., 77
Clef Records, 188
Cobra Records, 126, 145, 216
Cole, Nat King, 15, 36, 158
Collier, Charles, 116
Collins, Sam, 62
Columbia Records, 14, 20, 26, 32, 35, 44, 45, 49, 50–51, 62, 64, 65, 68, 90, 98, 99, 104, 117, 132, 133, 140, 144, 150, 151, 152, 158, 170, 196, 214
Combo Records, 132, 160
Conqueror Records, 91, 104, 108
Cooke, Sam, 118
Coral Records, 45
Corley, Dewey, 171
Cornshucks, Little Miss, 138, 162
Cotten, Elizabeth, 156, 171
Cotton Club Orchestra, the, 128
Covarrubias, Miguel, 188
Cox, Ida, 42, 57, 116, 191
Crayton, Pee Wee, 132, 142, 165
Creole Harmony Kings, the, 197
Crown Records, 165, 209, 212, 213, 218
Crudup, Arthur "Big Boy," 64, 206, 210
Crumb, Robert, 208
Crump, Edward "Boss" H., 12
Cuca Records, 215

Davenport, Cow Cow, 150
Davis, Blind Gary, 110, 111
Davis, Charlie, 27
Davis, Joe, 30
Davis, Miles, 206
Davis, Rev. Gary, 171, 190, 206
Davis, Walter, 64, 81, 140
Decca Records, 20, 33, 35, 44, 45, 64, 86, 87, 109, 125, 143, 150
Delaney, Tom, 16
Delaunay, Charles, 200
Delmar(k) Records, 160, 180, 206, 216
DeLuxe, Records, 132, 136, 137
Denson, ED, 171
Derby Records, 154–55
Dexter, Dave, 188
Diddley, Bo, 147, 207, 214
Dig Records, 135
Disley, Diz, 161
Dixie Syncopators, the, 55, 99
Dixie Washboard Band, the, 20
Dixon, Robert M. W., 186
Dixon, Willie, 126, 145, 171, 187, 200, 217
Dodds, Johnny, 49, 66
Domino, Fats, 15, 132, 203, 214
Dominoes, the, 134, 193
Donaldson, Walter, 24
Dootone (Dooto) Records, 95, 132, 138
Dot Records, 134
Down Beat Records, 132
Duke Randall and His Boys, 102
Duke Records, 134, 168, 209, 210
Dupree, "Champion" Jack, 123, 132, 200

E. J. Warner Poster Co., 118
Eaglin, Snooks, 156, 157
East Coast, US, 6, 62, 116, 118
Easton, Amos "Bumble Bee Slim," 64, 79, 143
Ebony Records, 144
Eckstine, Billy, 136
Edison, Thomas, 14, 50
Edwards, Esmond, 206
Edwards, Frank, 214
Edwin H. Morris & Co., 26
Eisenstaedt, Alfred, 44
El-Bee Records, 218

Ellington, Duke, 6, 15, 29, 34, 84, 121, 128, 150, 168
EmArcy Records, 154
Emerson Records, 104
Emerson, Billy "the Kid," 134
Epic Records, 160
Erby, John (Jack), 35, 101
Erdman, Ernie, 19
Ertegun, Ahmet, 132
Estes, Sleepy John, 64, 86, 144, 171, 206
Europe, James Reese, 200
Excello Records, 134, 164
Excelsior Records, 132, 175
Exclusive Records, 132, 198

F. W. Boerner Co., 76–77
Fahey, John, 170, 171
Fazzio, 206, 212–11
Feather, Leonard, 188
Federal Records, 134, 150, 218, 219
Fields, Ernie, 138
Fiorito, Ted, 19
Fire Records, 207, 210
Fitzgerald, Ella, 33, 202
Flair Records, 212
Flerlage, Raeburn, 180–81
Fletcher, Dusty, 129
Flora, Jim, 150, 152
Folk-Lyric Records, 156
Folkways Records, 152, 156, 157, 180, 186
Foster, Edward, 74
Foster, Little Willie, 145
Four Blues, the, 136
Foxx, Redd, 95
Freedom Records, 140–41
Friedlander, Lee, 157
Frost, Frank, 210
Fuller, Blind Boy, 85, 91, 104–05, 110–11, 186
Fuller, Jesse "Lone Cat," 171
Fuller, Walter, 139
Fulson, Lowell, 92, 93, 132, 140
Fulson, Martin, 140

Gabler, Milt, 188, 194
Gaither, Bill, 87
Gant, Cecil, 132
Gates, J. M., 82
Gayten, Paul, 132, 137
Geddins, Bob, 92
Gennett Records, 20, 25, 26, 62, 66, 67, 98, 99, 107
Gibson, Clifford, 69
Gillespie, Dizzy, 188
Gillum, Jazz, 64
Gilt-Edge Records, 132
Gleason, Ralph, 188, 194
Glenn, Lloyd, 213
Globe Poster Printing Corp., 9, 116, 118
Godrich, John, 186
Gold Star Records, 182
Goldband Records, 201
Goldstein, Norman, 116
Goodman, Benny, 30, 101, 197
Gordon, Dexter, 132
Gotham Records, 138, 211
Grainger, Porter, 15, 17, 65
Granz, Norman, 188
Green, Lil, 26
Green, Viviane, 92
Grey Gull Records, 20
Grissom, Jimmy, 138, 139
Guy, Buddy, 145, 216

Hall, Edmond, 94
Hammond, John, 188
Hampton, Lionel, 44, 138, 154, 188
Hamp-Tone Records, 138
Handy, W. C. (Father of the Blues), 6, 12, 13, 50, 61, 117, 119, 176, 188

Harlem Renaissance, the, 6, 13, 64, 128, 168
Harpo, Slim, 134, 182
Harptones, the, 128
Harris, Rebert H., 140–41
Harris, Sheldon, 188
Harris, Willie, 106
Harris, Wynonie, 95, 132, 175
Harvey, 214
Hatch, Will T., 116
Haven, Shirley, 127
Hawkins, Coleman, 98, 200
Hawkins, Erskine, 118, 194
Hayes, Roland "Boy Blue," 157
Haynes, Daniel L., 118
Hegamin, Lucille, 16, 20, 42
Heineman, Otto K. E., 44
Henderson, Fletcher, 18, 20, 22, 30, 98, 99, 101, 128, 197
Henry, Clarence "Frogman," 163
Herald Records, 182
Hicks, Robert "Barbecue Bob," 51
Hightower, Lottie, 102
Hightower, Willie, 102
Hines, Earl, 103, 139
Hinton, Jimmy "Skeeter," 103
Hite, Les, 31
Hodges, Johnny, 203
Hogg, Arthur "Smokey," 209
Holiday, Billie, 98, 150, 188
Holmes, Horace, 100
Hooker, Earl, 215
Hokum Jug Band, the, 105
Hooker, John Lee, 9, 118, 162, 167, 171, 188, 200, 206, 212, 213
Hooks, Henry, 176
Hooks, Robert, 176
Hooper, Louis, 99
Hopkins, Claude, 32
Hopkins, Linda, 128
Hopkins, Sam "Lightnin'," 132, 182, 200, 208
Horne, Lena, 121
Horton, Big Walter, 180
Hoskins, Tom, 170
Hot Five, 44, 59, 152
Hot Lips Page, 72, 169
Hot Seven, 44, 59
House, Son, 8, 42, 110, 156, 170, 171, 214
Houston, Joe, 160
Howard, Camille, 138
Howard, Rosetta, 86
Howell, Joshua Barnes "Peg Leg," 64, 65
Hughes, Langston, 56, 168
Hughes, Pee Wee, 214
Hull, Papa Harvey, 46
Hunter, Alberta, 14, 15, 18, 20, 42
Hunter, Ivory Joe, 132, 195
Hurston, Zora Neale, 168
Hurt, Mississippi John, 170, 171, 183
Hurte, Leroy, 132

Iglauer, Bruce, 188, 206
Imperial Records, 214
Impressions, the, 162
Ink Spots, the, 120
Israel, Marvin, 152, 158

Jack Mills Inc., 15, 18
Jackson, Armand "Jump," 173
Jackson, "Bull Moose," 95, 129, 134, 202
Jackson, Cliff, 100
Jackson, Jim, 44, 76, 116
Jackson, Little Son, 142
Jackson, Mahalia, 8, 132, 193
Jackson, Papa Charlie, 15, 191
Jackson, Tony, 20
James, Elmore, 134, 147, 213
James, Etta, 149, 162, 179
James, Skip, 42, 110, 171, 183

Jastrzebski, Zbigniew, 206, 216
Jazz Cardinals, the, 191
Jazz Hounds, the, 14, 16
Jefferson, Blind Lemon, 42, 52, 186, 189
John Stark & Son, 14
Johnson, Big Jack, 210
Johnson, Blind Willie, 50
Johnson, Charlie, 70
Johnson, Daniel, 74
Johnson, Ella, 193
Johnson, Elridge R., 68
Johnson, James P., 14, 128
Johnson, John H., 188
Johnson, Lil, 53
Johnson, Lonnie, 6, 8, 15, 44, 48, 58, 87, 88, 95, 101, 106, 200, 201
Johnson, Mary, 106
Johnson, Merline (Yas Yas Girl), 64, 105
Johnson, Pete, 151, 213
Johnson, Rev. Frank M., 140–41
Johnson, Robert, 6, 8, 9, 44, 85, 104, 110, 172, 176
Johnson, Tommy, 70, 101, 110
Jones, Alberta, 62
Jones, Curtis, 90, 143, 200
Jones, Floyd, 144, 145
Jones, Harry, 59
Jones, Jab, 171
Jones, Johnny, 83, 98
Jones, Moody, 144, 145
Jones, Paul, 139
Jones, Richard M., 66, 102
Jones, Sissieretta, 46, 168
Joplin, Scott, 6, 12, 14
Jordan, Charley, 64
Jordan, Louis, 15, 64, 87, 116, 124, 128, 174
Jordan, Luke, 70
Joseph, Benny, 168

Kahn, Gus, 19, 24
Kansas City Orchestra, the, 72, 120, 169
Kapp Music Company, 45
Kapp, Jack, 64
Keil, Charles, 186
Kennedy, Jesse "Tiny," 125
Kenny, Bill, 120
Kent Records, 140, 212
Keppard, Freddie, 191
Kersands, Billy, 20
King Cole Trio, the, 36, 124, 128, 132
King Oliver's Creole Jazz Band, 27, 62, 66, 98
King Records, 64, 95, 125, 132, 138, 150, 154–55, 160, 175, 202, 215, 218, 219
King, Albert (Albert Nelson), 128, 218, 219
King, B. B., 7, 118, 131, 132, 133, 145, 162, 168, 171, 176, 177, 186, 188, 212, 218, 219
King, Freddie, 134, 218, 219
Kirk, Andy, 30, 33, 45
Kirkland, Eddie, 206
Koester, Bob, 206
Kriegsmann, James J., 168

Laboe, Art, 160
Ladd's Black Aces, 67
LaMarre, Rene T., 92
Lauderdale, Jack, 132
Laurie, Annie, 132, 137
Law, Don, 110
Lawlars, Ernest (Little Son Joe), 109
Lead Belly, 118, 156, 157, 180
Leadbitter, Mike, 186, 188, 201
Lee, Bonnie, 209
Lee, George E., 28, 45
Lee, Julia, 28
Lenoir, J. B., 145
Lesser, Gene, 219
Lester, Lazy, 134, 164
Lewis, Edward, 64

Lewis, Furry, 44, 71, 127
Lewis, Jerry Lee, 134
Lewis, Meade Lux, 94, 116, 151
Lewis, Noah, 71
Liggins, Jimmy, 132, 199
Liggins, Joe, 132, 198, 199
Lightfoot, Papa, 214
Lion, Alfred, 94
Lippmann, Horst, 200
Lipscomb, Mance, 164, 171
Little Esther, 126, 132
Little Milton, 9, 128, 163
Little Richard, 186
Little Walter, 7, 118, 144, 159, 180, 188, 217
Littlefield, Little Willie, 142
Lockwood Jr., Robert, 172
Lofton, Cripple Clarence, 161
Lomax, Alan, 156, 157, 170, 188
Lomax, John, 156, 157
Lombardo, Carmen, 33
Lombardo, Guy, 15, 33
Long, J. B., 110–11, 156
Los Angeles, CA, 31, 35, 99, 101, 132, 142, 143, 160, 174, 175, 179, 198, 218
Louis, Joe Hill ("Be-bop Boy"), 134, 168, 177
Louis, Joe, 89
Loveland, Jan, 217
Lubinsky, Herman, 132
Lunceford, Jimmie, 35

M. M. Cole Publishing Co., 37
Mabley, Jackie "Moms," 129
Mabon, Willie, 118, 161
Mack, Ida May, 71
Maghett, Magic Sam, 145, 206, 216
Markham, Dewey "Pigmeat," 124, 125
Martin, Carl, 79
Martin, David Stone, 153, 188
Martin, Sara, 15, 17, 44, 49, 169
Marvel Records, 144
Mattis, David James, 134
Maurice Seymour Studios, 140–41, 168
Maybelle, Big, 160, 171
McClennan, Tommy, 64, 88
McCormick, Mack, 208
McCoy, Charlie, 45, 110
McCoy, Kansas Joe, 64, 109
McCoy, Robert (Nighthawk), 64, 112, 145
McCoy, Viola (Gladys Johnson), 100
McDonald, Earl, 49
McDowell, Fred, 156, 157, 171
McFadden, Charlie "Specks," 87
McGee, Rev. F. W., 69, 71
McGhee, Brownie, 90, 91, 110, 132, 156, 171, 200, 206
McKinney's Cotton Pickers, 150
McMullen, Fred, 140
McMurry, Lillian, 134
McNeely, Big Jay, 132
McTell, Blind Willie, 68, 140, 170
Melodisc Records, 175
Melotone Records, 104, 105, 113
Melrose, "Kansas City" Frank, 26
Melrose, Lester, 26–27, 44, 64, 66, 80, 88, 98, 105, 112, 144, 171
Melrose, Walter, 26–27, 66
Memphis Jazzers, the, 20
Memphis Jug Band, the, 68, 69, 75, 171
Memphis Minnie (Lizzie Douglas), 64, 104, 109, 144, 176, 188
Memphis Slim (John Lee Chatman), 64, 89, 156, 162, 164, 171, 178, 180, 200
Memphis, TN, 12, 18, 70, 71, 74, 75, 168, 176, 210
Mercury Records, 126, 154
Merrit Records, 28
Mesner, Eddie, 132
Mesner, Leo, 132

Meteor Records, 147, 177, 212
Micheaux, Oscar, 121
Milburn, Amos, 128, 132, 202
Miller, Al, 26
Miller, Luella, 54, 77
Miller, Punch, 55
Miller, Rice, 134, 172
Millinder, Lucky, 120, 129, 202
Mills Brothers, the, 30, 128
Mills, Irving, 198
Milton, Roy, 132, 138–39, 203
Miltone Records, 138–39
Miracle Records, 178
Mississippi Sheiks, the, 44, 64, 82, 86, 110
Modern Records, 132, 142, 165, 177, 178, 209, 210, 212, 213, 218
Moore, Johnny, 127, 128
Moore, Oscar, 36, 124
Moore, Rev. Gatemouth, 140–41
Morton, Jelly Roll, 20, 26, 62, 188
Mosley, Leo "Snub," 25
Moss, Eugene "Buddy," 105, 113
Moten, Bennie, 6, 23, 72, 120, 158, 169
Moten, Ira "Bus," 72
Moulin Rouge Syncopaters, the, 27
Mozelle, Moaning, 46
Murray Poster Printing Company, 118

Nadsco Records, 19
Napier, Simon, 188
Nathan, Syd, 95, 132, 134, 218
National Records, 132
Navarro, Fats, 132
Nelson, Jimmie, 203
Nelson, Romeo, 103, 150
New Orleans Rhythm Kings, 26
New Orleans, LA, 6, 12, 17, 20, 23, 44, 62, 132, 163, 191, 197, 200
New York City, 8, 12, 13, 14, 15, 16, 17, 20, 22, 32, 33, 59, 38, 44, 94, 98, 101, 108, 110, 111, 128, 132, 157, 168, 170, 188
Newport Folk Festival, 171, 182
Newport Jazz Festival, 164
Nix, Rev. A. E., 77
Noone, Jimmie, 44, 99, 135, 150
Norfolk Jubilee Quartet, the, 86

O'Neal, Jim, 188
Oertle, Ernie, 110
OKeh Records, 8, 16, 17, 20, 26, 27, 42, 44, 48, 50, 58, 59, 89, 90, 91, 98, 101, 104, 107, 110, 160, 169, 170, 171, 183, 189
Old Swing-Master Records, 133, 145
Oliver, Joe "King," 27, 55, 58, 62, 66, 77, 99
Oliver, Paul, 186
Ora Nelle Records, 144
Original Louisville Jug Band, the, 49
Original Memphis Five, the, 67
Oriole Records, 104
Ory, Edward "Kid," 99, 152
Oster, Dr. Harry, 156, 157
Otis, Johnny, 126, 132, 135
Overbea, Danny, 179
Owens, Harry, 22

Pace, Charles Henry, 73
Pace, Harry, 12, 42
Pace's Jubilee Singers, 73
Paley, William S., 50
Palmer, Fred, 121
Panassié, Hugues, 200
Paramount Records, 15, 16, 18, 20, 27, 42, 43, 47, 52, 70, 73, 74, 76, 87, 98, 101, 103, 108, 110, 111, 143, 170, 171, 187, 189, 190, 191
Paramount Singers, the, 92
Parham, "Tiny," 73
Parish, Mitchell, 29
Parker, Charlie, 132, 153, 188, 193
Parker, Little Junior, 134, 210

Parrot Records, 145, 218, 219
Patton, Charley, 6, 42, 76, 110, 111, 156, 170
Peacock Records, 134, 146, 168, 215
Perfect Records, 62, 104, 105
Perkins, Forrest "War," 138
Perkins, Frank, 29
Perls, Nick, 42, 170
Perry, King, 175
Phillips International Records, 210
Phillips, Gene, 213
Phillips, Sam, 218
Piedmont, 6, 111, 186, 211
Piron, Armand J., 17, 20
Planet Records, 144
Plaza Records, 104
Pope, Wayne, 215
Porter, Jake, 132
Powell, Vance "Tiny," 92
Presley, Elvis, 64, 134
Prestige Records, 98, 156, 180, 206, 209, 211, 214
Preston, Jimmy, 154–55
Primrose & West's Big Minstrels, 116, 117
Primrose, George, 116, 117
Pryor, Snooky, 144, 145
Pugh, Forest City Joe, 156, 157
Pullum, Joe, 64

QRS Records, 20, 103
Quattlebaum, Doug, 211

Rabbit Foot Minstrels, the, 43, 57, 116
Rainey, Gertrude "Ma," 42, 43, 57, 97, 98, 116, 189
Rau, Fritz, 200
Razaf, Andy, 30
Red Onion Jazz Babies, the, 20
Red, Speckled, 45, 150, 206
Red, Tampa (Hudson Woodbridge), 7, 15, 26, 54, 64, 76, 83, 98, 103, 105, 144, 186
Redman, Don, 36, 98
Reed, Jimmy, 9, 118, 145, 181, 192
Reed, John E., 179
Regal Records, 132, 170
Rene, Leon, 132
Rene, Otis, 132
Rhodes, Todd, 140–41
Rhumboogie Records, 133
Ricks, James, 74
Riverside Records, 191
RKO Pictures, 128
Robbins, Everett, 15, 17
Roberts, Luckey, 14
Robey, Don, 134, 168
Robinson, Bill "Bojangles," 34, 121
Robinson, Bobby, 210
Robinson, Fenton, 217
Rocco, Maurice, 128, 174
Rogers, Jimmy, 144
Roland, Walter, 104
Romeo Records, 104, 105
Rose, Vincent, 22
Ross, Doctor, 134, 206
Rowe, Mike, 186
RPM Records, 132, 177, 212, 219
Rupe, Art, 132, 138
Rush, Otis, 126, 145, 180
Rushing, Jimmy, 72, 120, 151, 158, 169
Russell, Leon, 218
Rust, Brian, 186, 188

Sabre Records, 98
Sane, Dan, 74
Savannah Syncopators, the, 99
Savoy Bearcats, the, 24
Savoy Records, 123, 132, 135, 214
Scales, Chester, 144
Schiffman, Bobby, 118

Schiffman, Frank, 118
Schlitten, Don, 206
Scott, Mabel, 174
Selah Jubilee Singers, the, 87
Sengstacke, John, 56
Sengstacke, Robert Abbott, 56
Sensation Records, 140–41
Session Records, 161
Shade, Will, 68, 171
Shapiro, Mike, 116
Shaw, Allen, 108
Shelter Records, 218
Shepard, Ollie, 86
Shines, Johnny, 144
Shrout, William C., 89
Shuler, Eddie, 201
Silas Green, 116
Sissle, Noble, 14, 15
Sittin' in With Records, 140
Slim, Guitar (Eddie Jones), 179
Slim, Lightnin' (Otis Hicks), 134, 164
Slim, Sunnyland, 144, 180, 200, 209, 214
Smith, Bessie (Empress of the Blues), 6, 7, 14, 15, 17, 18, 20, 45, 50, 51, 65, 98, 116, 119, 150, 154
Smith, Clara, 65, 98
Smith, Effie, 138
Smith, Jabbo, 45, 58
Smith, Leroy, 19
Smith, Mamie, 14, 16, 42, 98, 120
Smith, Pine Top, 44
Smith, Stuff, 37
Smith, Susie (Monette Moore), 42, 128
Smith, Willie "The Lion," 14, 128
Snow, Valaida, 161
Solid Senders, the, 138, 203
Sony Music, 50
Soul Stirrers, the, 140–41
Soule, Ralph, 25
South Side, Chicago, 20, 26, 55, 56, 73, 98, 118, 135, 144, 145, 178, 180
South, Eddie, 68, 200
Spand, Charlie, 90, 108
Spann, Otis, 144, 171, 200
Sparks, Milton, 83
Spaulding, Henry, 45
Specialty Records, 132, 138, 143, 173, 198–97
Speir, H. C., 110–11, 156
Spero, Phil, 170
Spikes, John, 99
Spikes, Reb, 99
Spivey, Addie (Sweet Pease), 74
Spivey, Victoria, 44, 69, 74, 100, 101
Stackhouse, Houston, 70
Starmer, Frederick, 14, 15
Starmer, William, 14, 15
Starr Piano Company, 62
States Records, 217
Stax Records, 103, 218, 219
Steele, Silas, 146
Steiner, John, 187
Steinweiss, Alex, 150, 151
Stitt, Sonny, 162, 202
Stokes, Frank, 12, 74
Strachwitz, Chris, 164, 206, 208, 215
Strong, Henry, 144
Stuart, David, 101
Sun Records, 134, 163, 177, 206, 210, 215
Sunday Sinners, 120
Sunshine Records, 99
Sunshine, Monty, 161
Swing Time Records, 132, 140
Sykes, Roosevelt, 64, 81, 86, 87, 105, 107

Taggart, Blind Joe, 47, 77
Takoma Records, 171
Tarnopol, Nat, 45
Taskiana Four, the, 74

Taylor, Koko (Queen of Chicago Blues), 217
Taylor, Eddie, 181
Taylor, Eva, 20, 169
Taylor, Montana, 150
Ted Claire Snappy Bits Band, the, 67
Temple, Johnnie, 64, 87, 144
Terry, Sonny, 91, 156, 171, 200, 206, 207
Testament Records, 180, 206
Tharpe, Sister Rosetta, 118, 120, 173
Theard, Sam, 45
Thelkeld, Buford, 67
Thomas, Jesse "Babyface," 52, 75, 138
Thomas, Rufus, 116, 134, 168
Thomas, Williard "Ramblin'," 52
Thompson, Sonny, 218
Thornton, Wille Mae "Big Mama," 134, 215
Three Blazers, the, 127, 128
Thurman, "Mr. Sad Head" William, 127
Tilghman Jr., Charles Francis, 122–23
Tin Pan Alley, 12, 19, 22, 24, 29, 118
Tom, Georgia (Thomas A. Dorsey), 15, 54, 62, 77, 98, 103, 107
Toscano, Eli, 145
Towles, Nat, 197
Traill, Sinclair, 200
Trent, Alphonso, 25
Tribune Showprint Inc., 118, 126
Trice, Rich, 87
Trilon Records, 92, 93
Trumpet Records, 134, 172
Tucker, Bessie, 75
Turner, Big Joe, 9, 128, 132, 140, 151, 193, 213
Turner, Ike, 163
Twelve Clouds of Joy, the, 33
Tyler, William A., 22
Tympany Five, the, 64, 124, 128

Up-to-Date Records, 19

Van Vechten, Carl, 13, 168, 180
Vanguard Records, 186, 216
Variety Records, 100, 198
Varsity Records, 31
Vassar, Callie, 66
Vee-Jay Records, 9, 145, 164, 181, 208, 214
Verve Records, 152, 206
Victor Records (RCA Victor), 19, 24, 26, 50, 52, 58, 62, 63, 64, 67, 68–69, 70, 71, 72, 73, 74, 75, 80, 81, 83, 98, 103, 118, 127, 128, 132, 140, 150, 151, 170, 171, 194, 206, 210
Vidor, King, 69, 77, 118
Vinson, Eddie "Cleanhead," 126, 132
Vinson, Walter, 86
Virginia Four, the, 75
Vocalion Records, 19, 20, 35, 37, 44, 47, 53, 54, 55, 74, 75, 76, 77, 79, 85, 90, 98, 99, 103, 104, 105, 107, 108, 109, 111, 112, 113, 127, 143, 161, 171, 182, 191, 196
Vogue Records, 161

Wade, Jimmie, 27
Walker, Aaron T-Bone, 7, 9, 31, 118, 133, 143, 165, 188, 200, 202, 203
Wallace, Minnie, 75
Wallace, Sippie, 20, 44
Waller, Ben, 138
Waller, Fats, 14, 17, 34, 36, 65, 75, 102, 121, 151, 200
Ward, Billy, 134, 193
Warner Brothers, 45, 128
Washboard Sam (Robert Brown), 64, 81
Washboard Serenaders, the, 58, 128
Washington, Dinah, 128, 154, 171
Waterman, Dick, 170
Waters, Ethel, 34, 42, 64, 65, 98, 121
Waters, Muddy, 7, 115, 118, 135, 144, 156, 162, 171, 188, 200, 206
Wax Records, 92

Weaver, Curley, 105, 140
Weaver, Sylvester, 44, 98
Webb, Chick, 33
Wein, George, 171
Weinstock, Bob, 206
Welding, Pete, 206
Wells, Junior, 180, 206, 217
West Coast, 7, 92, 116, 135, 143, 165
West, Billy, 116, 117
Wheatstraw, Peetie, 64, 86, 108
White, Bukka, 44, 170, 171, 182, 218
White, Georgia, 64, 86
White, Josh, 47, 113, 171, 180
Wilkins, Rev. Robert, 45, 170, 171
Williams, Bert, 12, 34, 63
Williams, Big Joe, 64, 160, 181
Williams, Clarence, 14, 15, 17, 20–21, 58, 79, 102, 169, 196
Williams, Cootie, 126, 154–55
Williams, Dootsie, 95, 132
Williams, J. Mayo, 42, 46, 58, 62, 102, 144, 189
Williams, Jody (Little Papa Joe), 145, 147
Williams, Nat D., 168
Williams, Robert Pete, 156
Williams, Spencer, 23
Williamson, John Lee "Sonny Boy," 26, 64, 83, 89, 144, 162, 163, 200, 217
Willis, Chuck, 160
Wilmer, Valerie (Val), 183
Wilson, Don, 217
Wilson, Edith, 50
Wilson, George "Chicken," 103
Wilson, Jackie, 45
Wilson, Jimmy, 143
Withers, Ernest C., 168, 180
Witherspoon, Jimmy, 142, 192
Wolcott, F. S., 116
Wolcott, Marion Post, 9, 134
Wolf, Howlin' (Chester Burnett), 9, 70, 144, 162, 163, 170, 171, 178, 180, 200, 213
Wolff, Francis, 94
Wood, Randy, 134
Woods, Oscar, 86
Wright, Billy, 146
Wynn, Albert, 55
Wynn, Big Jim, 143

Yancey, Jimmy, 161
Yates, Blind Richard, 99
Yazoo Records, 42, 208
Young, Ernie, 134
Young, Johnny "Man," 144

Zeldman, Maurice, 140–41, 168
Zeldman, Seymour, 140–41, 168